Fallen Idols

Also by Alex von Tunzelmann

*Indian Summer: The Secret History of
the End of an Empire*

*Red Heat: Conspiracy, Murder, and the
Cold War in the Caribbean*

*Blood and Sand: Suez, Hungary, and
Eisenhower's Campaign for Peace*

Fallen Idols

Twelve Statues That Made History

Alex von Tunzelmann

HARPER

An Imprint of HarperCollins*Publishers*

HarperCollins books may be purchased for educational, business, or sales promotional use. For information, please email the Special Markets Department at SPsales@harpercollins.com.

Originally published in a different form in the United Kingdom in 2021 by Headline Publishing Group.

FIRST EDITION

Designed by Leah Carlson-Stanisic

Chapter Illustrations © David Lawrence 2021.

Library of Congress Cataloging-in-Publication Data has been applied for.

ISBN 978-0-06-308167-3

21 22 23 24 25 LSC 10 9 8 7 6 5 4 3 2 1

To my godchildren, and the next generation:
you are the future, so make your own history.

I met a traveller from an antique land,

Who said "Two vast and trunkless legs of stone

Stand in the desert . . . Near them, on the sand,

Half sunk a shattered visage lies, whose frown,

And wrinkled lip, and sneer of cold command,

Tell that its sculptor well those passions read

Which yet survive, stamped on these lifeless things,

The hand that mocked them, and the heart that fed;

And on the pedestal, these words appear:

My name is Ozymandias, King of Kings;

Look on my Works, ye Mighty, and despair!

Nothing beside remains. Round the decay

Of that colossal Wreck, boundless and bare

The lone and level sands stretch far away."

—Glirastes (Percy Bysshe Shelley), "Ozymandias," 1818

Contents

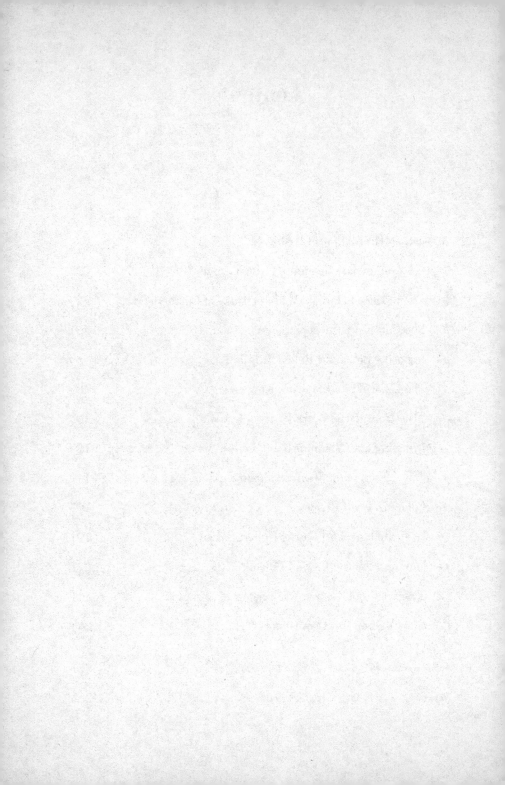

Fallen Idols

The Making of History

This is a book about how we make history. There are lots of ways we remember the past—in song, in verse, in movies and TV shows, in art, in artifacts, in exhibitions and festivals. We tell our stories in fiction, in nonfiction, in propaganda, in anecdotes, in jokes. This book looks at one particular and controversial form of historical storytelling: statues. Statues are intended, literally, to set the past in stone. As we'll see, that doesn't always work.

In 2020, statues across the world were pulled down in an extraordinary wave of iconoclasm. There had been such waves before—during the English Reformation, the French Revolution, the fall of the Soviet Union, and so on—but the 2020 iconoclasm was global. Across former imperial powers and their former colonial possessions, from the United States and the United Kingdom to Canada, South Africa, the Caribbean, India, Bangladesh

and New Zealand, Black Lives Matter protesters defaced and hauled down statues of slaveholders, Confederates, and imperialists. Edward Colston was hurled into the harbor in Bristol, England. Robert E. Lee was covered in graffiti in Richmond, Virginia. Christopher Columbus was toppled in Minnesota, beheaded in Massachusetts, and thrown into a lake in Virginia. King Leopold II of the Belgians was set on fire in Antwerp and doused in red paint in Ghent. Winston Churchill was daubed with the words "is a racist" in London.

Some feared that this was becoming a frenzy. In the United States, Confederate statues had long been a focus for public protest, but soon statues of national icons and progressive figures were attacked too. Protesters in Madison, Wisconsin, tore down the Forward Statue, celebrating women's rights, and another, of an abolitionist. A statue of the abolitionist Frederick Douglass in Rochester, New York, was knocked clean off its base: it was unclear if the perpetrators were confused anti-fascists or fascists, retaliating for the removal of Confederates and slaveholders. The statue of the Little Mermaid in Copenhagen, Denmark, was daubed with the words "Racist Fish." That one was probably just a prank.[1]

The backlash was led by President Donald Trump, who signed an Executive Order declaring: "Many of the rioters, arsonists, and left-wing extremists who have carried out and supported these acts have explicitly identified themselves with ideologies—such as Marxism—that call for the destruction of the United States system of government." The order reiterated that those who damage federal property could face ten years in jail. "Individuals and organizations have the right to peacefully

advocate for either the removal or the construction of any monument," it concluded. "But no individual or group has the right to damage, deface, or remove any monument by use of force."[2]

Trump visited Mount Rushmore, where, according to South Dakota governor Kristi Noem, he told her it was his dream to have his own face carved into the mountain alongside Washington, Jefferson, Roosevelt, and Lincoln. "I started laughing," she said. "He wasn't laughing, so he was totally serious."[3] Trump responded on Twitter by denying that he had suggested it, then, in the same sentence, suggesting it again: "This is Fake News by the failing @nytimes & bad ratings @CNN. Never suggested it although, based on all of the many things accomplished during the first 3½ years, perhaps more than any other Presidency, sounds like a good idea to me!"[4]

Boris Johnson, the British prime minister, also took to Twitter: "those statues teach us about our past, with all its faults. To tear them down would be to lie about our history, and impoverish the education of generations to come." The Conservative government announced that it would amend the Criminal Damage Act so anyone damaging a war memorial in Britain could also be looking at ten years in prison.[5]

Museums and civic authorities were quick to react too, though often in a different way. The day after slave trader Edward Colston's statue was pulled down, the Museum of London Docklands removed its own statue of another slave trader, Robert Milligan. The American Museum of Natural History in New York announced that the equestrian statue of Theodore Roosevelt outside its entrance would go: this one had caused trouble for decades, for it showed Roosevelt supported by a Na-

tive American and an African, both in subordinate roles. The city of Hamilton in New Zealand removed a statue of its namesake, Captain John Hamilton, after a Māori elder pointed out that he was a "murderous arsehole."[6]

In the United States and Britain, right-wing Republican and Conservative administrations took this as an opportunity to stoke a "culture war." They positioned themselves as the champions of American and British civilization: the last defense against barbarism and "political correctness"—or, as it was increasingly called, "wokeness." In September 2020, the British Culture Secretary, Oliver Dowden, wrote to museums, threatening them with funding cuts if they took any actions "motivated by activism or politics."[7] President Trump went further: "As I said at Mount Rushmore—which they would love to rip down and rip it down fast, and that's never going to happen—two months ago, the left-wing cultural revolution is designed to overthrow the American Revolution." He announced the foundation of a 1776 Commission, intended to promote "patriotic education." He also pledged to create a new statue park, the National Garden of American Heroes.[8]

Can statues really be this big a deal? Most of us who live in towns or cities probably walk past these lumps of stone and metal every day without thinking much, or at all, about who they are or what they mean. We may, of course, enjoy some of the more amusing ones, such as the hippopotamus statues that appear to be "swimming" half-submerged in the pavement in Taipei, Taiwan. When it comes to the standard-issue statue of an old gentleman on a horse, though, you can ask twenty passersby who he is and chances are none of them will get it right. As the

Austrian writer Robert Musil observed: "There is nothing in this world as invisible as a monument."[9]

Yet clearly some statues *do* matter because, when they are pulled down, world leaders proclaim draconian measures to protect them. In certain circumstances—maybe not the hippos—statues represent much more than lumps of stone and metal. They are icons of individuals: their symbolism may cross the line between secular and religious. They are held to represent those individuals and, at the same time, national, cultural, or community identity. To raise the question of any commemorated individual's flaws, then, raises the question of flaws in the nation itself. President Trump, as we have seen, repeatedly emphasized that taking down statues could lead to the destruction of the United States.

The term "culture war" has been used since the 1990s to describe polarizing issues that divide those people who hold traditional values from those who are progressive. On the face of it, the attacks on statues in 2020 followed this pattern: those who cheered on the protesters pulling them down tended to be younger and more socially liberal, while those who were dismayed by the destruction tended to be older and more conservative.

If you look into it more deeply, though, the issue of statues is far more complicated. When statues of Lenin were pulled down across Ukraine in 2014, and when the colossal statue of Saddam Hussein was pulled down in Iraq in 2003, many older Western conservatives rejoiced, while some younger progressives were less sure about celebrating. When the Islamic State of Iraq and the Levant (ISIL) destroyed ancient statues in Palmyra in 2015,

there was condemnation across the political spectrum. Many of those responding to these events responded very differently in 2016, 2017, and 2020, when statues of Confederates and slaveholders were the focus. Statues are not neutral, and do not exist in vacuums. Our reactions to them depend on who they commemorate, who put them up, who defends them, who pulls them down, and why. The "culture war" binary is an easy way for the media to get a punchy three-minute segment out of this issue, but it obscures a fascinating history of how societies around the world have put up, loved, hated, and pulled down statues in order to make statements about themselves.

Public discussions of history often view it through a culture-war lens. Do you feel pride or shame in your country's past? Was your country a force for good or bad? Was a particular historical figure a hero or a villain? These questions exasperate many historians, because they don't get you any closer to understanding history on its own terms: they're about your personal feelings today. Of course, you're free to have whatever feelings you like about history, but they don't make the slightest difference to what really happened. They may even get in the way of our understanding. As Kim Wagner, professor of history at Queen Mary University of London, remarks: "Historians are not time-travelling Santa Claus, making a list of who's naughty and nice. 'Good' and 'bad' are not analytically meaningful labels. Rather, historians seek to expose different experiences and worldviews of the past, and make some kind of sense of people's often-times senseless actions."[10]

Statues of historical figures have sway in this debate because they tap in to all those binaries that are not really about history at

all, but are about how we see ourselves reflected in history: pride versus shame, good versus bad, heroes versus villains. Statues are not a record of history but of historical memory. They reflect what somebody at some point thought we should think. Putting a statue up is a powerful symbol. So is pulling one down.

The effects of the iconoclasm of 2020 are still being felt at the time of writing. New stories of statues being put up or pulled down will doubtless continue to emerge. The underlying themes of these stories, though, will not change: all of them are about how historical memory is constructed and challenged. We live in a polarized world, where history is often politicized and even weaponized; where freedom of speech and thought are under threat, though not always in the ways that grab headlines; where the time it takes for a lie to travel halfway around the world is now less than a second. The question of who gets to define memory, and how, is crucial to who we are as societies—and to what we hope to become.

For years, I've traveled around museums and statue sites across the United States, Latin America, the Caribbean, Europe, Asia, the Middle East, and Africa, as well as the haunting "statue graveyards" of vanquished regimes in Moscow, Budapest, and Delhi. I'm often struck by the poignancy of statues from lost worlds. Broken monuments speak of the pride that came before the fall. Statues of individuals are a three-dimensional freeze-frame of a moment: willing you to imagine the person they represent as the tangible human they once were. This may be one reason that some people react so strongly when they are destroyed. Seeing a mob smash in the face of something that looks like a person is

shocking. Many cultures throughout history have made statues into idols, bathing and dressing them, bringing them offerings, and talking or praying to them. It's hard to forge that human connection with an obelisk.

I am acutely conscious of the interplay between fact and fiction because I work both as a historian and as a screenwriter, specializing in historical drama. In the first job, I bust myths. In the second, I make them. At least, that's what I tell myself, though really this distinction is too neat. While we historians generally try not to make things up, in attempting to "make some kind of sense of people's often-times senseless actions," as Professor Wagner describes it, we are still telling a story. In telling *any* story, in making any kind of selection of which historical facts to include or exclude, you inevitably impose a shape on facts and events—and that shape may be deceptive.

The scientist and philosopher Alfred Korzybski remarked that "the map is not the territory." Any written history, even the blandest series of historical documents, can only ever be a map, not the actual territory of history, which vanishes as soon as it has happened. History is gone. What we have is the *memory* of history, and that is always contested.

This is why I am interested in statues, and why I think their construction and destruction is so important to many people. They are a visible form of historical memory—and historical mythmaking. When somebody is transformed from human into statue, the act of memorialization tells a story about who *they* are and who *we* are. It is possible, even likely, that neither story a statue tells—about them or us—is true. Like the historical dramas we see on-screen, statues create myths.

At the root of the debate over statues is an issue that is essential, even existential, to our communities, societies, and nations. Whose stories do we tell? Who or what defines us? Who gets to make these decisions? What if we don't all agree? How is history made, why, and by whom?

I have chosen twelve statues through which to explore these questions. In a world where the question of who gets to define our history is under threat—where leaders can explicitly oppose freedom of thought and interpretation, and threaten to indoctrinate us with "patriotic education" or lock us up for a decade if we damage a monument—these issues are extremely urgent. This will be a whistle-stop tour through modern world history. Parts of it will be harrowing. The stories in this book include genocide, slavery, and terror. Yet they also speak of the ability of human societies to overcome those things: to change.

Which monuments count as statues? This book looks specifically at portrait statues: the figurative representations of individuals that are put up to celebrate and promote their virtues. My selection is secular and political. Michelangelo's David, Gian Lorenzo Bernini's Ecstasy of Saint Teresa, the Buddhas of Bamiyan, or the Khajuraho temple carvings would not qualify for inclusion here: they are magnificent examples of religious sculpture. The Statue of Liberty or The Motherland Calls in Volgograd would not qualify either: these spectacular monuments are not intended to represent individuals but to commemorate events, or to celebrate ideas and ideals.

The lines dividing political statuary from artistic sculpture

and from historical monuments are blurry. Religious sculptures can themselves be political statements; political statues are sometimes venerated as quasi-religious objects. The Mount Rushmore National Memorial in South Dakota is a monument made up of four honorific portrait carvings (there are currently no official plans to add President Trump). It could be described as a collection of statues of individuals, or a monument to American democracy, or an early twentieth-century tourist trap, or a desecration of Tȟuŋkášila Šákpe (Six Grandfathers), a sacred mountain of the Lakota Sioux. Gutzon Borglum, the sculptor, intended his presidential carvings to invoke divinity: "a nation's memorial should, like Washington, Jefferson, Lincoln and Roosevelt, have a serenity, a nobility, a power that reflects the gods who inspired them and suggests the gods they have become."[11] It is, by his definition, both political and religious.

Meanwhile, many other statues are not political at all. In the ancient world, statues were raised to private citizens, celebrities, athletes, and animals. This is still the case today. Some of the subjects of statues in this book were not politicians, or not principally politicians—they include merchants, entrepreneurs, generals, and royalty. Yet the purposes of their statues were political, and pulling them down, likewise, was a political act.

One reason that toppling statues often causes controversy is because we have come to think of them as art, and therefore part of our cultural heritage. To destroy our heritage feels like barbarism. Often, it is. Conquering forces, tyrants, and terrorists have often destroyed cultural symbols—not just carelessly, because

they were in the line of fire, but deliberately, because they were symbols. "Such was the purpose of the Nazi destruction of German synagogues on Kristallnacht in 1938," wrote the architectural critic Robert Bevan: "to deny a people its past as well as a future."[12] Symbolic targets can be secular as well as religious: on September 11, 2001, terrorists hit symbols of American power, including the World Trade Center in New York and the Pentagon in Washington, DC. There was widespread dismay around the world when the Taliban blew up the Buddhas of Bamiyan in Afghanistan in 2001, and, as previously mentioned, when ISIL smashed up statues and monuments in Palmyra, Syria, in 2015.

When Black Lives Matter protesters demanded the removal of Confederate statues during 2015 to 2017, and again when they knocked them down in 2020, there were many who compared them to the Taliban and ISIL. It is a comparison with emotional impact, but it relies on two assumptions that are false.

The first assumption is that the motivation to remove statues must always be senseless or hateful. It is not. There was no clucking about heritage when, in 2012, a wooden statue of Jimmy Savile was removed from outside Scotstoun Leisure Centre in Glasgow. Savile—a British children's TV personality of the 1970s and 1980s—had died the previous year. Stories began to emerge that he had been a prolific sex offender, preying mostly on children. Plaques, memorials, and even his gravestone were quickly removed—as was the statue. No one spoke in favor of keeping any of it: it was understood that to do so would be hurtful to his victims. The Savile case was grotesque, and resoundingly defeated the argument that it is always barbarous

to get rid of a statue. On this occasion, it would have been barbarous to keep it.

The second assumption that the comparison between the Taliban and Black Lives Matter makes is that all statues have equal cultural and artistic worth. They do not. Artistic merit may be subjective, but statues cannot be discussed intelligently without factoring it in. Bernini's bust of Louis XIV of France, sculpted in 1665 and displayed at the Palace of Versailles since the 1680s, was described by art critic Rudolf Wittkower as "probably the grandest piece of portraiture of the Baroque age." Bernini's skill with the marble implies texture, movement, and even—Wittkower argued—"the sensation of colour."[13] The king's imperious expression is breathtakingly lifelike; the folds of fabric that swirl around him appear to be in motion. During the French Revolution, which began in 1789, hundreds of statues and emblems of royalty were smashed or melted down. Versailles escaped mob pillage only to be pillaged by the regime itself, which sold off much of its art and furniture. Fortunately, Bernini's bust survived to the designation of Versailles as a museum in 1794. It is still there today.

At the other end of the scale from Bernini's masterpiece is the wooden statue of First Lady Melania Trump that went up near her birthplace in Slovenia in 2019, prompting international ridicule. Mrs. Trump's features were hacked roughly out of a linden tree, giving her a blobby nose and wonky eyes. Her body was clumsily painted powder blue, hinting at the outfit she wore for President Trump's inauguration. On the night of July 4, 2020, the statue was set on fire with gasoline and tires. Nobody minded. Even the artist who commissioned it did not seem in

the least upset. "There's a lot of buzz around the destruction of monuments," he told the *New York Times* cheerfully, declaring that he planned to re-exhibit the statue in its charred state.[14] The statue was, to put it politely, crap: destruction elevated it, lending it a cultural relevance it had previously lacked. (A bronze version went up in September 2020. If anything, it was even worse than the original.)

Perhaps some will try to argue that the relative merits of Bernini's Louis XIV bust and Slovenia's Melania Trump statue are irrelevant and that the two works must be treated as perfect equals. Perhaps they really have reached a level of philosophical abstraction where they refuse to acknowledge any difference in quality between Michelangelo's Pietà and a pile of horse manure. If so, I don't want them in charge of public monuments, or a shovel. (The Pietà was attacked in 1972—not with a shovel, but with a hammer.)

The value and meaning of statues varies enormously. The circumstances in which they go up and come down vary too. To suggest they are all exactly the same is a false equivalence. We have to do the real work of looking at statues case by case, and understand why they are different. When we defend any particular statue, what are we really defending?

Statues are much older than recorded history, dating back to the Palaeolithic era and the dawn of humanity. The oldest confirmed statues are both German. They were made of ivory, were found in caves, and are assessed as being between 35,000 and 40,000 years old: the Lion Man of the Hohlenstein-Stadel and the Venus of Hohle Fels. Forms of statuary can be found on every inhab-

ited continent, from the Easter Island *moai* of Polynesia to the Terracotta Warriors of China, to the Nok sculptures of Nigeria, to the colossal Olmec heads of Mexico.

The history of destroying statues is itself extremely ancient. It was common for Egyptian pharaohs to smash statues of their predecessors and rivals. Deuteronomy 12:3 mandates the destruction of idols: "And ye shall overthrow their altars, and break their pillars, and burn their groves with fire; and ye shall hew down the graven images of their gods, and destroy the names of them out of that place." European colonizers frequently destroyed the art of the civilizations they encountered, either because they considered it offensive or (as was the case with much Central and South American art) because it was made of valuable materials, such as gold, which they melted down for their own use.

The classical style of statuary that we recognize immediately in Europe and its former colonies dates back to ancient Greece and Rome. In ancient Greece, statues could be artistic, devotional, honorific, or a mix. Communities would thank deserving individuals with an εἰκών (*eikon*, from which we get the word "icon"): a publicly displayed bronze or marble statue, or a painted portrait on wood. Broadly, *eikons* began as exceptional honors awarded by public bodies; gradually, wealthy individuals began to put up statues of themselves and their families of their own accord.[15]

Subjects could be shown armored, costumed, or nude. Art historians sometimes talk about "heroic nudity" (or "heroic costume," which means nude but with weapons: perhaps not a costume most of us should try out in public). Statue nudity was not

always heroic in the ancient world, though: nakedness could be used to imply vulnerability or toil.[16] It could also, of course, represent plain old vanity.

Another enduring form created by the Greeks and Romans was the equestrian statue: a figure astride a horse. Older civilizations, such as the Egyptians, Assyrians, Babylonians, and Persians, depicted kings and princes standing in chariots, while guards and warriors rode horses. For the Greeks and Romans, horseback riding symbolized nobility by elevating the figure, showing him (it was almost always a him) leading invisible troops and mastering nature.[17] We have inherited this idea from them: equestrian statues continued to pop up in the twentieth century, and were not generally superseded by statues of leaders in cars. Having said that, there is a splendid statue of Yuri Gagarin, the first man in space, in Moscow: his heroic form is lifted to a height of 42.5 meters by a rocket trail.

The classical tradition was revived in Europe during the Renaissance in the fifteenth and sixteenth centuries—though with a new twist. In the ancient world, statues were usually painted in full color. Culturally, many of us now see painted statues as garish. This is based on a mass misremembering. By the fifteenth century, the paint had mostly worn off the ancient ones, and it was generally assumed that they were supposed to be plain marble or bronze. Artists such as Donatello and Michelangelo never painted their statues. The ancients might have considered Renaissance statues unfinished.

When protesters in 2020 attacked statues that they felt were symbols of white supremacy, some criticized them for applying modern standards to an ancient form. In fact, classical statues

have a long association with white supremacy. Greek and Roman paintings and ceramics depict all sorts of skin tones, including Black Africans. Yet it was the gleaming white Apollo Belvedere, a Roman statue that now stands in the Vatican, which obsessed generations of Europeans after its rediscovery in the fifteenth century. Seen as the ideal male form, it was used by anatomists to define a formula for "perfect" beauty based on facial ratios. Their work was later picked up by phrenologists and eugenicists, including the Nazis, to argue that white Europeans were the superior race. In 2017, the American white supremacist group Identity Evropa put the Apollo Belvedere on flyers, with the slogan "Our Future Belongs to Us."[18]

The modern tradition of portrait statuary that accounts for most of the statues that now inhabit our cities was a nineteenth-century revival of the Renaissance revival of the classical style. Individual heroism was in fashion. In 1840, the Scottish writer Thomas Carlyle published *On Heroes, Hero-Worship, and the Heroic in History*, in which he stated: "The History of the world is but the Biography of great men." He outlined the Great Man theory, which held that the twists and turns of world events could all be explained by the actions of extraordinary individuals who excelled in divinity, courage, leadership, the arts, and so on. (His examples were all men; he included one non-European man, Mohammad.) The Great Man theory has been pulled apart by sociologists, feminists, and writers ever since. Academic historians generally regard it as a Victorian relic: interesting as an example of how wealthy nineteenth-century British men understood history as the story of themselves, but far too limited as

a way to view history now. Nonetheless, its impact lingers in the enduring popularity of biographies and biopics—and in the existence of statues.

Statues became extremely popular in the nineteenth century because they were a visual expression of Great Man history. Commemoration was no longer just for royalty, rulers, and religious figures, but for philanthropists, social reformers, inventors, soldiers, and industrialists. The phenomenon was described as "statuemania." There were eleven statues of Great Men in Paris in 1870; between 1870 and the beginning of the First World War in 1914, 155 more appeared. In London, there were twenty-two statues in 1844; by 1910, a total of 215. This pattern was repeated across many European and American cities and in some colonies. So many were going up, according to the artist Edgar Degas, that "one puts iron wire around the lawns of public gardens to prevent sculptors from depositing their works therein."[19]

Campaigns to put up these statues were often driven by a zealous individual. It was frequently claimed that the funds were raised by "public subscription." Sometimes this was true, though it wasn't always easy to persuade the public to cough up cash. The zealous individuals often ended up paying for statues themselves. Just as in ancient Greece, where *eikons* had begun as public honors until wealthy individuals started putting them up according to their own priorities, something similar happened in the nineteenth and twentieth centuries.

When totalitarian regimes rose in the twentieth century, they often adopted and adapted this statue trend. The Soviet Union

went in for statues with such vigor that they have earned two chapters in this book, on Lenin and Stalin.

The Soviets' statuemania was not shared by all communist nations. Chinese communists put up far fewer statues. In 1967, a statue of Mao Zedong was erected at Tsinghua University in Beijing. This began a short but intense burst of Mao statues: 2,000 of them went up over the following two years. But they did not sit well with the Communist Party, still then led by Mao himself. In June 1969, a proclamation was issued ordering that such "formal and pompous" tributes to the leader must cease. In 1980, after Mao's death, the government issued another instruction to end his personality cult, and most of these statues were taken down. It is thought that only around 180 of the original Maos remain.[20] A few more have gone up since the 1990s. The government, still sensitive to Mao's dignity, tears down the most vulgar examples. A 36-meter golden "Mega Mao" in Henan, which went up in 2016 and provoked ridicule online, was draped in a black cloth and hacked to bits within days of being unveiled.[21]

The far right regimes in Europe—Mussolini in Italy, Hitler in Germany—also spent enormous sums on monuments. Mussolini put his own image everywhere, in the forms of statues, busts, and portraits: the writer Italo Calvino remembered, "I spent the first twenty years of my life with Mussolini's face always in view."[22] Statues in the classical style went up in many public buildings built during Mussolini's rule.

The Nazi aesthetic also included classical statues, which, in the tradition of the Apollo Belvedere, fit with their racial theories. Leni Riefenstahl's *Olympia* (1938) opens with tracking shots of Greek monuments before one of the ancient world's

most recognizable statues, the Diskobolos of Myron, dissolves into the nude decathlete Erwin Huber re-creating the discus-throwing pose.[23] Hitler's favored sculptor, Arno Breker, made busts of Nazi figures, including Joseph Goebbels, Albert Speer, and Hitler himself, as well as of Nazi icons such as the composer Richard Wagner. Portrait busts of leading Nazis were mass produced, and were displayed in offices, factories, shops, and homes.

East and West Germany both removed all Nazi statuary and symbolism, and criminalized any display of the swastika, in 1949. Italy removed most statues and images of Mussolini himself, but left a lot of Fascist art and architecture in place. From the beginning in East Germany, and later in the West too, public bodies invested heavily in a program of school and lifelong education aimed at de-Nazification and facing up to the past. The sites of Nazi concentration camps were turned into museums and memorials to the Nazis' victims. No memorials remain to the Nazis themselves.[24]

Seven decades on, the result in reunited Germany is that the Nazi regime and its victims are powerfully and meaningfully remembered. There has been a resurgence of the far right in recent years, but, even so, German schooling, museums, and memorialization have produced postwar generations who are, in general, far more educated about their history, and far more capable of taking a critical view of it, than many other European nations—some of which are still heavily in denial about their own histories. Germany proves that removing statues does not erase history, nor cause it to be forgotten. If anything, it may have the opposite effect.

Fallen Idols

▬ ▬ ▬

The twelve statues in this book come from all around the world: North America, Western and Eastern Europe, Africa, Latin America, and Asia. The chapters are arranged chronologically by the date of destruction. What stories were they meant to tell? Did they come to symbolize something else? Who removed them, how, and why?

I have included controversial statues representing figures from the left and the right of politics; from monarchies, empires, authoritarian regimes, and democracies; from the armed forces and commerce. Almost all of them are of white men—except for Saddam Hussein, and arguably Rafael Trujillo (who identified as white, though his heritage was mixed race). This race and gender imbalance is representative. In modern history, secular statues have mostly commemorated white men. In June 2020, one London museum claimed on Twitter that, in Britain, there are more public statues of goats (three) than there are of named Black women (two).[25] The demographics of statues have changed in Africa, Latin America, and Asia since the end of the colonial period, and recent campaigns to put up more diverse statues in North America, Europe, and Australasia have attempted to redress the balance there too. Many women and people of color are involved in the stories of how and why these statues were brought down.

During my research, I noticed that the same four arguments are often made against pulling down statues. Watch out for them: they are bound to crop up next time a statue comes down.

1. The Erasure of History

"America is waging a war on history," wrote the British journalist Tim Stanley in 2017. "They're taking down statues, removing plaques, erasing the memory of a difficult past."[26] This argument says that removing statues is an attempt to destroy history itself. Often, those putting it forward suggest that people pulling down statues are doing so because they want to cut out the nasty bits and make history nicer. They are, therefore, well-intentioned but misguided. Boris Johnson tried this line in 2020: "We cannot now try to edit or censor our past. We cannot pretend to have a different history."[27] Some offer more sinister explanations. Fox News anchor Chris Wallace said of the removal of Confederate statues: "it kinda reminds me of China during the Cultural Revolution where parts of history, under Mao Zedong, were simply expunged. They were not allowed to exist any more."[28]

Others allege that pulling down statues is not merely misguided but a deliberate plot against the national interest. "It's about Marxism, and the people controlling the narrative at this point," said the conservative commentator Tammy Bruce, speaking on Fox News in 2020. "The dynamic with Marxists is not to actually have a large conversation within the community and within America, which we've been having from our beginning. This is about erasing our past in its entirety."[29]

2. The Man of His Time

This argument is based around defending the individual commemorated by the statue, on the basis that he was a "Man of His Time" and can't be judged by modern standards. "To

wrench historical figures out of their historical contexts and expect them to hold modern views on issues such as race is anyhow absurd," wrote the historian Andrew Roberts. "People's reputations are being trashed for holding opinions that a large majority of people held at the time—essentially for being insufficiently woke."[30] Boris Johnson expressed similar views: "The statues in our cities and towns were put up by previous generations. They had different perspectives, different understandings of right and wrong."

The Man of His Time argument contends that the subject of a statue is complicated, because he did good things as well as bad things. These must be balanced against each other, and forgiven accordingly. Johnson again, talking about the statue of Winston Churchill in Parliament Square: "It is absurd and shameful that this national monument should today be at risk of attack by violent protesters. Yes, he sometimes expressed opinions that were and are unacceptable to us today, but he was a hero, and he fully deserves his memorial."[31]

3. The Importance of Law and Order

We heard about this argument already: it compares the Taliban and Islamic State to Black Lives Matter. "No doubt, for example, the fervent ISIS jihadis who torched the library at Mosul, or flattened the Temple of Baal in Palmyra, felt they were pursuing righteous justice in eliminating the evidence of past regimes they despised," wrote the journalist Sarah Vine. "In reality, they were, like that mob in Bristol [that pulled down Edward Colston's statue], merely indulging in cultural vandalism."[32]

Those making the Law and Order argument insist that stat-

ues must be removed through democratic processes. "What has stood for generations should be considered thoughtfully, not removed on a whim or at the behest of a baying mob," wrote the British government minister Robert Jenrick.[33]

4. The Slippery Slope

This final argument is concerned with drawing a line. If we pull down one statue, will we trigger a domino effect? Will we pull down Churchill's statue because he expressed racist views, forgetting that he also led Britain through the Second World War? Will we blow up the Colosseum in Rome because of slavery? Will we take down the White House because it was built by slaves? Where does it stop?

"I watch them [protesters] on television and I see what's happening and they're ripping down things they have no idea what they're ripping down," said Donald Trump on Fox News in 2020. "They started off with the Confederate [sic] and then they go to Ulyssius [sic] S. Grant. Well, what's that all about? And they would knock down Lincoln, there's a group that wants to take down Lincoln, they haven't figured exactly out why yet. George Washington, Thomas Jefferson. I've stopped them twice now from going over to the Jefferson Memorial. If I weren't president, they would have knocked down—if a guy like [Joe] Biden was president, they will knock the Jefferson Memorial."[34]

As with all authoritarians, Trump positions himself as the only thing standing between order and chaos. The Slippery Slope argument aims to raise fears about destruction and historical revisionism that will threaten deeply held values and undermine society.

＝ ＝ ＝

While these four arguments may appear to have substance at first glance, they are all fallacies. It is easy to demonstrate why with a simple thought experiment. Imagine whether the sort of people quoted above would make the same argument if they were talking about statues of Hitler or Stalin. If a Stalin statue was torn down, would these people be equivocating about how he was a Man of His Time, and everyone believed in murdering Kulaks back then, so you can't really judge him? If a Hitler statue was removed, would they be telling us that we must not impose our modern values on Germans in the 1930s, because they simply had a different understanding of right and wrong? Would they ask us to balance the Holocaust against all the good Hitler did for German railway punctuality? Would they denounce the American troops who blew up the marble swastika at Nuremberg on April 22, 1945, as a "baying mob," who should have put their request through a planning committee?

This thought experiment does not suggest that everything is equivalent to the Nazis or Stalinism: clearly, it is not. What it shows is that these arguments for keeping controversial statues do not spring from universal principles about statues or history, but depend on *which* statue and *what* history you're talking about. In practice, people tend to defend statues that they feel in some way reflect their identities and their values, and rejoice when statues that represent conflicting identities and values go. That's not inherently wrong. It's reasonable—in fact, it's probably the most reasonable position on this issue—to want to keep

some statues and get rid of others. It's just honest to admit that this is subjective.

My stories begin in 1776, when George Washington read out the Declaration of Independence in the United States, and a mob pulled down a statue of George III. They end in 2020, when another mob in the United States pulled down a statue of George Washington. There is a circularity to this tale of many revolutions, but the end of this book will not be the end of the story.

I won't call for pulling down all statues. I'm very fond of some of them. What I'll ask you to do as a reader is to think beyond the binaries of pride and shame, good and bad, heroes and villains, and consider what's really happening in each of these cases. How is memory constructed, how is it challenged, and what can we learn from this? What is the future for statues? Have they had their day? And, if they have: what comes next?

A Revolutionary Beginning

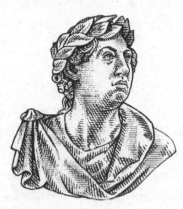

King George III

Location: Province of New York
Put up: 1770
Pulled down: 1776

On July 4, 2020, during the great wave of iconoclasm, President Donald Trump vowed: "We will never allow an angry mob to tear down our statues, erase our history, indoctrinate our children, or trample on our freedoms."[1] Yet there is little that is more fundamentally American than an angry mob tearing down a statue.

The statue in question was of George III, king of Great Britain and Ireland. At the time it went up in 1770, a swathe of the East Coast of North America was under British control as the Thirteen Colonies. The settler population of these colonies had

grown enormously in the preceding century and a half, pushing Native Americans out. Increasingly, the colonies became frustrated with British rule, especially with questions of taxation and control. They had no representation in the British parliament but could be subjected to laws and taxes in which they had no say.

The 1765 Stamp Act—a tax on printed materials—was a prime example of these unpopular taxes. When it was repealed in 1768, the General Assembly of the Colony of New York commissioned a statue of George III to celebrate. The statue was made by the British artist Joseph Wilton, sculptor to the king. Wilton was already at work on an equestrian statue of George III, commissioned by the king's aunt, Princess Amelia, for Berkeley Square in London. He was asked to produce one for New York too: it was probably identical, cast in the same mold.[2]

Wilton worked in the classical style, and his statue was modeled on the ancient figure of Marcus Aurelius on the Capitoline Hill in Rome. George III was shown in Roman dress, crowned in laurel leaves, in the hope that the public would make the link with the ancient philosopher-emperor. Marcus Aurelius was revered for his learning, moral character, and strong sense of public duty: qualities that perhaps fewer people saw in George III.[3] Marcus Aurelius's statue was in bronze, while Wilton cast George III in lead, then clad the statue in gilt. Any symbolism in the material was probably not intended, but there it is anyway: all that glitters is not gold. In this case, behind the gleam was a dead weight.

Though King George's statue appeared to be a fine tribute, it was commissioned as an afterthought. The General Assem-

bly of the Colony of New York's first choice had been to put up a statue of William Pitt the Elder, the British politician widely credited with driving the repeal of the Stamp Act. Pitt's statue was also commissioned from Joseph Wilton, in marble. It was destined for pride of place at the intersection of Wall Street and William Street, then right in the center of New York City. Yet Pitt became prime minister shortly after the Stamp Act was repealed, and there was concern in the General Assembly that to put up a statue of the king's minister when there was no statue of the king himself would be insulting—so they decided that they had better have one of those as well.[4] King George's statue, cast rather than carved, was cheaper than Pitt's. It would be set up in the less prominent location of Bowling Green.

The statue was dedicated on August 16, 1770, to the sound of a thirty-two-gun cannonade. It was raised to a height of eighteen feet on a pedestal to protect it from vandals. This did not work. In 1771, a protective fence had to be built around it, and, in 1773, an anti-desecration law was passed to punish those who defaced the king's statue.[5]

These interventions tend to suggest that American patriots had been attacking George III's statue from more or less the moment it went up. Yet it would take something really big to spark pulling the statue down entirely: a declaration of independence.

General George Washington arrived in New York City on April 13, 1776 and set up his headquarters right by Bowling Green on lower Broadway, next to the Battery—with George III's statue outside his front door. Washington had visited the city only twice before. His wife, Martha, arrived four days later. They moved

into a mansion in Lispenard's Meadows: then a delightful coun-
tryside location with views across the Hudson River, now the
busy intersection of Varick Street and Charlton Street. War with
the British was fast approaching, and Washington spent much
of the spring and summer fortifying New York.

Congress approved the final text of the Declaration of Inde-
pendence on July 4, 1776. Two days later, John Hancock sent a
copy to Washington, asking the general to read it aloud to his
army in New York. Washington received the broadside on July
8. He gathered his troops at the common (now City Hall Park)
the following evening at 6 p.m. There, the Declaration was read
out in front of each brigade. It detailed at length George III's
injuries to the American colonists, and concluded: "A Prince
whose character is thus marked by every act which may define a
Tyrant, is unfit to be the ruler of a free people." This was received
with delight by the men, who responded with "three huzzas."[6]

With the king identified as the enemy of the revolution, the
logical thing to do would be to find him and pull him off his
throne. Regrettably, he was around 3,500 miles away in En-
gland. The regicide would have to be symbolic. An excited
crowd headed down Broadway to George III's statue. The crowd
included perhaps forty or so soldiers (and sailors) led by Captain
Oliver Brown, as well as the New York chapter of the Sons of Lib-
erty, the revolutionary organization that had been responsible
for the anti-tax protest known as the Boston Tea Party in 1773.
Accounts differ as to how many civilian New Yorkers joined in
or spectated. The protesters climbed the fence, attached ropes
to the statue, and pulled it off its plinth.[7]

Later paintings and engravings of the incident added glamor-

ous details. The statue was often incorrectly depicted as showing George III in court dress, with robe and crown, rather than in Roman attire. Some depictions even forgot the horse and imagined his statue as a standing figure. The scene was set in front of a pretty lilac-hued dusk, dramatic sunset, or a backdrop of bonfire smoke. Elegant ladies were shown watching in shock; small children and dogs ran around in excitement; in some versions, African American figures and even a Native American family can be seen. All this was artistic license. We know little about who was in Bowling Green, who led and who followed, or the order of events. We *do* know that, at the end of it, the king's statue lay on the ground, in pieces. We also know that it was not the only British symbol attacked that night. British coats of arms were ripped from the walls of the council chamber, courts, and churches. Paintings of George III were smashed and burned.

General Washington himself was not pleased about the statue being toppled. "Tho the General doubts not the persons, who pulled down and mutilated the Statue, in the Broadway, last night, were actuated by Zeal in the public cause," he wrote in his orders the following day, "yet it has so much the appearance of riot and want of order, in the Army, that he disapproves the manner, and directs that in future these things shall be avoided by the Soldiery, and left to be executed by proper authority."[8]

Of course, revolutions are not always carried out with perfect decorum, no matter how much their commanders might wish it—and a revolution was now happening in New York.

After the fall, George III's statue was beheaded. The rest of its lead was broken into chunks. Captain Brown's men loaded it on

to wagons and took it to the harbor. It was shipped on a schooner to Connecticut, where it would be melted down and turned into 42,088 musket balls, to be used against the British in the War of Independence. The king's "Statue here has been pulled down to make Musket Ball of, so that his Troops will probably have melted Majesty fired at them," wrote postmaster Ebenezer Hazard on July 12.[9]

Special humiliations were reserved for George III's severed head. John Montresor was a loyal British captain in New York at the time. He wrote that he heard that the rebels "had cut the nose off, clipt the laurels that were wreathed round his head, and drove a musket Bullet part of the way through his Head, and otherwise disfigured it." The head was carried off to Moore's Tavern, adjoining Fort Washington, where the rebels hoped to impale it on a spike, like that of a traitor. Before that could happen, Montresor sent a man to steal it from the tavern and bury it. Later, he dug it up. "I rewarded the men, and sent the head by the Lady Gage to Lord Townshend, in order to convince them at home of the Infamous Disposition of the Ungrateful people of this distressed country."[10]

The head arrived at Lord Townshend's house in Portman Square, London, in November 1777. The Townshends were entertaining Thomas Hutchinson, the former governor of Massachusetts. "Lady Townshend asked me if I had a mind to see an instance of American loyalty? and going to the sopha, uncovered a large gilt head, which at once appeared to be that of the King, which it seems the rebels at N. York, after the Declaration of Independence, cut off from the statue which had been erected there," Hutchinson wrote. "The nose is wounded and defaced,

but the gilding remains fair; and as it was well executed, it retains a striking likeness."[11]

So the British had their head back; the Americans had their musket balls. Even so, much of the statue was unaccounted for. It reportedly weighed two tons, or 4,000 pounds. One pound of lead could make twenty musket balls. That meant around half the lead had gone astray. Some may have been taken as souvenirs by the patriots who pulled it down, or looted by opportunists. Other parts were stolen by loyalists, either from Bowling Green or in Connecticut. Gradually, over the years, bits began to turn up—an arm, part of the saddle, a length of cloak. The tail of the king's horse is now in the possession of the New-York Historical Society. In 1991, a resident of Wilton, Connecticut, who lived in a house that had once been inhabited by a loyalist, dug up their garden and found the king's left hand, wrist, and forearm. This piece was auctioned in 2019 for $207,000.[12] Even adding in the surviving pieces that are known to the musket-ball total, though, there is still a lot of statue unaccounted for. Should you live in a house with a revolutionary history, it may be worth taking a look in your yard.

In a setback for the American revolutionaries, British forces captured New York City in September 1776. They could not put the king's statue back up, of course: as any child knows, all the king's horses and all the king's men couldn't put Humpty together again. Instead, they wreaked vengeance on another. Their target was Joseph Wilton's white marble statue of William Pitt, friend to the colonists, which stood on Wall Street. Soon after they occupied the city, British forces beheaded it and ripped off

its arms. The mutilated remains of Pitt's statue were removed in 1788, after the Americans had won the Revolutionary War, and are now in the collection of the New-York Historical Society.[13]

George III's empty plinth remained in Bowling Green until 1818, when it was broken up and the materials dumped for scrap. The removal of the statue had not caused much distress among New York patriots, but the removal of the plinth—itself now a monument to American revolutionary spirit—did. "What was there odious in this simple memorial of a people's valour and devotion?" wrote one distressed correspondent to the *Evening Post*. "Why was it left untouched by hands that destroyed the statue of a king, under circumstances that swell the breath of an American with the proudest emotions? . . . I cannot but lament this vestige, however obscure, thus removed forever from our view."[14] To this individual, removing the statue had made history—but removing the empty plinth erased it.

And what of Wilton's statue of George III in London? It would not survive long either. This time, it was not politics that brought it down. George III had been popular at some points, despite losing the American colonies and suffering long bouts of physical and mental incapacity. He died in 1820. His statue in Berkeley Square still stood, but had fared poorly in the London climate. It turned out that lead was not a good material for statues. The horse's legs began to buckle, and the body of the statue slowly sank into its own plinth. In 1827, his deflated majesty was removed, and would ultimately be replaced with a pump house. A new and more durable equestrian statue of George III in bronze went up on Cockspur Street nine years later, and is still there today.

In the run-up to the American Civil War in the mid-nineteenth century, images of American revolutionary heroes were in vogue. The toppling of George III's statue became a popular subject. The art historian Arthur S. Marks wrote that these paintings were unusual for not including a singular hero: George Washington, as we have seen, was not involved in the statue toppling. "To the contrary, if anything, it may be said that the action in these works is focussed on a traditional anti-hero, the mob."[15]

These images of the mob as a manifestation of American heroism bore striking similarities to those of Black Lives Matter protesters pulling down statues in 2020. When that happened, two famous paintings of the pulling down of George III's statue were turned into memes and circulated on social media. William Walcutt's 1857 version was overlaid with text that reads: "July 9, 1776: After hearing a reading of the newly adopted Declaration of Independence, New Yorkers 'Destroy History' by toppling a statue of King George III. And that's why no one knows who won the American Revolution."[16] A new caption was also added to Johannes Oertel's 1853 painting: "Not OK to destroy monuments? Tell that to the American colonists."[17]

These comments were ripostes to suggestions from President Trump and his supporters that pulling down statues erased history and was un-American. More than that, though, they too were attempts to claim American history for their side. Both Trump's remarks and the social media rediscovery of the pulling down of George III's statue used "patriotic" history to assert moral and political legitimacy in the present.

Fallen Idols

This trend of claiming history for one side or another is strong in the United States. The Founding Fathers have long been revered as demigods. The story of the nation is often told as one of progress toward an ever "more perfect Union." The Constitution is often subject to "originalist" interpretations that aim to ventriloquize eighteenth-century figures for distinctly twentieth- and twenty-first-century aims. As we will see, though, this is not a uniquely American phenomenon. Across all cultures and continents, history is told and retold, used and abused.

History is important to politicians because we, the people, cannot resist thinking of it as a story. If they can rewrite it as a story that leads up to them emerging as a main character, or to their agenda feeling like a logical next step, that confers legitimacy. If power feels legitimate, people will generally accept it.

In the modern world, statues express this process of claiming legitimacy from history—for they themselves are a form with ancient associations. Joseph Wilton was trading on this when he depicted George III as Marcus Aurelius. Six years later, New York rejected that particular statue—but American patriots would start putting up their own statues soon enough, often in the same neoclassical style.

History can be a powerful propaganda tool. It is used in every country and in most political movements. It is one of the reasons why some people have such strong feelings for or against particular statues. In George Orwell's novel *1984*, one of the Party's slogans is: "Who controls the past controls the future. Who controls the present controls the past." Politicians around the world have taken note.

From Prince to Pariah

William, Duke of Cumberland

Location: London, Great Britain

Put up: 1770

Pulled down: 1868

This is the story of a man who was once celebrated with statues, flowers, and song, yet whose reputation fell so far that, in 2005, historians voted him the "Worst Briton" of the whole eighteenth century. This put him among the ten Worst Britons of the entire millennium, alongside fascist leader Oswald Mosley and serial killer Jack the Ripper.[1] His statues are long gone—and, as we will see, no amount of soap can clean his plinth.

On April 16, 1746, British forces met Jacobite rebels on Culloden Moor. The Jacobite rebellion, led by "Bonnie Prince Charlie"—Charles Edward Stuart—sought to oust the House of

Hanover and retake the thrones of England, Ireland, and Scotland for the Stuart dynasty. By this point, the rebellion was already well on its way to defeat. Stuart had reached Derby, in the north of England, at the end of 1745, but, knowing he did not have enough troops to press on, turned back to Scotland. He was pursued by British forces. Culloden, east of Inverness, was the last stand.

The battle itself lasted only around an hour. It was a straightforward British victory. What would be remembered with great emotion later was not the battle itself, but the actions of British troops afterward. Their commander had ordered "no quarter" be given to injured or fleeing Jacobites, or to any civilians, including women and children, who were unfortunate enough to live nearby. In the wake of the battle, thousands of wounded soldiers and ordinary people were murdered in a spree of vengeance. Some were executed by firing squad. Others were burned alive in buildings or clubbed to death.

This was not a case of British troops getting out of hand. These atrocities were ordered by their commander, who praised the most brutal of his officers ("Major General Bland . . . made a great slaughter, and gave quarter to none") and men (three Nottingham butchers serving as troopers were commended for their skill). Nor was the commander repentant after the atrocities. He considered the Scottish Highlands a "vile spot" that needed suppressing: in the months afterward, he ordered his men to "pursue and hunt these vermin [Jacobites] amongst their lurking hills."[2]

Who was this commander? His name was Prince William Augustus, Duke of Cumberland. He was the third and favorite

son of King George II of Great Britain and Ireland. He had already seen service in the navy and the army, had been shot in the leg at the battle of Dettingen in 1743, and had risen to the rank of commander in chief. He was remarkably young to have achieved all this: he had turned twenty-five years old the day before the battle of Culloden. Soon, he would have his first statue.

Following his terror campaign in the Highlands, the Duke of Cumberland returned to London triumphant. The full story of what he had just done—the atrocities committed in his name—was covered up. Lies were spread in the press to justify his actions. Forged documents were circulated, purporting to show that the Jacobite commanders had ordered "no quarter" be given to British forces: the truth, of course, was the other way around. There were lurid rumors that the Jacobites were raiders and even cannibals.[3] Cumberland, in contrast, was acclaimed as the savior of Britain. The composer George Frideric Handel celebrated him with the oratorio *Judas Maccabaeus*, with its chorus of "See the Conquering Hero Comes." His supporters wore Sweet William flowers in their lapels. (In Scotland, the flower is sometimes called "Stinking Billy.")

In England—and in much of lowland Scotland—Cumberland was hailed as a liberator who had finally crushed the Jacobite threat, which had provoked several uprisings since the Stuarts were ousted in the Glorious Revolution of 1688. At the time, progressive thinkers generally supported Cumberland. For them, the Jacobite cause represented a turn back to autocracy, superstition, and priestly rule. They believed Cumberland's victory opened the door to liberty and laid the way for the Enlighten-

ment. His Scottish supporters gave him the freedom of the City of Glasgow and made him chancellor of the University of St. Andrews. His father, George II, raised an obelisk to him in Windsor Great Park, inscribed with the word "Culloden" in giant letters. He was also popular in the American colonies, where, according to one historian, he achieved "nearly godlike status":[4] Prince William County, Virginia; Cumberland, Maryland; and Cumberland Counties in Maine, New Jersey, and North Carolina were all named for him. They still bear his name today.

There were those who did not buy the story of Cumberland as a paragon of virtue, though. By May 1746, people were beginning to ask why, if Cumberland had won such a decisive victory, there were so few Jacobite prisoners in British prisons. Tobias Smollett, then a surgeon in London, published his first poem shortly after the news of Culloden reached the capitol. Entitled "The Tears of Scotland," it was a haunting evocation of what we would now define as war crimes:

> Yet, when the rage of battle ceased,
> The victor's soul was not appeased;
> The naked and forlorn must feel
> Devouring flames, and murdering steel!

Cumberland acquired a new nickname: "the Butcher." An engraving of the time showed him, dagger in mouth, using his bare hands to skin a Highlander alive. The Highlander was tied to a tree by each wrist, wearing a loincloth (tartan, of course), in a pose reminiscent of the crucifixion. The caption reinforced the religious lesson: "This is the Butcher beware of your Sheep."[5]

When Cumberland was proposed for honorary membership in one of the City of London guilds, a member icily suggested that the appropriate choice would be the Guild of Butchers.

As questions started to be raised, Cumberland insisted his actions had been necessary. Many in England, Ireland, and Scotland agreed, and believed he had done the right thing in his brutal reprisals against Jacobites. They imagined Jacobites as Highlanders, and Highlanders as uncontrollable half-naked tribesmen. This was untrue: the Jacobite forces at Culloden had been armed with modern weapons such as muskets, and included conventional French and Irish troops as well as Scots. Paintings, illustrations, ballads, and plays of the time preferred the idea of hairy, wild-eyed savages, so that stuck.[6] There was a crackdown on Scottish culture: the British government banned the teaching of Gaelic, the wearing of Highland dress, and the playing of bagpipes. The image of modern British forces efficiently repressing primitive tribes was easily transferred from and traced back to colonial conflicts. The fact that it was the British themselves who had committed atrocities at Culloden did not interfere with the story. Those telling it simply argued that violence was the only language savages could understand. There were no further Jacobite rebellions after Culloden. To Cumberland's supporters, that was proof that his methods had worked.

One big fan of Cumberland's was Sir Laurence Parsons of King's County in Ireland. Parsons commissioned a statue of Cumberland from John and Henry Cheere of London, two brothers who were fashionable sculptors (their statues were often reproduced in miniature as ceramics or cast statuettes and

sold as household ornaments). The Cheeres created a lead statue of Cumberland in a Roman toga with his sword drawn, which Parsons originally hoped would stand in St. Stephen's Green, Dublin. This did not work out, so instead he put it in the town that then bore his name: Parsonstown in King's County. It was placed atop a 13.5 meter sandstone column in the center of the new Cumberland Square in 1747.

Cumberland became a political force in the 1750s and 1760s. His brother Frederick, Prince of Wales, was among his critics: Frederick loathed Cumberland, and swore to oust him from all military commands once he was king. Alluding to the atrocities in Scotland, Frederick's supporters claimed Cumberland intended to rule the country himself through the military. Darkly, they whispered that he was a new Oliver Cromwell—the man who had killed a king and ruled England as a republic a century before.

Frederick died in 1751 while his father, George II, was still on the throne. Crowds in London were heard to wail: "Oh that it was but the Butcher!"—wishing that Cumberland had died instead. Frederick had been right about his brother's ambition to rule. Cumberland tried to have himself made regent to Frederick's twelve-year-old son, George, who was now in line for the throne. This did not go well. Cumberland went to meet the boy and showed him a sword. According to Horace Walpole, "the young Prince turned pale, and trembled, and thought his uncle was going to murder him."[7]

Cumberland must have managed to be charming from this point on: by the time Prince George took the throne as George III in 1760, he voluntarily asked his uncle to form a government.

Cumberland advised the king to appoint the Marquess of Rockingham as prime minister, but he himself was the most powerful figure in the administration. Cabinet meetings were held at his London home and at Cumberland Lodge in Windsor. He collapsed and died at one of the London meetings in 1765, aged just forty-four.

After Cumberland's death, the idea of raising a statue to him in London came from one of the men who had fought with him in Scotland: Lieutenant General Sir William Strode. Strode was, at the time, suspected of defrauding soldiers under his command by taking payment from them for uniforms that he never delivered. He was eventually court-martialed for this and acquitted, but was ordered to pay the soldiers back. Strode lived on Harley Street, just north of Oxford Street, on land owned by William Henry Cavendish-Bentinck, the 3rd Duke of Portland. It was easy for Strode to persuade Portland to allow a statue of Cumberland. Portland had served with the late duke in the Rockingham administration, and Marylebone was his land, so he could do whatever he liked with it. The location chosen was a block south of Strode's home: Cavendish Square.

Strode hired John Cheere, who had made the statue of Cumberland in Ireland, to design an equestrian statue. This was appropriate: Cumberland's leg injury meant that he was uncomfortable standing and preferred to be on horseback. Cumberland was portrayed in contemporary dress with a tricorn hat and his sword drawn, and was again cast in lead. Famously, he was a large man: Cheere depicted him realistically, atop an equally stout horse. The statue went up on a plinth in the center of the square in 1770. Cumberland faced north, so that he

appeared to be waving his sword menacingly in the direction of Scotland.

Strode, approaching from his house just north of Cavendish Square, would have been treated to the statue's most striking aspect: the front view of Cumberland and the point of his sword. Unfortunately, the majority of traffic into Cavendish Square came from Oxford Street, to the south. This meant that, for most people, the first view of the statue was a gigantic horse's rump, surmounted by a human backside, also of impressive size.

The statue provoked widespread ridicule, not least because Cavendish Square was still under development and rented out to farmers, who surrounded it with livestock. In a book on London architecture published in 1771, John Stewart wrote that "the apparent intention here was to excite pastoral ideas in the mind; and this is endeavored to be effected by cooping up a few frightened sheep within a wooden pailing; which, were it not for their sooty fleeces and meagre carcases, would be more apt to give the idea of a butcher's pen."[8] Stewart's use of the word "butcher" was, of course, no accident.

As London grew around it, Cumberland's statue remained in the square, unloved and occasionally laughed at.

From the 1780s, the British establishment's view of Scotland began to shift. The ban on Highland dress was repealed in 1782. In 1814, the Scottish author Walter Scott published his novel *Waverley*, set in the Scottish campaign of 1745. Scott's hero, Edward Waverley, is an Englishman drawn into the conflict on the British side, yet finds himself sympathetic to the honor and romance of the Jacobite cause. (The novel skips lightly over the Battle of

Culloden.) By then, George III had been incapacitated by his illness, and his son ruled as the Prince Regent. The prince read *Waverley* and admired it greatly: he knighted Walter Scott in 1818. As King George IV, he visited Scotland in 1822. He was the first reigning British monarch to cross the border since Charles II in 1651.

Sir Walter Scott arranged the pageantry for George IV's visit. He presented the new king with a royal tartan (later known by the astonishing name of Royal Stuart) and coached him to show respect for Highland culture—even to identify as a Highland clan chief himself. The king loved dressing up, and joyfully embraced all this, positioning himself as heir to Bonnie Prince Charlie as well as the Hanoverians. He restored the aristocratic titles that had been stripped from Jacobites. By 1836, Culloden Moor had become a tourist attraction.[9]

Queen Victoria, who came to the throne in 1837, adored Scotland and visited often. She considered herself as much a Stuart as a Hanoverian. "Her Majesty always maintained that she was an ardent Jacobite," wrote her biographer Lytton Strachey.[10] In 1852, her husband, Prince Albert, bought Balmoral Castle, which the royal couple decked out with absurd quantities of tartan. A statue of Albert in Highland dress stood in the hall. After Albert's death, Victoria grew close to her ghillie, John Brown: a bluff, kilt-wearing Scotsman, who called her "woman" rather than "ma'am," and treated her to whiskey in her tea. Brown's familiarity with the Queen was widely discussed in terms that were not entirely respectful—even by her own daughters, who jokingly called him "Mama's lover."[11] Whatever the true nature of their relationship, Victoria certainly embraced the hale and

hearty image of Highlanders. This included the annual Ghillies' Ball, organized by Brown: a thrilling, drunken knees-up, all reels and jigs and whirling sporrans. It was quite out of keeping with her majesty's public image as a not-amused widow, and would have been illegal on several counts in the time of her grandfather, George III.

The rebellion of 1745 had, by the mid-nineteenth century, been thoroughly romanticized with enthusiastic royal approval. There was a problem, though, and it was Queen Victoria's great-grand-uncle: William, Duke of Cumberland, the Butcher of Culloden. Victoria herself is thought to have ordered the word "Culloden" erased from his memorial obelisk in Windsor Great Park, though the obelisk itself still stands.[12] "Cumberland's brutality came more and more to be seen as an obstacle to the premiss of modernization and unity which his victory at Culloden had come to symbolize," wrote the historian Murray Pittock.[13] That meant Cumberland had to be cast out from the pantheon of British heroes. To that end, popular history books began to claim he had always been a villain. In *The Comprehensive History of England*, first published in 1856, it was said that Cumberland "left behind him in Scotland the name of *the Butcher*, and the people of England, disgusted sooner than any other with cruelty, confirmed this title to the hero of Culloden."[14] The story continued to be one of English victory, modernity, and unity: it was just that the history books now claimed this was shown by the English people *rejecting* Cumberland, whereas in his own time it had been shown by them *celebrating* him.

In 1868, the 5th Duke of Portland took Cumberland's statue down from its plinth in Cavendish Square. The official explana-

tion was that its lead body had deteriorated badly, and required restoration or possibly a full recasting. This was probably true, though it may not have been the only reason. The Portland estate promised Cumberland's statue would be back soon. It has not been seen since. The lead may have been melted down for reuse, or parts of it may have been stored. There are rumors that some parts were kept in a warehouse that was destroyed by bombing during the Second World War, but these are unsubstantiated. "I suspect there are still fragments of the Cavendish Square Cumberland somewhere in storage," says the historian Lewis Baston. He points to the Irish Cumberland statue, whose severed head can now be seen in Birr Castle.[15]

Parsonstown reverted to its Irish name of Birr at the end of the nineteenth century. There, too, Cheere's lead Cumberland statue deteriorated badly. It was taken down in 1915. Reportedly, some Scottish soldiers stationed nearby at Crinkhill Barracks could not abide the Butcher gazing down upon them. It is not clear whether the damage was a pretext for removing a politically embarrassing statue, or whether politics was a pretext for removing a damaged statue. Either way, down it came.

In both Birr and London, the plinths on which Cumberland's statues stood are still there. The one in Birr is a towering column in the center of town with nothing on the top of it. Occasionally, the possibility of putting someone else up there has been discussed. An architectural firm who surveyed it in 2009 dismissed this:

> *In conservation terms, there is a guiding principle to conserve as found, in order to allow a building or structure to tell its*

own story for locals and visitors alike. The only statue that could, however, be justified for reinstatement on conservation grounds would be the Duke of Cumberland. However, as only fragments of the Duke survive, this is no longer possible. To erect another statue of a different subject would require planning permission and would doubtless prove to be controversial.[16]

So there is nothing on top of the Cumberland Column in Birr. There is nothing on top of the Cumberland Plinth in London either. The London plinth still bears its original dedication:

WILLIAM DUKE OF CUMBERLAND
This Equestrian Statue was erected by
LIEUTENANT GENERAL WILLIAM STRODE
In Gratitude For His Private Kindness
In Honor To His Publick Virtue

There is one more chapter in this story, though—because one of Cumberland's statues did, for a while, return.

In 2012, the equestrian statue of William, Duke of Cumberland, reappeared on its plinth in Cavendish Square. This time it was not made of lead. It was a replica made of soap, installed by the Korean artist Meekyoung Shin. Though no original designs or models of the statue remained, Shin had found an 1808 etching of it. She matched that to a mid-eighteenth-century statuette of Cumberland held in the National Army Museum—probably one of those household ornaments modeled on Cheere's statue.

Shin began by sculpting her Cumberland statue in clay. She designed a metal skeleton to hold it upright, then cast it in soap, made of ingredients including coconut oil and eco-friendly palm oil. A crane hoisted it onto the plinth in July 2012, shortly before the Olympic Games were held in London. "As the sculpture erodes due to the effects of the weather, the scented soap will disintegrate and release a perfumed aroma," said the accompanying plaque. "The detail of the statue will soften and fade over time, symbolising the mutable meanings we attached to public monuments and to our history."[17]

Though 266 years had passed since the Battle of Culloden, the soapy Cumberland still caused upset. "I think this is a terrible idea," said Paul Scott, the president of the Saltire Society. "As far as I know he had few redeeming features and is certainly not deserving of a statue. The plinth should be left empty." An independent councillor for Culloden, Roderick Balfour, agreed: "I know the people round here would regard it as an affront, even though it is a soap statue and might wash away pretty quickly. This is not the kind of thing that will improve relations between the Highlands and England."

Robert Davis, the deputy leader of Westminster City Council in London, defended the statue: "The fact it will erode due to the weather is part of the artist's broader comment about changing perceptions of history over time."[18]

In addition to Shin's comment on the changeable nature of historical memory, her statue's scent recalled *Macbeth*, act V, scene 1. Lady Macbeth, sleepwalking, hallucinates bloodstains on her hands that she cannot scrub off: "Here's the smell of the blood still; all the perfumes of Arabia will not sweeten this little

hand." Following another Scottish tragedy, the perfume could not sweeten Cumberland's reputation either, nor could the soap cleanse it. Subjected to the London weather and pollution, the statue did not melt into suds, but instead became sticky. Dirt clung to it, gradually turning its original pure white form mossy green, rusty brown, and then dingy gray. Great cracks appeared across its flanks, and one by one its limbs began to fall off. Shin had expected the statue to stand for a year. In fact, it endured bloody-mindedly for four. Cumberland's scummy remains were finally scraped off his plinth in 2016.

It seems unlikely that the Butcher of Culloden will make a permanent reappearance anywhere—though, looking at the history of statues, it would be unwise to make a firm prediction. If Scotland moves toward independence, might English nationalists rediscover sympathy for the prince once seen as an icon of modernity? We will have to wait and see. For now, the memory of William, Duke of Cumberland, is universally detested in Scotland and Ireland, and considered an embarrassment in England. Perhaps the empty column in Birr and the empty plinth in London tell just the historical story they need to: that Cumberland, once a unifying hero across the British Isles, was later disowned by English, Irish, and Scots alike.

The Cult Leader

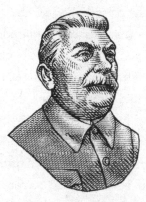

Joseph Stalin

Location: Budapest, Hungary
Put up: 1951
Pulled down: 1956

This is the story of a man who would raise thousands of statues to himself. He was born Yoseb Dzhughashvili in Gori, Georgia. He would be better known by the name he chose: Iosef (or Joseph) Vissarionovich Stalin. The story is about a statue in Budapest, Hungary—one of the Soviet satellite states. And yet, to understand what that statue meant, and the atmosphere of terror in which it went up and was pulled down, we must go back to Stalin's own story.

It is often difficult to sort the facts about Stalin from the fictions he himself created. There is confusion about his date of

birth, variously given as 1878, 1879, 1880, and 1881 (it was the earliest of these); his family background (the identity of his father has been questioned); his performance at school (good, but not as great as would later be claimed); and the reason he stopped training for the priesthood (he chose to leave the seminary, though he preferred the more glamorous story that he had been expelled). Even as a youth, he began to create myths around himself. By the time he settled on the name Stalin, meaning "the steel one," he had already gone through a host of others, including Koba, Vasily, Ivanovich, Salin, Solin, Stefin, and Kato. His identity shifted between Georgian and Russian: he did not learn to speak Russian until he was eight or nine, and still made mistakes in adulthood. No one dared correct him.[1]

During the Russian Revolution, Stalin emerged as a significant figure in the Bolshevik leadership. He became a propagandist, using his storytelling skills to write for *Pravda*. When Lenin fell ill in 1922, Stalin visited him often—though he was not always welcome. "Stalin is too crude," Lenin wrote at the beginning of 1923. "I therefore make a proposal for comrades to think of a way to remove Stalin and in his place appoint someone else who is distinguished from comrade Stalin in all other respects through having the single superior feature of being more patient, more loyal, more courteous and more attentive to comrades, less capricious, etc."[2] Soon afterward, Lenin suffered a third stroke. He would live for another nine months until early 1924, but in a severely weakened state. Had Lenin crushed Stalin before he was incapacitated, Soviet history might have played out differently. As it happened, though, Stalin dodged a metaphorical (or

possibly real) bullet. Later, Stalin would rewrite this history too, presenting his relationship with Lenin as perfectly united.

After Lenin died, Stalin maneuvered against rivals while gradually tightening his grip on power. He was driven and personally needy yet emotionally isolated: a dangerous combination. "He had a personality prone to mistrustful fantasy and, tragically, he had the opportunity to act out his own psychological damage by persecuting millions of his people," wrote his biographer Robert Service. "He was a human explosion waiting to happen."[3] Stalin embarked on a series of purges, eliminating rivals, party members, and ordinary people. Millions of them were imprisoned or tortured, forced into labor, killed, or sent to gulags (labor camps). He pushed the Soviet Union into a "cultural revolution," attacking religion, the arts and sciences, and intellectuals.

There were tight restrictions on how Stalin could be portrayed, and dire consequences for anyone who broke them. One of the pictures he liked of himself showed him being hugged by an adorable eight-year-old girl called Engelsina "Gelya" Marzikova, who had presented him with a bouquet of flowers. It was taken in 1936. Stalin had it turned into a statue by the Siberian art deco sculptor Georgiy Lavrov. Statues of Stalin and the Happy Soviet Child were mass produced and installed in schools, hospitals, and parks all across the Soviet Union.

In 1937, Gelya's father was accused of being anti-Stalin. He was taken from their home by the secret police and executed. Gelya's mother was imprisoned for a year. She died shortly after her release in a mysterious accident. The purging of Gelya's

family was awkward for Soviet propagandists. They could not remove the statues featuring Gelya, because Stalin was also depicted in them. To remove or damage a Stalin statue meant a one-way ticket to a gulag, or worse. Yet the girl herself—still just ten years old—was now politically unacceptable and could not be shown with Stalin.

Their solution was to find another Happy Soviet Child. Thirteen-year-old Young Pioneer Mamlakat Nakhangova had been awarded the Order of Lenin for her exceptional cotton-picking. True, Mamlakat was conspicuously a few years older than Gelya, but Soviet citizens learned to survive Stalinism by not noticing this sort of thing. Lavrov, the sculptor, was not around to object: in 1938, he too was purged and sent to a labor camp.

Gelya, the Formerly Happy Soviet Child, went into hiding. She grew up using her aunt's surname, seeing statues of herself everywhere while having to pretend they were not her. After Stalin's death in 1953, the statues were removed. Around 1990, Gelya, then in her sixties, was surprised to see one when she visited a museum in Ulan-Ude. "It was very funny," she told a journalist. "We were going up the stairs in the tour, and one of the women from the group saw this sculpture by the window. It had been removed from the cellar, and there was rust between Stalin's fingers. It looked like blood. And the woman asked the tour guide, "Why do you still have this sculpture?" And I said, "Because one of us is still alive."[4] She died in 2004.

When the Nazi threat rose in Europe, Stalin tried to avoid conflict with Adolf Hitler. Hitler did not return the favor. Nazi Germany invaded the Soviet Union in 1941. Shocked and embar-

rassed, Stalin took control of the response. Invading the Soviet Union proved to be a big mistake for Hitler; meanwhile, Stalin sat with Churchill and Roosevelt as one of the "Big Three." The Second World War is still remembered in much of the former Soviet Union as the Great Patriotic War, and Stalin as a flawed but effective commander. There is irritation in some former Soviet states today that the Soviet Union's essential contribution to defeating Hitler is played down in the West in favor of Britain's and the United States' own patriotic narratives. This has fueled the rehabilitation of Stalin's image in Russia and some other former Soviet states, including Georgia.

After the war, Stalin purged his generals and struck up a new propaganda campaign against a softening of public opinion toward the Allies and the West. He extended his rule into Hungary, Poland, East Germany, Czechoslovakia, Romania, Bulgaria, and Albania, and more loosely into Yugoslavia. These states were known collectively as the "satellites," or the Eastern Bloc. Most were put under strict Stalinism, complete with all the propaganda and repression that implied. "Stalin invested his whole being in producing illusion or delusion," wrote another biographer, Robert Conquest, in 1991. "It was above all this domination by falsehood which kept even the post-Stalin Soviet Union in a state of backwardness, moral corruption, economic falsification and general deterioration until in the past decade the truth became too pressing to be avoided."[5]

Stalin celebrated his seventieth birthday on December 21, 1949. The date was inaccurate—he had been born on December 6, 1878, so was in fact a couple of weeks over seventy-one. There

was a great celebration in Moscow on the official day: a huge balloon was raised over the Kremlin, onto which was projected an image of Stalin's face, appearing to beam down from the heavens like a medieval saint.[6]

In the satellite state of Hungary, the city of Budapest celebrated Stalin's birthday with a competition to design a Stalin statue. It was won by the sculptor Sándor Mikus. An initial budget of 350,000 Hungarian forints was provided by the city, though the final cost exceeded that twenty-seven times over. The Regnum Marianum church, a theater, and a tram station all had to be demolished to install the massive statue on the edge of Városliget (City Park), at the top of Városliget Alley. The place where it stood would be renamed Stalin Square. The statue was unveiled a year later than had initially been hoped, on Stalin's (official) seventy-second birthday, December 21, 1951.

The statue in Budapest was colossal. This was important: the real Stalin was five feet four inches tall, and very unhappy about it. He wore platform shoes and stood on boxes when he appeared in public. "It makes him miserable that he cannot convince everyone, including himself, that he is a taller man than anybody else," said Nikolai Bukharin.[7] Stalin resented anyone who presumed to be taller than him, while simultaneously sneering at other men who were short. On his first meeting with Lenin, Stalin remembered much later, he was disappointed: he had imagined "a giant, stately and imposing," but found Lenin instead to be "below middle height, distinguished from ordinary mortals by nothing, literally nothing."[8] Lenin was an inch taller than Stalin.

The Budapest statue, like all Stalin statues, re-envisaged him

as the giant he believed he should be: 8 meters tall, raised on a red limestone plinth that itself stood on a wide tribune. The total height of the monument was 25 meters. The real Stalin was self-conscious about his smallpox scars and short left arm, which had been damaged after a bout of blood poisoning. The bronze statue was smooth skinned and harmoniously proportioned, trim around the waist. It was created in part by the destruction of other statues: older Hungarian statues were removed because the communist regime found them politically objectionable, and were then melted down to contribute some of the 20,840 kilograms of bronze Stalin required.[9] On its plinth, his name was spelled out in a Hungarian transliteration: SZTÁLIN.

"Stalin was with us earlier; now he will be with us even more," wrote one loyal journalist, laying it on thick. "He will watch over our work, and his smile will show us the way. I have been told that in Moscow it is customary to pay a visit to Comrade Lenin in Red Square before beginning, or after finishing, an important task . . . Undoubtedly the same will occur here with the statue of Comrade Stalin . . . we shall pay personal visits to 'discuss' our problems . . . And there is no doubt that the father and guardian of our peace will never turn us away."[10] The term "cult of personality" was no exaggeration. Hungarians were being urged to pray to Stalin's statue.

Stalin collapsed and died of a brain hemorrhage in March 1953. The people of Budapest were ordered to his statue to mourn him. The authorities expected 100,000 people to turn up; three times that number did. With a high wind whipping through the park, no one could hear the Hungarian ministers speak. The crowd pushed forward against the ropes that kept

them back from Stalin's statue. Budapest police chief Sándor Kopácsi remembered that those at the front were being crushed. He ordered his officers to cut the ropes: "Let them climb up on the statue." The officers sawed through the ropes with bayonets and the crowd was released into the area around the great bronze figure. Kopácsi recalled the Hungarian communist leaders trembling as members of the public surged around them, clambering up on to the statue's base. "I really think it was the first time they had seen the people at such close quarters."[11]

In February 1956, Stalin's successor, Nikita Khrushchev, gave what is known as the "Secret Speech." It was not kept secret from the Soviet people but from outsiders: millions of edited copies were printed and read out across the Soviet Union. In it, Khrushchev denounced Stalin, and began a program of "de-Stalinization"—liberalization.[12] "A genius and a murderer cannot be combined in the same person," Khrushchev wrote in his memoirs. "Thousands of victims should not be placed together with their murderer, leaving unexplained what Stalin really did. You can't put two statues on one pedestal. Stalin was an evildoer!"[13]

In parts of the Soviet Union, people celebrated by defacing Stalin's statues. Meanwhile, in Georgia, there was a huge demonstration against Khrushchev for insulting the twentieth century's most famous Georgian. After the tight control of Stalinism, this was a dangerous moment. How far would liberalization go? Would the Soviet people and those in the satellites accept moderate changes, or demand more?

Khrushchev removed Stalin's protégé Mátyás Rákosi from

the Hungarian leadership in the summer of 1956. Rákosi was unpopular with Hungarians, who referred to him as "Baldy" or "Arsehead," though not in his earshot. He was replaced with Ernő Gerő, who few considered an improvement. By October, Budapest students were expressing discontent. The trigger came on October 21, when another satellite, Poland, elected Władysław Gomułka as first secretary. Gomułka was not a radical anti-Soviet, but he opposed the Soviet military presence in Poland, and believed the country should set its own economic and political policies. Shaken by Gomułka's election, Khrushchev flew to Poland to try to bring him into line. Gomułka rebuffed him. This act of defiance inspired Hungarian students to mount a protest of their own on October 23.

That morning, the Hungarian students, along with some professors, writers, and even Communist Party members, issued a list of demands. These included the withdrawal of Soviet troops, free elections, free expression—and the removal of Stalin's statue. In the afternoon, the students congregated at another statue: that of József Bem, a Polish general who had joined Hungarian forces to fight in a previous revolution in 1848. The symbolism was stark. Like the Poles, the Hungarians were rejecting foreign—Soviet—control. Thousands gathered, with factory workers and some Hungarian soldiers joining the students. Protesters carried the Hungarian flag—a red, white, and green tricolor with a communist hammer, wheat sheaf, and red star in the center—with the communist emblem torn out.

By 6 p.m., the crowd, which had swelled to between 200,000 and 300,000 people, was entering Parliament Square. They were addressed by the leader they wanted, Imre Nagy, who dis-

appointed them by addressing them as "comrades," and by the leader they did not want, Ernő Gerő, who made things much worse by telling them that they were nothing more than "a mob attempting to make trouble."[14] A large section of the crowd decided to act on one of their demands immediately and take down Stalin's statue. Somebody had already hung a sign around its neck, reading: "Russians, if you take to your heels, please do not leave me behind."[15]

Despite perhaps 100,000 witnesses, it is hard to re-create exactly what happened in the square when the crowd arrived at the Stalin statue. No one filmed it. There are photographs taken shortly before, during, and after the statue was pulled down, but they do not confirm the precise series of events. For years afterward, the fate of the statue could not be mentioned publicly in Hungary. By the late 1980s, when it could be discussed again, some memories were not as clear as they had once been. There are eyewitness accounts collected in the 1990s, and a few earlier ones that were written by foreign journalists or by Hungarians who fled the country. Some of them disagree with each other.

The accounts all agree, though, that pulling down the statue was incredibly difficult. Attempts began between 7 p.m. and 7:45 p.m. Several times, ropes were thrown around the statue's neck, and protesters attempted to haul it down with trucks. The ropes kept snapping. "Even the strongest wire cables gave way, because from inside it had been strengthened with a huge great arch-shaped iron bar," remembered one participant, Mihály Nagy. "The constructors had given it some thought, they wanted it to be a lasting creation. It would even have been hard to blow it up."[16]

According to police chief Sándor Kopácsi, the municipal council had already decided that they must either get rid of Stalin's statue or relocate it to somewhere obscure. This information was not public, though, and he received a report that between 100,000 and 200,000 protesters were surging around it. The crowd was shouting: "Down with the statue! Russians go home!"[17] Kopácsi asked his junior, Lieutenant Kiss, how many officers were available at the precinct, and received the answer: twenty-five.

"I suppose that, with twenty-five men, you're not about to break up a crowd of one hundred thousand people?" he asked.

He remembered Kiss was silent for a moment, then said, "We have forty rifles, Comrade Colonel."

Kopácsi knew that the officers were ready to fire on the crowd. He did not give the order. By then, an engineer, Dániel Szegő, was getting to work with metal-burning equipment on Stalin's left leg, a blue flame sparking as it met the bronze. Steel cables were requisitioned from local trams and tied around Stalin's neck. The other ends were attached to a truck, which slowly pulled away.

Kopácsi tried to identify the people attempting to haul down the statue. "They're workers from one of the large factories in Pest," he told Kiss. "They are the only ones who would have access to that equipment." He considered adding "and the balls to undertake an operation like that." He told Kiss to send plainclothes officers into the crowd, warning people that the statue weighed tons and they should move back at least a hundred meters in case it fell on them.[18]

The crowd's mood was upbeat, and a cheerfully mocking

shout went up, addressed to Stalin: "Hold on, little Joseph!" The painter and writer Gábor Karátson explained: "Because, as we know, he didn't want to come down . . . 'Hold on little Joseph!'— which was in no sense a Stalinist shout, but was actually a little bit of popular sportsmanship, because there he was alone now, however big he might be, and we were so many."[19]

Cables sliced against bronze. "No, the way it came down, really, it was like a rubber ball, it jumped a couple of times before coming to a rest," remembered István Kállay, who ran an underground radio station at the time.[20]

"It was such an eerie sound," recalled Stephen Vizinczey, one of the students who was there to see it fall, "several thousand people sighing with joy. I think we all had a sense of making history."[21]

The time was recorded variously as between 9:21 p.m. and 9:37 p.m. All that remained on the plinth were Stalin's boots.

With the statue down, the square echoed to the sound of sawing and hammering as everyone tried to hack off a little chunk of Stalin as a souvenir. Others roamed around Budapest, chiseling Red Stars off buildings. The remains of the statue were loaded on a truck the next day and taken to the People's Theatre on Blaha Lujza Square, where they would be broken up. A youth took a sign from nearby roadworks and placed it on Stalin's severed head: "Dead End."[22]

The Hungarian Rebellion, the first armed uprising against Soviet control in the satellites, had begun.

Thousands of Hungarians fought with courage, resourcefulness, and determination against the repressive elements in their own government and Soviet forces from October 23 until No-

vember 4, 1956. On that day, Khrushchev sent in the tanks. The rebels fought back—in some cases, jumping up on tanks, hurling a grenade through the driver's window, slamming it shut, and jumping off. But they were lightly armed and cut off from outside help. They had no chance against a Red Army force that included 2,500 trucks, 1,000 supporting vehicles, and between 75,000 and 200,000 fighting men and women. The rebellion was crushed.

A new government was brought in under János Kádár, a Soviet loyalist, who returned to Budapest from Moscow on November 7 in a convoy of Red Army tanks. More than 100,000 people were arrested for their part in the rebellion; 35,000 faced trial, 26,000 were jailed, and it is thought that around 600 were executed. Meanwhile, around 200,000 Hungarians fled over the border to Austria or Yugoslavia as refugees. The Soviets, hoping the troublesome element might purge itself, allowed them to leave. At a New Year's party some weeks later, Khrushchev loudly declared that he and his colleagues were all Stalinists. Less than a year on from the Secret Speech, he reined liberalization in, feeling that he had gone too far and lost control.[23]

Photographs from Budapest soon after Stalin's statue fell were powerful. Broken boots, unmistakable above that name: SZTÁLIN. Locals now referred to Stalin Square as "Boots Square" (it would eventually be renamed Parade Square). The new Hungarian government removed the boots and placed a Red Star on the plinth. The relief carvings on the wide lower tribune were covered up. In 1975, the reliefs were also removed, and the tribune reclad in marble and granite. A much smaller statue of Lenin was put up in the square—positioned at ground

level, like an equal, rather than raised up to a lordly height above the Hungarians.

Sándor Kopácsi had joined the rebellion and was imprisoned after it was put down. When his fellow prisoners were asked why they were in jail, they often replied, "I'm a sculptor." He explained: "To be a sculptor meant to be imprisoned for having participated in the destruction of Stalin's statue."[24]

After the communist period ended, the unloved remainder of the Stalin statue's plinth was finally removed, along with Lenin's statue. In 2006, the fiftieth anniversary of the felling of Stalin, a new monument was unveiled on the site, entitled Central Monument of the 1956 Hungarian Revolution. Parade Square was renamed again, and is now called Fifty-Six Square (in Hungarian, Ötvenhatosok tere). The new monument was designed by a group of Hungarian artists and architects in an abstract style. A triangular forest of rusting metal posts converges on a shining steel point, designed to evoke the march of protesters from the Bem statue to this place in 1956. Each individual slowly combines into a great and powerful force.

Communism finally fell across Europe in 1989. In Hungary, the transition was peaceful, and the first free elections were held in 1990. As this new era began, Hungary, like many former satellites, was stuck with a lot of statuary it no longer wanted. Many of the most recognizable Soviet pieces were relocated to a small area outside Budapest, which was turned into an outdoor museum. Memento Park opened to the public in 1993: a government initiative taken over by a private company the following year. A few tourists venture out there every day from Budapest,

by slow bus or expensive taxi, to pose for photographs with the relics of a vanished world. The statues and monuments, dating from the 1940s to the 1980s, include multiple Lenins, Marx and Engels, Bulgaria's first communist leader Georgi Dimitrov, various Hungarian communists, and memorials to workers, martyrs, Hungarian-Soviet friendship, and so on.

The statues have been arranged with care and ceremony amid modern brick architecture, created by the park's designer, Ákos Eleőd, holder of a PhD in historic monuments engineering. "The park is about both dictatorships and democracy, since only democracy provides us the opportunity to treat the surviving monuments of the former regime with humanity and dignity," explains Dóra Szkuklik, who now helps to run the park. "It's not a mock exhibition, but a memento."

Eleőd arranged his park with reference to the original architectural and sculptural plans of the statues, and as a comment on totalitarian regimes. "This park is not about the statues or the sculptors, but a critique of the ideology that used these statues as symbols of authority," he said. The park's website emphasises the point: "Memento Park is not about Communism, but about the fall of Communism!"[25]

Memento Park does not have Stalin's boots, which have long since disappeared. It does, however, have a statue of them. It was made by Eleőd in 2006, to mark the fiftieth anniversary of the Hungarian Rebellion. The boots, cast in bronze, are not a perfect copy of Stalin's original boots: Eleőd intended the work as an homage rather than a facsimile. The statue of Stalin's boots that now stands in Budapest is not only a statue of a statue; it is a statue that commemorates the pulling down of a statue.

Stalin's cult of personality was extraordinarily effective in his lifetime. "If, as George Bernard Shaw claimed, the art of government is the organization of idolatry, then Stalin was the greatest statesman of the twentieth century—indeed, of modern times," wrote yet another of his biographers, Walter Laqueur, in 1990. Laqueur added a caveat: "Stalin wanted not only the adulation of contemporaries but also of posterity; seen in this light, he has been much less successful."[26] Many Stalin statues were taken down as part of Khrushchev's de-Stalinization in 1956 and afterward. More yet fell at the end of communism.

Still, Laqueur may have spoken too soon. In Russia, Stalin's reputation has been substantially rehabilitated. According to Levada, a respected independent pollster in Russia, 70 percent of Russians said in 2019 that they approved of Stalin's role in history; only 19 percent did not. While Russian president Vladimir Putin has stopped short of actively endorsing Stalin, he has echoed Stalinist language and trades heavily on the glorification of Russian history—including, prominently, the Second World War. "Stalin—as an imaginary rather than actual historical figure, the embodiment of an idea of order and justice—is at the core of Russian perceptions of the glorious past," wrote Andrei Kolesnikov, of the Carnegie Moscow Center, in 2020.[27] In Red Square today, there are always fresh flowers on Stalin's grave.

As Stalin has become more popular, statues have started to go back up. The first post-communist Stalin was unveiled in May 2010 in Zaporizhya, Ukraine, organized by the local Communist Party, with donations from Second World War veterans.

It provoked widespread controversy and was condemned by members of the Ukrainian government. "We should not establish monuments for tyrants," said the justice minister. "We must know about them and know about them very well. We have to learn from the lessons of history to avoid its repetition."[28] The 2.5 meter statue, depicting Stalin from the waist up in steel atop a granite plinth, did not last long. On December 31, 2010, it was blown to bits in what the state prosecutor described as a "terrorist incident."[29]

Remarkably, in the same year, a Stalin bust was also unveiled in the small American town of Bedford, Virginia: part of a series of busts of Second World War Allied leaders forming a D-Day memorial, along with Roosevelt, Truman, and Churchill. The bust bore a plaque that read: "In memory of the tens of millions who died under Stalin's rule and in tribute to all those whose valor, fidelity, and sacrifice denied him and his successors victory in the cold war." Most people do not read plaques. Local reaction to the Bedford Stalin ranged from bemusement to offense and horror. The bust was removed after just three months, supposedly so that it could be reinstalled elsewhere. It has not reappeared.[30]

The fate of these Stalins has not deterred others. In May 2019, a Stalin bust was unveiled at the Communist Party headquarters in Novosibirsk, Russia, to the strains of Beethoven's Fifth Symphony. The local party had been trying to put a new statue up since 2006, but the plan was originally turned down flat by local government. When a communist mayor was elected in 2014, the idea popped back up—yet a poll of Novosibirsk residents in 2017

revealed that 60 percent did not want a Stalin statue. Thousands signed a petition protesting against it. The Communist Party persisted, trying to site it at a military location. The Defense Ministry objected on account of what it called, with some understatement, Stalin's "controversial role in history." Finally, the party decided to put it at their own headquarters—which they can because it is, somewhat ironically, private property.[31]

At the time of writing, the Novosibirsk statue still stands—behind a high wall. These days, Stalin must be protected from the wrath of the proletariat.

4

Imposing Erections

Rafael Trujillo

Location: Santiago de los Caballeros, Dominican Republic
Put up: 1949
Pulled down: 1961

The name of Rafael Leónidas Trujillo Molina is not widely known outside Latin America today. That is not the way he would have wanted it.[1] In some ways, Trujillo was a similar character to Stalin: a vicious, ruthless tyrant who terrorized everyone around him. Yet while Stalin projected political power with his monuments, Trujillo projected sexual power as well.

Even in the twentieth century, among plenty of murderous, narcissistic dictators, Trujillo stood out. He ruled the Dominican Republic for three horrific decades. We can only wonder how much worse it might have been had he been able to take control

of a larger country, with more riches to steal, more people to oppress. Trujillo was a sadist, a rapist, a torturer, and a murderer. He loved putting up statues and monuments to himself. It has been estimated that, by the time of his death in 1961, there were 1,800 public statues and busts of Trujillo in the Dominican Republic: roughly one for every 27 square kilometers of land.[2]

During the Era of Trujillo, defacing or disrespecting a monument was extremely dangerous. In the 1940s, Luis González Castillo—a supporter of the resistance to Trujillo—protested against the regime by smearing the tomb of Trujillo's father with excrement. Trujillo's police soon caught up with him. González was a strong man, and broke off the branch of a tree to defend himself. He swung it at the police. They shot him in the stomach and dumped him at a nearby hospital. He pleaded for water, but everybody ignored him. To help an enemy of Trujillo was to make an enemy of Trujillo. It was too risky for medical staff to help González. By the morning, he was dead.[3]

Trujillo tried to make himself into something between gangster and god. More than sixty years later, not only have Trujillo's statues all been removed—it would be illegal to put them back up.

For decades, the truth about Trujillo's regime was not taught in Dominican schools. Even today, much of the general public's knowledge about him is based on anecdote and legend rather than hard evidence. Did pulling down his statues erase his history?

The Dominican Republic occupies the eastern side of the island of Hispaniola; Haiti occupies the west. Haiti was a French colony,

and the site of world history's only successful slave revolution. Haiti defeated Napoleon's forces to win its people's freedom. In doing so, it became a pariah state. The United States and European colonial powers feared that Haiti's example might inspire slave rebellions in their own territories. The Dominican Republic's colonial history was complex, and its European influence was mostly Spanish. Tension remained between Haiti and the Dominican Republic, fueled by racial prejudice. Trujillo knew exactly how to exploit it.

Trujillo was born in 1891 in San Cristóbal, a small town outside the Dominican Republic's capital, Santo Domingo. Of his four grandparents, two were Dominican, one was Cuban, and one—his maternal grandmother—Black Haitian. Though he loved her as a child, he would later in life obscure her memory. He considered himself white, wore pale makeup to lighten his skin, and positioned himself as the defender of the Dominican Republic against Black Haitians.

Little is known about Trujillo's youth, but he appears to have had a reasonably successful career in crime before joining the Dominican National Guard in 1917. The United States was then occupying the Dominican Republic, and United States Marines were training Dominican forces. Trujillo was trained by them in techniques that included torture: he excelled at it. Rising swiftly through the Dominican ranks, he became chief of police, then a general. He staged a coup in 1930 and ran for president. There was no opposition candidate. The voting booths were manned by Trujillo's soldiers. If anyone wrote in an alternative candidate, the soldiers had orders to shoot. Unsurprisingly, Trujillo won this election. Over the following thirty-one years, he would

hold various offices in addition to his honorific titles, including "Benefactor of the Fatherland"—but he would never have less than absolute power.

Trujillo cultivated an image that has been described by the historian Lauren Derby as the ultimate *tíguere*. This is a Dominican slang term that means "tiger," but describes "a rogue, a trickster who rises from poverty to a position of wealth and power, often through illicit means."⁴ A *tíguere* carries himself with macho pride, is often sexually aggressive, and always comes out on top. Trujillo's statues and imagery styled him in a range of masculine costumes, illustrating that no part of society was closed to him, no achievement beyond his reach. Some of his statues showed him in white tie and tails, the urbane sophisticate; some on horseback, the hardy outdoorsman. Some showed him in military dress, representing strength; others in lawyers' robes or academic gowns, illustrating his great intelligence.

Trujillo dominated every aspect of life in the Dominican Republic. He even renamed his country's capital city, Santo Domingo: from 1936, it was known as Ciudad Trujillo. He renamed the highest mountain in the country Pico Trujillo too. Dozens of parks and several provinces bore his name. Dates on official documents were formatted according to the Era of Trujillo, beginning in 1930. From 1933, every new building had to bear a plaque glorifying him. Even in private homes it was common to display plaques saying: *"En este hogar Trujillo es el Jefe"* ("In this house Trujillo is the boss").

Trujillo built his power on appropriating national wealth, business, and industry, and on horrific violence. His regime's

violence was so stylized that some historians have described it as theatrical. This was a deliberate part of his image. He created an atmosphere of terror by humiliating both his favorites and his enemies. Being in or out of favor was a matter of life or death. He increased the size of the military fifteen times over and mostly used it for parades. His secret police toured the streets in black Volkswagen Beetles. Random disappearances were common. Torture and prison camps, with coffin-size, rat-filled cells, awaited his victims. He was said to throw the mangled bodies of his enemies to the sharks. In 1937, he ordered an indiscriminate slaughter of Black people, presumed to be Haitians, in the Dominican Republic. An estimated 17,000 to 35,000 people were beaten or hacked to death with clubs and machetes over the course of two to five days. Trujillo's officers had been ordered not to waste their bullets on Haitians.

Like any *tíguere*, Trujillo was sexually voracious. With him, though, consent was irrelevant. Women who resisted his advances faced public humiliation, losing their jobs, or worse. Sometimes, their fathers or brothers were imprisoned or tortured until the women gave in. Trujillo was nicknamed "El Chivo" ("the Goat") on account of his sexual appetite. He saw himself as a seducer rather than a rapist. It is not known how many of the women involved agreed.

Trujillo's sexual swagger was reflected in his monuments. One of the first of this type was dedicated in 1937, when he held a grand carnival in Ciudad Trujillo to celebrate himself. The carnival was presided over by women, including his mother, his latest wife, and his mistress, Lina Lovatón. His wife was already unhappy because Trujillo had managed to get his previous wife

pregnant again, after their divorce. Now, she was unhappier still: Trujillo made Lina the Carnival Queen.

The festivities culminated in the unveiling of a monument to Trujillo: a towering white obelisk, forty meters high. It could be seen for miles around. When it was unveiled, officials made it clear in their speeches what this enormous column was supposed to symbolize. Trujillo's vice president, Jacinto Peynado, proudly announced that the obelisk was a tribute to Trujillo's "superior natural gifts." Queen Lina and the other women involved in the festivities were required to praise this phallic symbol, with Lina describing Trujillo as an "inexhaustible sower."[5] As if to prove the point, she would soon bear two children by him. The obelisk is known as the Obelisco Macho, or the Male Obelisk. (There is also an Obelisco Hembra, or Female Obelisk, built a few years later by Trujillo to celebrate freedom from foreign debt. It takes the form of two columns with a big hole in between.)

Trujillo could be accused of many things, but not of subtlety. The next time he built a phallic monument, he would go even bigger.

The funds to build a monument to Trujillo in the Dominican Republic's second city, Santiago de los Caballeros, were raised by "voluntary" contributions from citizens.

On April 10, 1944, at 10 a.m., work began on the Cerro del Castillo, the highest hill in Santiago. Designed by the architect Henry Gazón Bona in a neoclassical style, the new structure would be called the Monumento a la Paz de Trujillo (Monument to the Peace of Trujillo). A long flight of steps led up the hill. At

the top of these was a colossal statue of Trujillo himself, wearing an academic gown, holding a parchment proclaiming his honorary doctorate. The statue was placed in 1949: it was twelve feet high and weighed four tons.

Behind Trujillo's statue stood a large colonnaded building on a square floor plan. On the first floor was a statue chamber filled with busts of prominent Dominicans, including many members of the Trujillo family. On the second were relics of Trujillo's life. On the third was a presidential library filled with flattering books about Trujillo. This monument was not merely a statue, though it was fronted by one: it was a spectacular memorial complex dedicated to Trujillo's version of history.

Above all of this a mighty white column rose high into the sky, topped with a bulbous viewing gallery and a "figure of peace"— a bronze statue of a woman with open arms, appearing to spurt forth from the tip of the bulb. The effect was unmistakable, almost comical. The historian Edwin Espinal said, "Symbolically it is a phallic allusion to power, even circumcized."[6]

The monument was ostensibly intended to proclaim that Trujillo had brought peace to the Dominican Republic. Everyone for miles around could see a different message: Trujillo's statue standing before a gigantic representation of Trujillo's virility. It was almost twice as high as the Male Obelisk in Ciudad Trujillo, and much more elaborate in its anatomical details.

The Monument to the Peace of Trujillo was dedicated in 1955, proclaimed the "Year of the Benefactor" by Trujillo to mark a quarter century since he had come to power. The celebrations were termed the "Free World's Fair." Trujillo—while running a vicious dictatorship himself—curried favor with the United States

by posing as a champion of freedom and enemy of communism. This time, the carnival queen was his daughter Angelita. He dressed her in a white silk gown embellished with diamonds, pearls, and rubies, with a 75-foot train made of Russian ermine.[7] The dress alone cost $80,000 at the time, in a country where a factory worker might take home $1.00 or $1.50 a day.

Soon, Trujillo was planning an even greater monument, which was to stand in Ciudad Trujillo. It was yet another enormous white marble pillar. This time, the pillar was abstracted and squared off at the edges, but the proportions were now all too familiar. The whiteness of all these columns was no accident either, and reinforced Trujillo's racial identification. Atop this one would stand a marble equestrian statue of himself, made by the Spanish sculptor Juan Cristóbal at the cost of $500,000. The pillar would double that cost to a cool $1 million. The model did not impress everyone. "Trujillo, on his rump and with reins in hand, looks like one of those circus riders who barely knows how to ride," wrote a reporter for the Spanish newspaper *El Socialista*. "I see this work as a monstrous satire on the moral pettiness of a man, and on his inordinate ambitions. The one worth seeing here is the horse . . . Trujillo is a useless burden."[8] The statue was scheduled for erection in 1960.[9]

In 1955, Trujillo seemed so powerful as to be untouchable. The bigger the monument, though, the harder it falls.

Soon after the Year of the Benefactor, things began to go wrong for Trujillo. Outside the Dominican Republic, he was threatened by the rise of Fidel Castro in Cuba. Inside the Dominican Republic, dissent was beginning to cohere against his regime.

Cuba's dictator, Fulgencio Batista, fled in fear of the Cuban revolution on New Year's Eve, 1958. His escape plane landed in Ciudad Trujillo, with a few cronies and millions of dollars in cash on board. Trujillo was furious: he had been paying Batista to stay and fight Fidel Castro.

As soon as Castro entered Havana, he was heard to shout, "Trujillo next!"[10] This was no idle threat. Aged twenty-one, in 1947, Castro had joined the Caribbean Legion, aiming to invade the Dominican Republic and oust Trujillo. Back then, the Cuban government had thwarted the invasion. Now, Castro was installing a new government.

Correctly, Trujillo feared that Castro would try to finish the job. Small groups of guerrillas from Cuba attempted to infiltrate the Dominican Republic by plane and boat in the summer of 1959. They were quickly defeated. In response, Trujillo hired American and Cuban mercenaries to invade Cuba. They were immediately captured.

The American president Dwight D. Eisenhower's administration was concerned. In April 1960, the State Department produced a document entitled "U.S. Plan for Trujillo's Retirement."[11] Successive United States administrations had tolerated and even supported Trujillo. Now, though, Eisenhower's government was worried about Castro's administration in Cuba. It hoped to build an international consensus against Castro but was struggling to do so—because Latin Americans widely considered Trujillo to be much worse. As Eisenhower himself put it in a National Security Council meeting: "it appears impossible to shake the belief of Latin America that the Trujillo situation is more serious than the Castro situation. Until Trujillo is eliminated, we cannot

get our Latin American friends to reach a proper level of indignation in dealing with Castro."[12]

While all of this was going on, resistance was also growing inside the Dominican Republic—and part of that was due to four young women known as the Mirabal sisters. Patria, Dedé, Minerva, and María Teresa Mirabal were part of the anti-Trujillo underground. Some sources suggest that they outraged Trujillo in the 1940s by leaving one of his parties early. Minerva's daughter has suggested that her mother offended Trujillo by refusing his sexual advances.[13]

The sisters increased their anti-Trujillo activities throughout the 1950s, and became known as "the Butterflies." They and their husbands were repeatedly detained and jailed by the regime. In November 1960, three of the sisters, Patria, Minerva, and María Teresa, were ambushed in their jeep and beaten to death. The jeep was pushed over a cliff in an unconvincing attempt to make the deaths look like an accident. Everyone knew Trujillo must have ordered it. This brutal murder of three young women shocked even those who were used to his violence.

Eisenhower sent emissaries to Ciudad Trujillo to persuade the dictator to step down, offering him asylum in the United States. Trujillo was unpersuadable. In early 1961, a new president, John F. Kennedy, tried again. Trujillo remained unpersuadable. Kennedy was told in February that the CIA was arming rebels in the Dominican Republic. He was informed specifically in March that the men they were arming saw "liquidation as the only way to accomplish their ends."[14] By then, though, Kennedy was embroiling himself in the disastrous Bay of Pigs invasion of Cuba.

Trujillo remained impervious to all pleas to leave. On May 29,

Kennedy wrote to his ambassador, stating (prudently, on the record) that the United States wanted to help Dominicans remove Trujillo, but "we must not run the risk of U.S. association with political assassination."[15] Questions remain over how much he knew about what would happen next.

The following evening, May 30, 1961, Trujillo drove out of Ciudad Trujillo to visit his mistress. At around 10 p.m., his car was ambushed by men armed with some of the CIA's weapons. In the first burst of automatic fire, Trujillo was shot in the back. He stumbled out of the car, wielding a revolver. As he stood in the beam of the car's headlamps, the assassins shot again. With a yelp, Trujillo collapsed.[16] The White House in Washington, DC, announced Trujillo's death before the Dominican Republic did.

The plotters failed to finish the coup, though, and Trujillo's family and cronies remained in power. His body lay in state in Ciudad Trujillo, where thousands sobbed and beat their heads with their hands in a necessary public display of grief. The body was taken to San Cristóbal for burial in the elaborate church Trujillo had built there, opposite a huge bronze equestrian statue of himself. As for the million-dollar equestrian statue on the phallic column he had planned for Ciudad Trujillo, it never reached the Dominican Republic. Instead, a monument was built for Trujillo at the spot where he had been killed. Once again, this took the form of a large white marble column. It was probably what he would have wanted.

Before long, though, the statues would fall.

Though he still held power, Trujillo was not technically president when he was assassinated: that job was nominally held by

a reliable crony, Joaquín Balaguer. Trujillo's son Ramfis was in effect his heir. The assassins of Trujillo did not get as far as ousting either of them, so Balaguer and Ramfis took over. Ramfis had inherited his father's cruelty but none of his political skill. He was easily manipulated by Balaguer on one side, and by various scheming uncles on the other. In June, the Trujillo family requested that the names of bridges, roads, and so on that had been named after them be changed. Ciudad Trujillo became Santo Domingo again.

If this was an attempt to mollify the public, it failed. On October 16, 1961, demonstrations began at the University of Santo Domingo. Students were enraged that a new rector had been appointed with links to the Trujillo regime. They rampaged through the town, and were joined by many citizens. Everywhere protesters went, they smashed pictures and destroyed statues of Rafael Trujillo. Over the next few days, protests spread across the country. There were plenty of statues of Trujillo to tear down: busts of him had been mass produced and stood in many homes and offices, as well as in hundreds of public places.

After seven days of rioting, Balaguer announced that two of Trujillo's brothers were leaving the country. Ramfis remained, but would not cling on for long. On November 18, 1961, he had a few of his father's assassins who he had managed to capture murdered in front of him, then boarded his yacht. He took with him the body of his father, hastily disinterred from San Cristóbal, in a refrigerator below deck. He is also thought to have taken around $90 million in cash.

Now, it was open season on the remaining statues. On No-

vember 19, 1961, anti-Trujillo protesters went from house to house in Santiago de los Caballeros, telling everyone to come and help pull down Trujillo's statue. A mob 5,000 strong gathered. They ransacked and vandalized the Monument to the Peace of Trujillo. The huge statue of Trujillo in academic dress that stood outside it was pulled down with chains tied to a truck and then beheaded. It was rolled down the steps that led up the hill, bouncing all the way to the bottom. Statues of the Trujillo family inside the monument were broken and defaced.[17]

On November 27, another mob attacked the white marble column that marked the spot where Trujillo had been assassinated, shattering it to bits and scrawling accusations such as "Murderer" on the fragments.[18] In December, there were days of rioting in San Cristóbal. All around town, busts of Trujillo were thrown into the street and smashed. Several attempts were made to pull down the enormous bronze equestrian statue of Trujillo that stood opposite the church where he had briefly been buried. Protesters finally succeeded with the help of steel cables and a tractor. When the figure of Trujillo fell to the ground, the people shouted *"Viva San Cristóbal libre!"* They set about whacking it to pieces with sledgehammers. Some took fragments of the dictator home as souvenirs.[19]

On December 29, 1961, Balaguer formally announced that the ransacked Monument to the Peace of Trujillo in Santiago would be repurposed. All remaining Trujillo statues and artifacts would be removed. The building would be re-dedicated as the Monumento a los Héroes de la Restauración (Monument to the Heroes of the Restoration)—devoted to the far less controversial figures of the 1863–68 war of liberation against Spanish

colonialism. The turmoil in the country continued. Balaguer re-
signed and went into exile a couple of weeks later.

With Balaguer gone, the Dominican Republic adopted Law
5880–62:

> *Any person who praises or exalts the Trujillos or their tyran-*
> *nical regime, out loud, or through shouts, speeches, public or*
> *epistolary writings, drawings, prints, engravings, paintings*
> *or emblems will be considered, and judged, as the author of*
> *crime against peace and public security, and will be punished*
> *with imprisonment from 10 days to a year, or a fine of 10 or 500*
> *pesos, or both penalties at the same time.*

Interestingly, statues were not specifically mentioned in this
law, but they were considered to be covered by "emblems." All
remaining statues of Trujillo were removed.

Some years later, an accountant involved in one of the many
audits of Trujillo's former property let his brother visit a disused
warehouse of the Puerto Plata chocolate company. It was being
used to store Trujillo memorabilia that could no longer be seen
in public. "I could see an immense quantity of those statues and
busts almost all of bronze and some of marble," remembered
the accountant's brother. "On the floor I saw one of the signs
displayed in houses that said, 'In this house Trujillo is the boss.'"
He wanted to take the sign as a souvenir, but the accountant told
him he could not: "That goes in the accounts."[20]

Trujillo's monuments were banned in 1962 because the ad-
ministration recognized that they glorified a dictator, caused
pain to many people, and would continue to be used by "Trujil-

listas" as rallying points. This appeared to be the beginning of a process of truth and reconciliation. At the end of 1962, the people of the Dominican Republic voted in the first free elections in their history. They elected Juan Bosch, a senior anti-Trujillo figure who had opposed the dictator from exile for decades.

Unfortunately, the prospects for a new era of democracy soon faded. Bosch's moderately left-wing government lasted seven months before it was deposed by a military coup in September 1963. In 1965, revolution broke out. Obsessed by the unfounded fear that the Dominican Republic might turn communist like Cuba, President Lyndon Johnson staged a massive American military intervention. New elections were held in 1966, characterized by extreme violence against Bosch supporters—including torture and murder. The military and rural police openly campaigned for Trujillo's former lieutenant, Joaquín Balaguer. Balaguer was duly elected with 56 percent of the vote.

A brutal, repressive "semi-dictatorship" returned—restoring many old Trujillistas. During Balaguer's first two terms, between 1966 and 1974, more than 3,000 political opposition figures and activists were murdered.[21] It has been estimated that 11,000 people were killed, tortured or disappeared by the state in his first three terms, between 1966 and 1978.[22]

Balaguer was a powerful and ruthless leader, but he did not have the charisma of Trujillo—and did not attempt to repeat his statuemania. He was in power for twelve years before losing the 1978 election. He regained the presidency in 1986, at the age of eighty. He would spend another decade in power before finally being forced to step down in 1996.

Fallen Idols

The Era of Trujillo is not well remembered today. While he lived, Trujillo was such a flamboyant figure that he frequently (and deliberately) drew international attention. The controversial 1965 American intervention in the Dominican Republic brought the country back into the headlines. Yet the Vietnam War soon eclipsed that as far as the American public was concerned. The Dominican Republic is a fascinating and vibrant place with an extraordinary history. Even so, it is a small country. The affairs of superpowers are always likely to command more global interest.

There is another reason, though, that the history of the Dominican Republic is poorly known—even inside the country itself. Under Balaguer's regime, those who asked questions or challenged the government risked their lives. That is not an environment in which the study of history can flourish. The regime did not teach or even publicly acknowledge much of the grim history of the Era of Trujillo because it was itself implicated in the abuses.

Removing Trujillo's statues did not cause this erasure of history. The history of the Era of Trujillo was not suppressed after the statues were removed and banned in 1962, during Juan Bosch's brief administration, or even in the period of turmoil after that. This erasure of history happened after Balaguer returned in 1966. The historian Roberto Cassá, now the director of the Dominican national archives, wrote in 2001 that "knowledge of history has been reduced to meager levels, so that most of the population lacks information about what happened."[23] His-

tory was obscured by the repressive measures Balaguer used to quash criticism of his own regime.

Had some or even all of Trujillo's statues been left in place, there is no reason to think Balaguer would have been any less repressive. If the historical memory of Trujillo had not been so toxic, it is possible Balaguer would have capitalized on his role in it, rather than suppressing it. That would not have meant being more honest about history. It would have meant telling a slightly different set of lies.

Removing statues is not enough. As we have seen, after the Nazi regime fell, Germany removed its monuments—but de-Nazification only achieved its goals of creating a tolerant and democratic society with a thorough program of education. Under Balaguer, the Dominican Republic could not do this. It is impossible for a process of truth and reconciliation to work without the truth.

After Balaguer, that truth can be told again. Yet the repression of history during those years has left a black hole in historical memory that has, in some cases, been filled by nostalgia. Faced with social problems, corruption, and poverty, some Dominicans say that a new Trujillo is needed. Roberto Cassá argues that "Trujillo has become a quasi-mythical character." For years, he says, history was not taught in a way that encouraged students to ask questions: "The educational system does not provide tools for critical thinking, which affects the difficulty of conceptualizing the historical past."[24]

Trujillo's defenders still push back against attempts to restore history. For instance, in 2011, a new Memorial Museum of Dominican Resistance (MMRD) was opened to tell stories

of those who opposed the Trujillo and Balaguer regimes. There was a backlash. "Did he commit a number of excesses? Absolutely. He was human. Was he a monster? Absolutely not," the dictator's grandson, Ramfis Domínguez-Trujillo, told the *New York Times*.[25] The MMRD estimates that 50,000 Dominicans were murdered by the Trujillo regime, in addition to the 17,000 to 35,000 Haitians killed in the massacre of 1937. This is a pretty high number of "excesses."

Undeterred, the Trujillo family set up a web page to start a Museo Generalísimo Trujillo, intended to honor the dictator. As of 2021, the web page is defunct. Meanwhile, Domínguez-Trujillo has announced that he will run for president of the Dominican Republic. At the moment, he is reportedly not allowed to do so, because he was born in the United States and has not renounced his American citizenship.[26]

Two of Trujillo's phallic obelisks remain. The Monument to the Heroes of the Restoration is still a popular attraction in Santiago. It now houses statues of nineteenth-century heroes and Dominican baseball players, as well as history exhibitions. Its silhouette still dominates the city. Much may be forgotten about Trujillo—but this one part still stands proud.

As for the Male Obelisk in Santo Domingo, that takes us back to the story of the Mirabal sisters. Under Balaguer, the Dominican government was cagey about officially acknowledging how or why they died.[27] Yet they were not forgotten in the rest of the world. The date the three sisters were murdered, November 25, was officially commemorated across the Caribbean and Latin America beginning in 1981. In 1999, the United Nations desig-

nated it the International Day for the Elimination of Violence Against Women.

In 1997, with Balaguer finally out of the way, a mural of the Mirabal sisters was painted on the Male Obelisk by a Dominican artist. The obelisk was painted white again in 2009, but a new Mirabal mural returned in 2011. Now, once again, the Mirabal sisters gaze down from the obelisk.

Historical memory in the Dominican Republic may be fragmentary, but there are people working to explore and preserve it. By creatively altering remaining monuments such as the Male Obelisk, subverting their intention and drawing attention to the resistance to Trujillo, artists have helped open up that history to new generations. Anyone who walks past the obelisk now may wonder who these women were, and why they are painted on a gigantic phallic symbol. Some will look for answers—and begin their own process of learning about history.

It is appropriate that this aggressive symbol of Trujillo's machismo has been reclaimed as a monument to the extraordinary women who were brave enough to resist him. Sometimes, at least, memorialization may deliver a form of justice.

The Great White Elephant

King George V

Location: New Delhi, India
Put up: 1936
Pulled down: 1968

This chapter tells the story of a towering statue of King-Emperor George V, made as the centerpiece of the largest empire the world has ever seen. It began as a gleaming marble icon in the heart of New Delhi. It is now falling to bits in scrubland in the north of the city, rarely visited except by stray dogs. This is a story of how even the mightiest statues may crumble when they are no longer relevant to the people they were meant to impress.

The British left India in 1947, after resisting an intense independence campaign for decades. Yet they were not forced out by violence, and their statues were not all smashed up there and

then. (It is sometimes said that Indians destroyed most British statues as soon as they became independent. This is untrue. Considerable numbers of British monuments still stand across the subcontinent today, though they are in various states of disrepair, and many have been moved.[1])

The origins of George V's statue can be traced back to the height of the empire in the early twentieth century. In December 1911, the newly crowned King George V and Queen Mary traveled to Delhi to hold a grand durbar, or court. George V was the first reigning British king to visit India, and the first to be there for his own proclamation as emperor. He would also be the last.

The durbar was one of the most spectacular events ever staged by the British Raj. It was held in an amphitheater outside Delhi, in front of 100,000 spectators, 30,000 troops, hundreds of Indian princes, and the King-Emperor and Queen-Empress themselves. The king wore a new Imperial Crown made for the occasion, studded with 6,100 diamonds as well as emeralds, rubies, and sapphires. He complained in his diary afterward that "it hurt my head, as it is pretty heavy"[2]—just under a kilogram. It cost the India Office £60,000, and would never be used again.

Years later, George V's son David—later briefly King Edward VIII, before abdicating and becoming the Duke of Windsor—wrote that the Delhi Durbar had made a great impact on his father. "Himself the least pompous of Monarchs, my father had gained in India a new conception of the Imperial rôle and of the importance of elaborate display and pageantry in impressing the Oriental mind."[3]

And what could impress the "Oriental mind" more than statues? Between 1800 and 1940, more than 140 monuments were

exported from British workshops to India and Southeast Asia. Most were of white Britons—administrators, clergy, and military figures, such as Robert Clive, who were probably considered more heroic by the British than by their Indian subjects. There were also monarchs, especially Queen Victoria. After the great rebellion of 1857, the new British Raj realized it needed to make Indians feel as if they were partners rather than merely resources, so it put up statues of them too. Popular subjects included merchants who spent the fortunes they made trading opium with China on civic good works. Sir Jamsetjee Jeejeebhoy, the first Indian to be made a British baronet, was celebrated with three statues. David Sassoon, the Baghdad-born leader of the Jewish community in Bombay, had two. Kristo Das Pal, the editor of the *Hindoo Patriot* newspaper and a legislator, was remembered with a marble statue in Calcutta.[4]

Though some Indians may have felt included, others took out their frustrations with imperial rule on imperial statues. In 1876, two Indian brothers who had been refused places in the army vandalized a statue of Queen Victoria in Bombay, pouring tar over its head. The statue was covered by the authorities and placed under armed guard, but all attempts to remove the tar failed. Finally, a professor from Surat made a chemical compound that did the trick. Following further incidents of statue defacement, an act was passed in 1901 requiring the Bombay municipal authorities to keep all statues perfectly clean. The art historian Mary Ann Steggles observed that, as a result, employees of the Public Works Department were regularly required to climb up Queen Victoria and "shampoo the head to remove all of the bird droppings."[5]

Fallen Idols

Several more statues of Queen Victoria, including one in Delhi, were tarred following the unpopular partition of Bengal in 1905. As the independence movement grew, Victoria's statues were the most popular target for vandalism. Partly this was because there were so many of them; partly because Victoria's image was more recognizable than that of her son Edward VII or grandson George V. Tarring the head and breaking the nose remained the usual form of attack. Before ascribing any uniquely Indian sentiment to this practice, it should be noted that statues of Queen Victoria are unusually difficult to pull down. Her majesty was a short and, later in life, stout woman, often depicted seated and always wearing full skirts. This meant her statues were approximately the shape of a pyramid: the hardest shape to knock over. Without a crane and heavy equipment, she is more or less topple-proof.

At the Delhi Durbar of 1911, it was announced that the capital of British India would be moved from Calcutta to Delhi. A new city would be built alongside the winding lanes, palaces, and mosques of Old Delhi. New Delhi, designed by the architects Edwin Lutyens and Herbert Baker, was an epic, low-rise sweep of elegant bungalows and green lawns, arranged precisely around a series of five- or six-point junctions and diagonal streets. From the air, New Delhi recalls the patterns of spokes and stars in Mughal architecture. From the ground, it is a maze, the extravagant scale and irregular diagonals making it virtually impossible to navigate. Still, encouraging visitors was hardly the point. Here stood the ridiculously massive Viceroy's House, the palaces of India's ruling princes and the residences of all British officials—themselves strictly arranged according to salary and rank. As

the historian David Cannadine has observed, "a bungalow for a gazetted officer [was] altogether superior in size and location to that of a Class I Married European Clerk."[6]

New Delhi stood on the site of seven great medieval cities, and settlements dating back to ancient times. The French prime minister Georges Clemenceau visited during building works, remarking perceptively: "This will be the most magnificent of all these ruins."[7] The city was inaugurated in 1931. What it still needed, though, was a focal point: a statue.

From the Viceroy's House in the west of New Delhi, a ceremonial avenue called Kingsway (now Rajpath) led directly east to a hexagonal space, Princes' Park. The park already contained the War Memorial Arch (now India Gate), designed by Lutyens to commemorate soldiers of the British Indian Army who had died in the First World War. It was the Maharaja of Kapurthala's idea to put a statue of King George V there, and he put up most of the money. The maharaja was incredibly wealthy: he built himself a gigantic pink palace modeled on Versailles. He was often described as a Francophile. The viceroy Lord Curzon, writing privately to Queen Victoria, put it more plainly: "The Raja of Kapurthala is only happy when philandering in Paris."[8] The maharaja was a friend of several generations of the British royal family, and, like most Indian princes, had a mutually beneficial relationship with the British Raj. As long as he more or less held things together in his state, it would allow him to carry on as he wished, whether in Paris or the Punjab. Lutyens commissioned Charles Sargeant Jagger, who had made statues of royalty and war memorials before, to design the statue.

Jagger's statue was inspired by the king's appearance at the

Delhi Durbar of 1911, twenty years before. His first model featured an elephant: George V stood in a howdah on its back, the train of his robe tumbling over the animal's left flank, as it gathered the "fruits of empire" in its trunk. Indian figures in relief were clustered around the base. This version was rejected: not for positioning Indians firmly at the bottom, which was wholly in keeping with the Raj aesthetic, but for being too focused on the elephant. The tiny king could barely be seen atop its massive bulk. To be fair, the elephant itself was quite lovely, but this was not enough to sway the committee. A second version, showing the king seated on a throne, was also turned down.[9]

Jagger was upset by these rejections but was coaxed into producing a third design. In February 1934, it passed: a conventional standing figure of the king, with the ermine train of his robe spilling all the way down the back of its tall plinth.

Jagger's work on the statue was recorded on film by a Pathé news crew. He modeled it in miniature using clay, then marked it up with a grid to indicate the joins in the eventual marble. Next, it was enlarged to half size, remodeled in clay on a supporting wooden frame. This version would be sized up again in marble for the final statue: the crowned head carved in Britain and shipped to India, and the rest, from the shoulders down, crafted in India by local masons.[10]

Jagger died of pneumonia at the age of forty-nine, with his half-size model not quite finished. It was completed by another sculptor, William Reid Dick. George V died in January 1936, meaning that neither sculptor nor subject would see the finished statue.

When the statue was dedicated in New Delhi in the autumn

of 1936, it stood under a sandstone canopy designed by Lutyens, reportedly inspired by the sixth-century pavilion at Mahabalipuram. It rose to nearly 13 meters (43 feet, 6 inches): towering over the flat, wide city of New Delhi. The extraordinary vertical dimension was emphasized by that great robe falling in heavy folds down the back of the plinth. The sculpture historian Richard Barnes wrote: "It resembles an Art Deco missile and there is no other statue in the world that uses this effect to gain height."[11]

If the "Oriental mind" was impressed by this, though, the effect would not last. Just eleven years after the statue was erected, the British Raj itself would come to an end.

When the "Art Deco missile" went up in 1936, the campaign for Indian independence had been going for decades.[12] There was considerable support for some form of Indian self-government in Britain as well, but there were many questions to settle. These included what form government would take, which authorities Britain might hand over to, and whether India would become a dominion or be fully independent. There was also the problem of how to deal with the hundreds of princely states, which were not directly ruled or owned by Britain—these were the kingdoms of individuals, such as the Maharaja of Kapurthala. Many princes were nervous about their fates if British protection was withdrawn. Moreover, after provincial elections in 1937, the lawyer Mohammad Ali Jinnah would fire up the Pakistan movement: aiming at separate representation, and possibly even a whole separate country, for Muslims.

In 1945, a Labour government was elected in Britain, determined to end the empire. It faced obstruction in Britain from

old imperialists such as Winston Churchill, then leader of the opposition. It faced obstacles in India too, from politicians including Jinnah and Mohandas K. Gandhi, who could not agree with each other on who should be put in charge, or whether India should be united, federalized, or partitioned.

George VI's second cousin Lord Mountbatten was sent out to India in March 1947 to give Indians their independence. He did so more than nine months ahead of schedule in August 1947. Two independent nations were created: Pakistan and India. They would not be friends. Perhaps the India-Pakistan animosity was one reason why there was relatively little antagonism toward the departing British Raj. The final act of "divide and rule" worked a treat. It is often estimated that one million people were killed and fourteen million displaced in the disastrous partition, though the true numbers will never be known.

India and Pakistan were born amid blood and destruction—yet the British statues stayed up. The only one that was reportedly damaged during independence celebrations was the Angel of Cawnpore, a monument to British women and children massacred during the great Indian rebellion of 1857. On August 15, 1947, revelers smashed its face and painted it black. The local Indian authorities apologized to the British high commissioner: they ensured the Angel was restored and relocated to a local churchyard, where it still stands today.[13]

The new government in Pakistan, headed by Jinnah as governor-general and Liaquat Ali Khan as prime minister, showed no immediate interest in removing statues. Nor did the new government in India, initially headed by Mountbatten as governor-general and Jawaharlal Nehru as prime minister.

These governments had more pressing things to worry about, including massive population movements, social upheaval, and civil unrest. In 1949, Vallabhbhai Patel, the deputy prime minister, reacted furiously to the state government in Bombay "bothering about the question of monuments when they had far more urgent business on hand."[14]

Nonetheless, some of the statues were controversial, either as a result of their position or subject—and George V's, right in the center of Delhi, had the highest profile of all. Throughout the 1950s, questions were asked about statues in the Indian parliament. Those that had been put up by Indian princes, such as the statue of George V, no longer had princes to defend them. When the British Raj ended, the princely states were incorporated into India or Pakistan: a handful of rebel states were dealt with quite swiftly. (Kashmir was the notable exception, and is still disputed today.) The Maharaja of Kapurthala died in 1949, and there would be no more maharajas after him. His pink Versailles-style palace is now a school.

The centenary of the 1857 rebellion renewed demands to get rid of British statues in India. Some were vandalized, and a few were removed by local authorities. Socialist politicians taunted the Congress government for doing nothing to remove symbols of subjugation. On May 13, 1957, Jawaharlal Nehru set out his government's policy. "There are various kinds of statues," he told parliament, "some may be considered historical, some may be considered artistic, and some may be considered, well, rather offensive in themselves." He said that the offensive ones were already being removed discreetly, to avoid creating bad feelings between India and Britain. If they were historically significant

but not offensive, they would go to museums. As for those statues that were neither historical nor artistically distinguished: "I do not know what we will do with them; if somebody else wants them, we will make a present of them."[15]

Nehru argued in parliament that statues of gods were part of ancient Indian culture, but statues of humans were not. He objected strongly when one member of his own party wanted to erect a statue of Gandhi in Parliament House itself. This was not from any feeling against Gandhi, who had been one of Nehru's closest allies and most beloved friends. Nehru had always been suspicious of cults of personality. He fought the constant demands to rename roads and towns after Gandhi, arguing that this would be confusing when everyone in India simultaneously woke up "to find that his address was now Gandhi Street, Gandhinagar."[16] Nehru fought even more fiercely against being commemorated himself, reacting with annoyance when Allahabad University proposed renaming its library after him. "I really do not understand why you should want to attach my name to the University library," he wrote to the vice-chancellor. "Personally, I do not much approve of this practice, more particularly, in using names of living persons."[17]

Nehru's anti-glorification stance placed him at odds with most of his own party and the Indian parliament. MPs kept pushing for the removal of British statues and the creation of Indian ones. Though removals were supposedly progressing, they were doing so at a sedate pace. The American president Dwight D. Eisenhower, visiting India in 1959, was surprised to see George V's statue still up: "I could not help wondering whether we in our early days of independence would have tolerated among

us a statue of King George III."[18] Americans had not; but there was George III's great-great-grandson, still firmly on his plinth. When Nehru died in 1964, the king remained, along with many other statues of British viceroys and dignitaries.

With Nehru gone, the floodgates opened. Work to remove statues of British viceroys began within a few weeks. In 1965, a new Advisory Committee on the Installation of Statues set about putting up new monuments.

One problem when it came to commissioning new statues was that the freedom movement from which 1960s India drew its icons was diverse, and most choices for statues were contentious. There was Nehru himself: he represented secular and liberal values, which some considered degenerate, as opposed to Gandhi's more traditional religious and cultural attitudes. There was Subhas Chandra Bose, the leader of the Indian National Army, who had been so determined to fight the British that during the Second World War he had set up an Indian Legion attached to Hitler's Wehrmacht. This was not as controversial in India as it was in Europe: Bose's Axis allegiance was generally viewed as opposing empire rather than supporting Nazism. Still, he was a man of violence (not nonviolence), and had fallen out with Gandhi, so some were reluctant to give him prominence. There was B. R. Ambedkar, who had risen from Dalit (outcaste) origins to become the author of independent India's constitution. He was an impressive figure, but traditional Hindus disdained him for converting to Buddhism. Moreover, he too had fought bitterly with Gandhi. On and on it went: almost any choice would offend someone, or represent undesirable values.

The only figure who secured wide agreement was Gandhi himself. Gandhi was far from uncontroversial in his lifetime, as all these differences of opinion with other freedom fighters attest. After his assassination in 1948, though, he began to be reclaimed as a myth: the difficult bits of his life and legacy were forgotten, while the saintly virtues were brought to the fore. A narrative was created that India had won independence with Gandhi at the helm—not by violence but by gentle nonviolent persuasion. The story held that the British stood against this persuasion for a while, but eventually accepted it and left with dignity.

This story put both India and Britain in a rosy light, so it was popular—but it was not really true. The independence struggle was often violent, as was the British response. Gandhi's heyday was around 1930: he was no longer in political control by 1947, and had little influence over independence beyond the spiritual. Lord Mountbatten pulled off a feat of public relations by leaving India on friendly terms. The reality of partition, though, was a disaster that tore apart families and communities, and created a deadly fault line for the future. The appalling implementation of partition could not be blamed only on Mountbatten, his speedy timetable, or the failures of British, Indian, and Pakistani authorities, though there was plenty of blame to go around. It was deeply rooted in years and years of British rule that had been undemocratic and deliberately divisive.[19]

By 1965, though, India was moving forward, and the only reason to look back was to build useful myths. If anyone's statue could replace George V's, it had to be Gandhi's. "It was only after

Nehru's death that the figure of Mahatma Gandhi could consensually stand as the symbol of Indian independence when the debate on the canopy took place," wrote academic Sushmita Pati.[20]

At last, the Raj statues were disappearing. In line with Nehru's suggestion that the Indian government make a present of the statues to anyone who wanted them, a few had been offloaded. A bronze equestrian statue of Edward VII that had stood in New Delhi since 1919 was sent to Toronto, where it would be unveiled in 1969. The viceroy Lord Reading, also sculpted by Charles Sargeant Jagger, was returned to Britain and put up, appropriately enough, in Reading. (Other colonial statues have been moved around the world like this. A great statue of Queen Victoria once stood in Dublin, Ireland: it was not popular with locals, and James Joyce nicknamed it "the Auld Bitch." It was removed in 1948 and dumped in the grounds of a hospital. In the 1980s, the Lord Mayor of Sydney was looking for a statue to put in front of the Queen Victoria Building. Like many convicts in the early part of her reign, Queen Victoria was duly transported to Australia. She now stands in Sydney's Central Business District.)

By 1964, most of the remaining British statues that could not be foisted on anyone else had been moved to the Exhibition Grounds in New Delhi, a dusty wasteland where they were stored in a heap. Yet the statue of the old king was still on its plinth.

Early in the morning of August 13, 1965, around a dozen people crept through the dark, silent avenues of New Delhi toward the

statue of George V. They were members of the recently formed Samyukta Socialist Party. They brought ladders, chisels, hammers, and buckets of tar. As they approached the canopy, they were intercepted by two policemen. In the ensuing tussle, one policeman was left unconscious and the other badly beaten. The Samyukta Socialists scaled the statue of the king, hacked off parts of his nose, ear, and crown, and poured tar over him. They hung upon him a portrait of Subhas Chandra Bose before taking their leave.

This act of vandalism and violence was widely condemned in India and in Britain, and brought a new urgency to removing the statue. The usual objections to removal were rehearsed. "Let's face it," an Indian civil servant told the *New York Times* in 1966, "King George and many other British kings are part of our history and we can't eradicate history by removing statues." Others argued that removal had nothing to do with eradicating history and everything to do with India's present. "It is preposterous that 18 years after independence we should still have a British King staring down at us from the most prominent spot in the capital," said one MP.[21]

What to do with it, though? The Indian government offered George V to the British high commission in New Delhi, but the high commission's garden was not big enough to accommodate the gigantic thing without comic effect. "Good God, no!" exclaimed one diplomat. "The compound is bad enough without that."[22] There was a suggestion it might be shipped back to Britain, but the Treasury ruled that out on grounds of cost: it was too big to ship, and too big for any potential site in London. Delhi's authorities rejected the idea of relocating it anywhere

in the city parks. To put it bluntly, nobody wanted it, and the Commonwealth Relations Office in London began to fear that it would meet a sticky end: "the longer matters are left the more likely this effigy of the Queen's grandfather will be subject to some kind of indignity."[23] Finally, at the end of 1968, the statue was taken down and moved to a warehouse in Old Delhi.

The Indian government hit on a solution. The grounds where George V had held his Delhi durbar were available. Long stripped of all the durbar's finery, there was not much to see there. An obelisk carved from Rajasthani sandstone had been placed to commemorate the durbar in 1911, but it was the only structure. Originally, the British had hoped to build the Viceroy's House and their imperial city on the site, but it had turned out to be prone to flooding, so all it ever got was the obelisk, while New Delhi was laid out fifteen kilometers to the south. Now, the durbar site was scrubland—but at least it was scrubland with a glamorous past. It was proposed that this be turned into Coronation Park: a final resting place for the unwanted statues, or, as one diplomat described it, "a graveyard for distinguished old Englishmen."[24] The British authorities reacted queasily to the suggestion, fearing that it would turn into a dump. In the absence of any better ideas, though, Coronation Park won out. The statues, including George V, were moved there without fanfare in 1982.

Meanwhile, the distinguished Indian sculptor Ram Sutar began work on a statue of Gandhi to go under the empty canopy at the end of Rajpath. Sutar's design was approved by the government in 1979, but that government fell. The new prime minister, Indira Gandhi (the daughter of Nehru, and no relation

to Mohandas K. Gandhi), put the project on ice. "I have always wanted to build big statues," Sutar told the *New York Times* in 1988. Twenty years after George V had been removed, he was still working on Gandhi's. "I have no deadline, but the work gives me pleasure, and I am existing on that."[25]

Back in Coronation Park, the statues began to look the worse for wear. Local children used the scrubland as a playground; housewives dried laundry on lines around it; young men smoked cigarettes amid the plinths. Games of cricket were played with the busts as stumps. Plans to build a visitor center and a café never came together. Some of the statues were vandalized, or disappeared entirely. The grass grew longer.

After decades of neglect, it was announced that Coronation Park would be revived in 2011 to coincide with the centenary of the Delhi durbar. Some trees were cleared, the lawns were neatened up, and work began on buildings and a gateway. The words "Coronation Park" were emblazoned on the gate in silver letters. Yet construction stopped, and the letters started to fall off. The world moved on. Teenagers took selfies in the park with smartphones. Graffiti appeared on the coronation obelisk. From a heritage point of view, says Rana Safvi, a historian of Delhi, "Anything that is grand and monumental is cared for and there's a lot of interest. But I have never heard people talking about statues. Had a statue been in the Red Fort, it would be of interest. A statue in the middle of a lawn is nothing."[26]

Under Lutyens's canopy in the center of New Delhi, there remains a vacancy. No statue of Gandhi has ever materialized there. The scheme to build it was abandoned in 2009. Though there has been talk of reviving the idea, there is little political

will to do so at present. Not least, this is because Gandhi's own myth has moved on, and he no longer commands the universal near-agreement he once did. The Bharatiya Janata Party (BJP) government is of a Hindu nationalist persuasion, and the Hindu nationalist movement has never liked Gandhi. He is blamed for being too conciliatory toward Muslims and for allowing partition. These, too, are myths—but myths can be powerful.

Gandhi's assassin, Nathuram Godse, was a Hindu nationalist. In 2016, a statue of Godse was unveiled by the Hindu Mahasabha party in Meerut. "Gandhi was a traitor," the party's leader, Pooja Shakun Pandey, told the *New York Times*. "He deserved to be shot in the head." She explained why the party venerated Godse: "Our hero stopped Gandhi's poison from spreading in this pure land." Pandey made a viral video of herself shooting an effigy of Gandhi, causing fake blood to gush out. Her followers garland their Godse statue with flowers, revering the murderer as an icon.[27]

In the last couple of decades, India has undergone its own statuemania. Under Prime Minister Narendra Modi, the BJP government has focused on building statues that reinforce its own myths: asserting the towering might of a glorious Hindu past in an extremely literal form.

When it went up, George V's statue was unusually tall at 13 meters, standing out even in the massive scale of New Delhi. By modern Indian standards, it is a dwarf. The Statue of Unity, dedicated in 2018 in Gujarat, commemorates India's first deputy prime minister, Vallabhbhai Patel. The sculptor was Ram Sutar, who worked for so many years on that doomed statue of Gandhi

that never appeared under the canopy by India Gate. His wish to build big statues was granted. The Patel statue rises to 182 meters in height, on a 58-meter base. The height of the whole monument is 240 meters, which is about twice that of Godzilla in its most recent American cinematic incarnation.

At the time of writing, Patel's is the tallest statue in the world, though it will not be for long. More gargantuan statues are under development in India, including a 212-meter statue of the seventeenth-century Maratha emperor Shivaji, which will rise out of the sea off the coast of Mumbai. Patel was a leading politician in the opposition Congress Party; Shivaji alternately allied with, as well as fought against, the Muslim Mughal Empire. As the writer Debika Ray has pointed out, "they are examples of the [Hindu nationalist] movement co-opting complex historical figures for its own purposes."[28] Once again, history is remade to serve a modern agenda.

There are statuemaniacs across the political spectrum. One of the best known is Mayawati, the leader of the Bahujan Samaj Party, who has served four terms as chief minister of Uttar Pradesh. Bahujan means "the majority of the people": in practice, its supporters are people of low or no caste who have generally been disadvantaged in Indian society. Mayawati's personal enthusiasm for putting up statues has been an ongoing story—and scandal—for more than a decade. She spent gobsmacking amounts of public money erecting statues of Dalit icons, including B. R. Ambedkar and the Buddha. She has also put up scores of statues of elephants, which are the symbol of her party, as well as statues of herself.

Across the river from New Delhi, Mayawati built a pink sand-

stone dome, flanked by twenty-four elephants. The dome contains three huge bronze statues, depicting her party's founder Kanshi Ram, alongside Ambedkar and Mayawati herself. As in most of her statues, she is shown carrying her trademark handbag. This monument cost a reported US $150 million when it went up in 2011—no mean sum in a country where the poverty line, at the time, was set at 65 cents a day.[29]

In 2012, the Election Commission ordered that all of Mayawati's statues and her elephants be covered up for the Uttar Pradesh election campaign period. Some have been vandalized: one was beheaded in Lucknow in 2012. It has been widely reported that the total Mayawati spent on statues over her periods of tenure came to 2,600 crore rupees (around US $350 million at 2020 rates). This has not been officially confirmed and some critics suggest that the total may have been even higher.

A court case has been underway since 2009 challenging Mayawati's statue expenditure as a misuse of public funds. In February 2019, India's Supreme Court took the "tentative" view that Mayawati should pay back the money she spent on her own statues and the elephants out of her own pocket.[30] She defended herself the following April, arguing that the statues represented "the will of the people." She also took aim at the national government for spending a fortune on its own statues.[31] The case is ongoing.

In 2020, the Delhi Development Authority called for a new tender to regenerate Coronation Park, displaying the statues in context and adding an interpretation center. Perhaps this time, the scheme will come together. Seventy-four years after the end of the British Raj, though, and fifty-three years after George V's

statue was removed, all this inaction suggests that no one really cares enough to sort it out. If the "Oriental mind" was ever impressed by the statues of the Raj, it has evidently moved on. Those British officials who feared in the 1960s that Coronation Park would become a dump were right.

Sometimes, though, being dumped is appropriate. At the time of writing, Coronation Park remains a desolate place where the proud white marble statues of Great Men have gone to be forgotten: their carved jewels and ermine trims crumbling back into the Delhi dust.

"The Horror! The Horror!"

King Leopold II

Location: Léopoldville, Congo Free State,
and Brussels, Belgium
Put up: 1928/2005 (Léopoldville/Kinshasa), 1926 (Brussels)
Pulled down: 1966/2005 (Kinshasa), still up (Brussels)

This story is about two identical statues of King Leopold II—one in his home kingdom of Belgium, one in his colony of Congo. Together, the twin Leopolds tell a remarkable story about the twists and turns of attitudes to history in a former colonial power and a former colony. This battle over fact and fantasy became not only dangerous but deadly.

Leopold II is often said to have presided over one of the most brutal regimes in history in the Congo Free State—and one of the most personally lucrative. It is to be expected that the histor-

ical memory of this might be different in Belgium and the Democratic Republic of the Congo. The ways in which it is different, though, may be surprising.

Leopold was born in Brussels in 1835, and became king of the Belgians thirty years later. Belgium did not then have an empire. Leopold II tried to persuade the government to expand its interests in Africa, but it showed little interest. Frustrated, he acted alone, sending his agent Henry Morton Stanley to acquire land from local chiefs. Leopold also participated in the Berlin Conference of 1884–1885, at which European powers (plus Russia, the United States, and the Ottoman Empire) formalized their control of much of Africa. The territory controlled by his International Congo Society was recognized as Leopold's own private property—not a Belgian colony. Two million square kilometers of central Africa now belonged to one European man who had never been there. The Africans living on that land could do little about it. Leopold called his colony the Congo Free State.

The first statue of Leopold II went up in Ekeren, Belgium, in 1873, before he acquired the Congo. Leopold hoped to establish a reputation as a builder king. His revenues from the Congo financed projects at home: parks, racetracks, galleries, railway stations. For some in Europe, the flow of wealth from the Congo made the case for Leopold's right to rule.

In the 1890s, Leopold spent a lot of time and effort on propaganda, including the 1894 World's Fair in Antwerp, the 1897 International Exposition in Brussels, and the Palace of the Colonies in Tervuren, opened to coincide with the International Exposition. These were showcases designed to draw the world's attention to Belgium, and to justify the Congo Free State. The

exhibits included some Congolese people themselves, displayed in "human zoos."

For the Antwerp fair, a mock village was constructed with grass huts and a pond. To populate it, 144 Congolese people were shipped in, along with assorted African wildlife. Eight of the people died after their arrival in Belgium from diseases, including flu and dysentery. Their bodies were disposed of in a mass grave. Those who survived were expected to perform "village life" in front of Europeans between May and November 1894.[1] The human zoo was a hit with visitors, so Leopold staged another in Brussels in 1897. This time, 267 Congolese were imported. Seven died, and were again dumped in a mass grave. The last human zoo in Belgium was exhibited in 1958, two years before Congolese independence.

But it was at the Palace of the Colonies—renamed the Museum of the Congo in 1898—that Leopold created what he hoped would be a permanent vision of the Congo Free State's history. The museum was filled with Congolese artifacts, taxidermy, and statues. More statues would be added to the collection over the following twenty-five years. Some of these glorified European rule and Leopold in particular: his own statue stood in the museum's Memorial Hall. Some were looted Congolese art. Others were "ethnographic" representations of Congolese people. Still others told the story of something Leopold liked to say was an achievement of his rule: the abolition of slavery. A statue entitled Slavery showed an Arab trader trampling on a dead Congolese man and enslaving his widow. Leopold claimed to have saved the people of the Congo from this oppression.

In the entrance stood a giant golden statue of a European

missionary—who, with his long beard, looked not unlike Leopold himself. The missionary cradled an African baby with one arm and with the other comforted an African child who appeared to be praying to him. The inscription on this statue read: "Belgium brings civilization to the Congo."

If Leopold's rule in the Congo really was so successful—abolishing slavery, generating wealth, and promoting civilization—then what was the need for all this propaganda? Was it an attempt to cover something up?

In 1899, the author Joseph Conrad serialized his novel *Heart of Darkness*, inspired by his own experiences as a steamboat captain in the Congo Free State. The Congo he portrayed was no happy land of free trade and liberated Africans, but an inhuman hellscape of violence and exploitation. The novel's Africans may be depicted as primitive (it has often been criticized for its racial attitudes) but, in Conrad's tale, savagery is found among European colonizers. Conrad wrote that his time in the Congo had left him with "the distasteful knowledge of the vilest scramble for loot that ever disfigured the history of human conscience and geographical exploration."[2]

King Leopold's efforts to persuade the Belgian people of the genius of his rule had not worked. At best, public opinion toward the Congo Free State was indifferent. Leopold sulked that he was not properly appreciated.[3] As stories of what was really happening in the Congo began to leak out, though, this public indifference turned to anger.

The African American journalist and politician George Washington Williams traveled to Leopold's domain in 1890, and

was horrified by what he saw. He wrote an open letter to Leopold detailing failures and brutalities committed in the name of the Congo Free State, including the enslavement, torture, and murder of Congolese people. "Your Majesty's Government has sequestered their land, burned their towns, stolen their property, enslaved their women and children, and committed other crimes too numerous to mention in detail," he wrote.[4] Williams found that the existing language was inadequate to describe what he had seen. He had to invent a new term for what Leopold was doing—"crimes against humanity"—which was later used to describe the Nazi holocaust, and is now part of international law.

In 1904, a Congo Reform Association was formed, pushing back against Leopold's propaganda with testimonies and photographs of real life in the Congo. Perhaps the most striking images were of men, women, and children without hands. Leopold's regime set rubber quotas for workers, which were enforced on pain of death. The paramilitaries sent by the regime to enforce them had to prove that they had killed inadequate rubber workers by presenting chopped-off right hands to their European supervisors.

The rubber quotas were impossible to fill, so the paramilitaries regularly had to provide buckets full of severed hands instead. In practice, they would hack these off anyone they could catch. Some survived the injury, some did not. A British missionary, Alice Seeley Harris, took one of the most haunting of the photographs of that time. It shows a rubber worker, Nsala, sitting on the veranda of a house, staring at the severed hand and foot of his five-year-old daughter. Nsala's little girl and his wife had just been murdered by men acting on behalf of the

Anglo-Belgian India Rubber Company as a punishment for him failing to meet his quota.

Outrage spread across the world and was picked up by writers, including Mark Twain, Booker T. Washington, and Arthur Conan Doyle. Professor Félicien Cattier of the University of Brussels investigated Leopold's administration in the late 1890s and early 1900s, concluding that it was "the clear and indisputable fact that the Congo Free State is not a colony in the proper sense of the term; it is a financial speculation." Its only purpose, Cattier said, was to make money for Leopold. "The colony is administered neither in the interests of the natives, nor even of the economic interests of the Belgium; the moving spirit is the desire to assure to the sovereign King the maximum of pecuniary benefit."[5]

With Leopold's reputation tanking, he threw yet more money into constructing monuments, rebuilding his principal residence, the Palace of Laeken, in a grand style, and regenerating an entire neighborhood of Brussels as the Mont des Arts, at a reported cost of $50 million.[6] Few statues of him were going up by this point. One was installed on the facade of the Leuven town hall in 1903, but it stood amid 236 others: a pantheon of biblical figures, historical monarchs, and notables of the city.

With his propaganda no longer really working, Leopold turned defensive. In 1906, he gave a remarkable interview to an American journalist, who asked him about the Congo Free State. "I suppose there is nobody in Europe painted as a monster of such blackness as I am," Leopold replied sarcastically. "Nero, it is said, was a saint compared to me. I am an ogre, who delights to torture helpless African negros."

"Then it is not true that atrocious conditions exist in the Congo region?" asked the reporter.

"Of course not," replied Leopold. "It would be absurd for us to mistreat the blacks because no State prospers unless the population is happy and increasing. America knows perhaps, better than any other country, how true this is."

While there were, Leopold admitted, "some cases of misjudgment on the part of Congo officials," he asserted that these had been dealt with. He claimed that his administration had introduced motorcars, railways, and the telegraph; abolished slavery; and reduced smallpox and "barbarism." As for the firmness of his rule, he remarked: "In dealing with a race composed of cannibals for thousands of years, it is necessary to use methods which will best shake their idleness and make them realize the sanctity of work."

Leopold claimed that his rule of the Congo Free State had made him poorer, which was surprising given that he had just found $50 million to spend on a new arts district. He was only involved in the Congo, he claimed, to improve the condition of the country and its people. "I know there are persons so constituted that they are unable to appreciate such a statement," he said. "They believe readily enough, however, false charges that I am rolling in wealth at the expense of dying natives. They see me as a boa constrictor, squeezing the life out of the blacks in order to put gold into my purse."[7]

Since Leopold had never bothered to go to the Congo and see what was happening, his denials were not widely accepted. International pressure grew until, in late 1908, the government of Belgium intervened, taking control of the Congo Free State

as the Belgian Congo. Furious, Leopold burned the historical archives detailing what had been done in his name. It took eight days to incinerate all the documents.[8] Never mind pulling down statues: burning archives is, unquestionably, an attempt to erase history.

It is impossible now to produce a remotely accurate figure for how many Congolese people were killed under Leopold's rule, let alone how many were maimed, raped, or traumatized. Excess deaths in the Congo between 1885 and 1908 have been estimated between five and thirteen million. Historians such as Jan Vansina and Adam Hochschild have agreed approximately with the Belgian government's own commission of 1919 that the population of Congo had been reduced to about half of what it was in 1879—implying an excess death toll of around ten million.

Leopold died in disgrace in 1909, a year after losing his colony. Such was the anger at that time at his behavior over the Congo Free State that his funeral cortege was booed by crowds.

And there it might have ended, with Leopold II of the Belgians discredited and despised. But history does not end. There is always someone trying to change the story. And there is usually someone trying to put new statues up.

Five years later, Europe plunged into the First World War, and Belgium was occupied by German forces. This small country was torn apart along the western front. After the war came the Spanish flu pandemic, which hit Belgium in 1918 and 1919.

Leopold had no surviving sons, so his nephew had succeeded him as King Albert I of the Belgians. One of Albert's first acts after coming to the throne in 1909 was to tour the Belgian Congo

and recommend reforms. During the war, he took command of Belgium's rather underprepared army. Many European monarchies did not make it through the First World War. Belgium's survived, and Albert wanted to keep it that way. That meant modernizing in the present—he was instrumental in bringing in universal male suffrage—and revising the past by attempting to rehabilitate his uncle's image. Soon enough, the statues began to go up.

A statue of Leopold II in Brussels had been proposed by the government in 1914, and a large fund was raised by public subscription—with donations led by Albert himself. After the end of the war, the Belgian sculptor Thomas Vinçotte was commissioned to start work. Leopold was sculpted in bronze, a tall figure with a flowing beard and robe, atop a horse with its head reverentially bowed. The statue was raised in the Place de Trône, right in the center of Brussels. There was an unveiling ceremony in 1926, attended by hundreds of notables. Albert gave a speech in praise of his uncle. With some difficulty, he laid a bouquet of flowers that was almost as big as himself at the statue's base.[9]

So much money was raised by the subscription that an exact copy of this statue was made and sent to Léopoldville, as the capital of the Belgian Congo was then called. In 1928, about eighteen months after he had unveiled the Leopold statue in Brussels, Albert traveled to Léopoldville to unveil the statue again. It was in pride of place, against a backdrop of the Congo River. There were few objections at the time. There had been a world war; soon there would be another, and the atrocities of the Congo Free State would be pushed back in Belgian historical memory by atrocities closer to home.

Belgian authorities continued to raise statues to Leopold in the late 1920s and the 1930s, including in Ghent, Ostend, and Auderghem. Under Albert's watchful eye, the myth that Leopold had always sought to promote about himself was cemented by these statues. The Ostend statue even featured at its base a group of "grateful Congolese," naked and groveling, giving thanks to Leopold for supposedly freeing them from slavery.

In terms of his historical reputation, Leopold II was back on his way up. The statue in the Congo itself, wrote the Belgian historian Davy Verbeke, "was a rehabilitation of a tainted figure from the start. Like a nice, clean lid over a stinking sewer."[10]

The lid over the sewer of Leopold's reputation was not lifted until 1960, when the Belgian Congo achieved independence as the Republic of Congo. By then, Belgium's monarch was the twenty-nine-year-old King Baudouin, a grandson of Albert I and great-grand-nephew of Leopold II. Baudouin had been on the throne for nearly a decade by 1960, but was still a young man. His generation had no memory of the Congo Free State or Leopold II. He had grown up in an environment in which Leopold II's image had been fully rehabilitated: his statues stood proudly all over Belgium.

Perhaps this was why, when the Congolese achieved independence on June 30, 1960, Baudouin misjudged his speech so badly. He stood at the Palais de la Nation in Léopoldville, right opposite the equestrian statue of Leopold II that matched the one in Brussels, to deliver his remarks. "The independence of the Congo is the crowning of the work conceived by the genius of King Leopold II undertaken by him with firm courage, and con-

tinued by Belgium with perseverance," he claimed, patronizingly and untruthfully. "For eighty years Belgium has sent your land the best of her sons . . . to deliver the Congo basin from the odious slave trade which was decimating its population." Leopold II, Baudouin said, "appeared before you not as a conqueror but as an agent of civilization."[11]

Baudouin's speech revealed how thoroughly history had been rewritten along the lines Leopold himself had hoped. There was no mention of the crimes against humanity that so many international and Congolese observers had reported; no mention that Leopold was the person for whom the term "crimes against humanity" had to be invented; no mention of the fact that Belgium had to annex the Congo owing to Leopold's mismanagement. Leopold's contemporaries had seen clearly that he ran the Congo Free State for his personal profit and that alone. All this nonsense about ending slavery and promoting civilization had been debunked by 1909. Half a century later, it was back.

The incoming Congolese prime minister, Patrice Lumumba, had not been scheduled to speak. So incensed was he by Baudouin's speech, though, that he took the stand, and delivered a searing response. Far from being granted independence, he said, the Congolese people had fought for it, and that fight "was filled with tears, fire and blood. We are deeply proud of our struggle, because it was just and noble and indispensable in putting an end to the humiliating bondage forced upon us. That was our lot for the eighty years of colonial rule and our wounds are too fresh and much too painful to be forgotten."[12]

Lumumba's speech was interrupted eight times by loud ap-

plause from the Africans present. Most of the Europeans sat in stony silence. Baudouin stormed out.

Six months later, in January 1961, Lumumba was taken captive, beaten, and murdered by Belgian and Congolese officers. (The CIA was involved in the decision to render him to his enemies.) In 2001, it emerged that Baudouin had been told in advance of the plot to assassinate Lumumba. He had done nothing to stop it. "We are not going to allow an undertaking spanning 80 years to be destroyed by the hateful politics of one man," Baudouin had written of Lumumba that October.[13] The objection to Lumumba was rooted in Cold War fears that he would incline toward the Soviet Union. Anti-imperialist sentiments were seen by some in the West as inevitably entwined with communist sympathies, though the reality was often much more complex. The Belgian monarchy's preferred version of the Congo's past and present aligned with Lumumba's opponents' view of the Congo's future, and this had to be defended—even to death.

The man who had ousted Lumumba and became the new leader of the Republic of Congo was Joseph-Désiré Mobutu. He embarked on a program of Authenticité. Under that program, Congo was renamed Zaire, Léopoldville became Kinshasa, and Joseph-Désiré Mobutu became Mobutu Sese Seko. In 1966, the statue of Leopold II that stood in Kinshasa was pulled down by the authorities. It was taken to the department of public works and dumped under a tree behind a shed, along with other symbols of the colonial past.

Mobutu and his kleptocratic regime clung to power in Zaire until 1997, when he was ousted by Laurent Kabila. Zaire became the Democratic Republic of the Congo (DRC). By this time, the

views of some in Congo itself had shifted. The culture minister, Christophe Muzungu, argued that colonial statues were part of Congo's heritage and should be restored to their original positions. In his words, "a people without history is a people without a soul."[14]

On February 3, 2005, without any warning, the equestrian statue of Leopold II went back up. On the personal orders of Muzungu, it was re-erected near the central station in Kinshasa: still mucky from its decades behind the shed.

An angry crowd formed around it. "[Leopold] left us in poverty," one man told the BBC. "He exploited our raw materials and left us with nothing." It was quickly pointed out that Leopold had been put back in the wrong place, on a plinth that had originally supported a statue of Albert I—whose statue was also now behind the shed. Leopold's original plinth, opposite the Palais de la Nation, by this point hosted a statue of Laurent Kabila, who had been assassinated in 2001. The president of the Democratic Republic of the Congo was Kabila's son, Joseph. Everyone agreed he was unlikely to take his own father's statue down to put the king back up.

A few hours later, amid threats of a riot, the day descended into farce as the statue of Leopold II was pulled down again. This time, it had stood for only a few hours. Muzungu claimed, not all that credibly, that it had only been put up as a trial, to test the stability of the plinth. "We are going to put it up again later, in a grand ceremony," he said.[15]

That never happened. The statue of Leopold II was discreetly moved to the National Museum of the Congo. It was put in the museum's grounds, alongside others of the same era. "Look, a

statue is just an object. Iconoclasm leads nowhere," said Joseph Ibongo, director of the museum. "Putting Leopold's statue here does not mean that we subscribe to a colonial narrative. On the contrary, it offers the opportunity to talk about the abuses and to challenge clichés about the colonial period . . . A museum is the only place where such a statue can be systematically given context."

Jacob Sabakinu Kivilu, a professor of history at the University of Kinshasa, argued against putting the statue in a museum. He suggested that history could be taught in many ways: in schools, on radio and television, and through cultural policy. "But colonial statues can also support that collective memory. That's why I think they should be in the public space, not in a museum."[16]

While these academics were divided over exactly where the statues should go, they were united by the idea that they had the potential to be part of a balanced view of Congolese history. Meanwhile, in Belgium itself, public opinion was going in precisely the opposite direction.

In 1998, the historian Adam Hochschild published *King Leopold's Ghost*, a new history of the Congo Free State. The book built on decades of research by academics in Belgium and the Congo, uncovering once again the story of Leopold's crimes against humanity. It became an international bestseller. Generations of Belgians had grown up with Leopold's statues all around them. Now they were confronted with a shockingly different version of their history, though it would have been fa-

miliar to their ancestors in 1909: a story of terror, brutality, and genocide, symbolized by buckets of severed human hands.

In 2004, someone vandalized the statue in Ostend of Leopold supported by "grateful Congolese." You had to look closely to see it: a male Congolese figure on the far left of the statue group had had his hand sawn off. This reminder of Leopold's regime was horribly effective. A group called De Stoeten Ostendenoare (The Bold Ostenders) said they would give the hand back if Belgium and its royal family apologized for their colonial past. No apology was forthcoming, so they kept the hand—though one member of the group produced it at a debate in Ghent in 2019.[17] Meanwhile, a chain was put around the neck of Leopold's earliest statue in Ekeren in 2006. The statue was daubed in red paint in 2007 and 2009.

As for the equestrian statue in Brussels that matched the one in Kinshasa, it came in for a spectacular attack in September 2008. A Belgian activist, Théophile de Giraud, announced that he would assail it with graffiti, a symbolic hanging, and more red paint. He invited members of the public to join in: "Brushes will be available to anyone who wants to decorate the pedestal of the bearded terrorist. In a hubbub of revolutionary roars, the ceremony will end with a collective bombardment of the hated memorial: come in large numbers and consider bringing eggs."[18]

On the appointed day, Giraud scaled the statue, doused it in paint, and posed cheerfully sitting in front of Leopold on the horse. He allowed himself to be arrested shortly afterward, giving an interview as he was taken away. "*Voilà*, he's a bastard, there's a statue that glorifies a serial killer and crimes against

humanity, and [gestures to police arresting him] the guardians of injustice, *voilà*, and this sums up well all the contradictions of our society," Giraud said. "We'll continue to protest against these contradictions, *voilà*, and replace this piece of shit statue with statues of more positive people."[19]

In Belgium, Leopold's reputation was clearly on its way down again. The Museum of the Congo—now the Royal Museum of Central Africa—shut down in 2013 for a thorough renovation. It reopened in 2018 with exhibits recontextualized and contributions from Congolese historians. When, in 2015, the city of Brussels planned to hold "an homage" to Leopold in front of his statue, the idea was widely slammed. Brussels MP Bruno De Lille described it as "morally reprehensible" and compared it to "laughing at the suffering of the genocide victims and their families."[20] Once again, activists daubed Leopold's Brussels statue in red paint. In 2018, a group called Citizens for a Decolonized Public Space brought down a bust of Leopold in nearby Duden Park.

In June 2020, as statues of slaveholders and colonialists were being torn down all over the world, Leopold's statue in Brussels was painted yet again. It now seemed to be red as often as it was bronze. The authorities scrubbed the paint off. As soon as they had finished, new graffiti appeared on its plinth: "Stop cleaning, start reflecting."[21]

On the sixtieth anniversary of Congolese independence in June 2020, King Philippe of the Belgians expressed his "deepest regrets" about the atrocities that had occurred under Leopold's rule. It was not quite an apology, but it was a significant step. The king's aunt, Princess Marie-Esméralda, a writer and climate

activist, called for the removal of statues. "Statues are not neutral, they represent something, they hurt people," she told the BBC's *Newsnight* program. In schools, she said, "nobody was learning about the colonial past. There was a lot of lies, a lot of myths and that has to change."[22]

For more than a century, the Belgian royal family had aggressively pushed a myth about Leopold II. At last, a reckoning was beginning. But was the situation in Belgium different from that in the Democratic Republic of the Congo itself? Were the descendants of the victims of colonialism now ready to come to terms with these statues in public places or museums, while the descendants of the perpetrators insisted on tearing them down altogether?

Of course, it is more complicated than that. A fourteen-year-old boy with Congolese heritage was behind a viral petition to remove all statues of Leopold II in Belgium, which garnered more than 84,000 signatures over the summer of 2020. A younger Belgo-Congolese generation is less afraid to challenge prejudices. "Our parents tell us not to protest as they fear violence towards us," one Belgo-Congolese activist, Mireille-Tsheusi Robert, told Al Jazeera. "We have seen our parents being humiliated and degraded in front of our eyes, and they are our heroes. We do not want to allow and endure the same relationship they had with the rest of the Belgian society."[23]

"Brussels is the capital of Europe today thanks to the Democratic Republic of the Congo," says the Congolese artist Kabund Arqabound. "The majority of Belgians are afraid to come to the Congo because of the atrocities committed by their ancestors—

that if they came here, we'd do them harm. In fact, they'd be treated like kings. But they could still have shame . . . We can forgive. And the Congolese have kept on forgiving. To be forgiven, you have to be able to take responsibility for the bad things you have done to others."[24]

For now, there is little pressure to remove Leopold II from the grounds of the museum in Kinshasa—not least because the museum itself moved to a shiny new building in 2019. In the grounds of the old museum, Leopold is among other artifacts of bygone ages. He has already been knocked off his plinth twice. Now, in effect, he has been put out to pasture.

There is, on the other hand, considerable pressure to remove the identical Leopold II from the Place de Trône in Brussels, not least because of the cost of regularly scrubbing red paint off him must be mounting up. "I think we need a debate about it," said Brussels heritage minister Paul Smet. "You know it's a double debate. If you take the statue away, you will forget it, if you leave the statue, you have to contextualize it at the minimum." Smet emphasized that he wanted the debate to be resolved fast. "What are we going to do with the statues of Leopold II in our city? What are we going to do with the street names that we still have . . . and how are we going to remember the colonialism in what we did and the errors that have been [made] by Belgium in the past? How are we going to make that visible in our city? And, for example, I think a kind of memorial of a statue for the decolonization is something that this city needs."[25]

The Belgian historian Davy Verbeke has also proposed a new memorial in Leopold's place. "I dream of an impressive twenty-first-century Congo-Belgo Memorial with universal ambitions,"

he wrote. "A serene place of healing and reconciliation. Commissioned by the Belgian government, conceived and executed by Congolese and Belgians together."[26]

"I'm going to use a saying—a fish rots from the head," says Kabund Arqabound. "If change is going to happen, we need political leadership to recognize that this generation needs to know where it comes from. As soon as we have a president who condemns the atrocities committed by the Belgians, and Belgium starts to recognize its part, that would be a start."[27]

Professor Georges Nzongola-Ntalaja, one of the world's foremost scholars of Congolese history, proposes a different form of reconciliation. "Removing Leopold II's statues in Belgium is fine, if that is what the majority of Belgians want," he wrote. "But gestures and statements change nothing in the DRC. The people of the Congo want redistributive justice and reparations, both for the wrongs suffered by their ancestors and the present consequences of Leopold's legacy in their country."[28]

In the early twenty-first century, former colonial powers such as Belgium are beginning to reckon with their histories. Ultimately, it is easy to pull down a statue—or to put one up. To make real reparations for the past is a much greater challenge.

Lying in State

Vladimir Ilyich Lenin

Location: USSR and satellite states
Put up: from 1926
Pulled down: from 1991–2017

Stalin sought to create a cult of personality around himself. Lenin actively rejected it until he became too ill to protest. This is the story of a man who never wanted a statue, yet ended up with thousands of them—becoming one of the most memorialized men in history. Even his own body would become a "living sculpture" after his death.

During the Soviet period, hundreds of statues of Stalin, Karl Marx, Friedrich Engels, and assorted grandees went up all over the Soviet Union and its satellites. Most of all, though, there were statues of Lenin: the founder of the Soviet Union. Lenin's sharp

face, his mariner's cap and his billowing overcoat became elements of the Soviet landscape, reproduced in every city, every town, every village. There would be busts of Lenin high in the Arctic Circle; a bust of Lenin near the South Pole; bas-reliefs of Lenin in outer space, after Soviet Venera probes were launched bearing them in the late 1960s.[1]

The obsession with statues ran deep in Russian history. For centuries, the tsars had commissioned statues of themselves. St. Petersburg, for instance, was said to have "three horsemen." The first went up in 1782, when Catherine the Great raised an equestrian statue of Peter the Great in Senate Square. Mindful of her shaky position as a German princess who had married into the imperial family, Catherine used the statue to link herself to Russia: inscribing her name alongside Peter's. The statue was a success, its place in the popular imagination cemented by Alexander Pushkin's 1833 ode to St. Petersburg, "The Bronze Horseman," in which it comes to life.[2]

The second horseman was an awkward bronze of Tsar Nicholas I, which went up in 1859 in St. Isaac's Square. The tsar is seated rigidly on a rearing horse, its two back hooves the only point of contact between statue and base. The third and final horseman went up in 1909: a statue of Alexander III, who, even by the standard of tsars, was reactionary and unpopular. Depicting a stiff, stout Alexander astride an equally stiff, stout horse atop a plinth, this statue inspired widespread ridicule and a folk poem:

> *Here stands a chest of drawers,*
> *On the chest a hippopotamus,*
> *And on the hippopotamus sits an idiot.*

On February 23, 1917, there were huge demonstrations in Petrograd, as St. Petersburg was then called. Socialist agitators swarmed the statue and climbed up the "chest of drawers." When they dispersed, the word "Hippopotamus" had been carved on the plinth.[3]

All three horsemen survived the Soviet era, though in 1937 the Hippopotamus was moved to a museum; it is now in the courtyard of the Marble Palace. Others did not. Symbols of the tsars were destroyed all over Russia during the February Revolution of 1917, including a massive statue in Moscow of Alexander III on a throne. A team of workers wrapped ropes around its head and used dynamite to blast bits of it off. Photographs show its colossal head lying on its side in the street afterward while children look on.

The real tsar, Nicholas II, was in effect hauled off his throne by the same revolution. He abdicated in March 1917. Nicholas Romanov, as he was then known, and his family were taken prisoner and shunted off to Siberia, where they would be murdered the following year. By that time, Lenin had returned from exile, the Bolsheviks had taken over, and the Soviets had extended control over a great swathe of territory. A civil war continued.

Soon after the execution of the imperial family, Vladimir Ilyich Lenin claimed: "all our lives we have waged an ideological struggle against the glorification of personality, of the individual; long ago we settled the problem of heroes."[4] Yet he knew that the Soviet regime he was establishing could not leave a void where the tsars used to be. If he did not dictate what filled it, someone else would. "I've just come from Vladimir Ilyich," the head of

the People's Commissariat for Education, Anatoly Lunacharsky, told a meeting of artists and sculptors in the winter of early 1918. "Once again he has had one of those fortunate and profoundly exciting ideas with which he has so often shocked and delighted us. He intends to decorate Moscow's squares with statues and monuments to revolutionaries and the great fighters for socialism. This provides both agitation for socialism and a wise field for the display of our sculptural talents."[5]

The Plan for Monumental Propaganda, often just called "Lenin's Plan," aimed to speed up the dismantling of tsarist monuments and replace them with socialist ones. Lenin approved a list of sixty-six individuals suitable for statues. Karl Marx and Friedrich Engels were the most important. There were also icons of revolution and socialism drawn from world history: the slave leader Spartacus, the French revolutionary Georges Danton, and the Welsh social reformer Robert Owen. Russian and international literary, artistic, and musical figures featured, including Fyodor Dostoyevsky, Andrei Rublev, Modest Mussorgsky, Heinrich Heine, Leo Tolstoy, and Frédéric Chopin. These were intended to give socialism a cultural pedigree. The tsars had banned statues of Tolstoy and Chopin. The Bolsheviks intended to be more progressive.

On April 12, 1918, Lenin issued a decree: "The Soviet of People's Commissars expresses the wish that on 1 May the most hideous idols will already have been taken down and the first models of the new monuments put up for the judgment of the masses."[6] Statues went up all over the Soviet Union that year, mostly in cheap, easily sculpted materials such as terra-cotta

and plaster. The statues were unveiled on Sundays, providing an alternative to religious observance, and were accompanied by small festivals, speeches, music, and explanatory booklets. Lenin's Plan aimed to create statuary that was educational rather than merely symbolic.[7]

The plan's public art successes included Igor Tatlin's Monument to the Third International, a design for a 400-meter-high rotating tower. Though it was never built, the model for the tower inspired artists and architects worldwide. Yet where there is a sublime end of the scale there will often be a ridiculous one too, and in the case of Lenin's Plan it was full of poor-quality statuary plonked in weird places. Lenin himself spoke at the dedication ceremony for new statues of Marx and Engels in Moscow to mark the first anniversary of the October Revolution. Alas, the statues had been made of gypsum. Far from symbolizing the strength and permanence of the revolution, they melted away in the rain.[8] Some Lenin's Plan statues were quickly knocked down: one of the French revolutionary Maximilien Robespierre, who was on Lenin's approved list, was blown up by an anticommunist who equated the Bolshevik revolution with the Terror in France.[9]

Lenin was strongly opposed to statues of living Bolshevik leaders, including himself. Nevertheless, the first official sculpture of him was commissioned in February 1919 by the Moscow Soviet. Copies were sent to twenty-nine cities. In April 1920, for his fiftieth birthday, there were outpourings of devotion—which made him extremely uncomfortable.[10] It was too late. From the early 1920s, as Lenin's health deteriorated, images of him be-

came common in Soviet propaganda. Lenin withdrew to the Gorki estate south of Moscow. His doctors insisted he limit his contact with friends, family, and colleagues. "I haven't died yet," he complained, "but under Stalin's supervision they are already trying to bury me."[11]

By the spring of 1923, Lenin was isolated and carefully controlled. While the real Lenin faded away, though, a new Lenin was being forged. Lenin's writings were censored and altered; he was endowed with new opinions; his image was promoted everywhere. To the real Lenin's horror, the term "Leninism" was created. But the real Lenin no longer mattered very much, nor would he have further opportunities to protest. He had a stroke and lost the ability to speak, read, and write. What mattered now was not Lenin, the flesh-and-blood man who had been born Vladimir Ilyich Ulyanov in 1870 and was still just about alive in Gorki, but "Lenin": an icon that could be constructed and reconstructed to suit the party's needs.[12] This was the basis of what Nikita Khrushchev would later critique as a "cult of personality": the use of mass media to raise a leader to the status of a god. The cult leader was Stalin. As we have seen, he would later perfect his techniques on himself.

Lenin—the old Lenin—died in January 1924. At last, the new "Lenin" could fully assume his form. Lenin's body lay in state, first at the House of Trade Unions in Moscow, and later in a glass sarcophagus inside a temporary wooden mausoleum in Red Square. Thousands of Soviet people traveled to pay their respects.

By March, as Moscow's freezing winter receded, Lenin's corpse began to decompose. Leon Trotsky and Nikolai Bukharin were opposed to preserving it on the grounds that it might become a religious relic. If this happened, said Kliment Voroshilov, "We will cease to be Marxist-Leninists." Lenin's widow loathed the idea of preservation, arguing that her husband did not want to be venerated. The real Lenin's wishes were of no interest to Stalin, so she was ignored.[13]

Schemes were proposed to freeze the corpse, suspend it in a transparent capsule of nitrogen, or submerge it in embalming fluid inside a metal and glass coffin. Felix Dzerzhinsky, the head of the secret police, vetoed this, arguing it would be distasteful to display Lenin's body "as though it were some kind of dead meat." Dzerzhinsky's rough words hinted that Lenin's body was now in the process of becoming something more than dead meat—which, after all, was literally what it was. It was becoming an icon.

The Commission for the Immortalization of Lenin's Memory was established. "We did not want to turn the body of Vladimir Ilyich into some kind of 'relic,'" it declared in July 1924. "We wanted to preserve the body of Vladimir Ilyich ... [because] it is of great importance to preserve the physical appearance of this remarkable leader for the next generation and all the future generations." The difference between these two things is perhaps too subtle for most people to appreciate.

The eventual scheme to preserve Lenin's body was devised by a professor of medicine and a biochemist. The corpse was submerged in a bath of special liquid and injected with chemi-

cals. Some of the organic matter was removed. Artificial replacements were added. Surfaces were resculpted. This process had to be repeated in some form every eighteen months, and still is. Even parts of Lenin that cannot be seen, such as his armpits and feet, have undergone cosmetic correction in the century since his death. The result of all of this is that Lenin's body is referred to by its curators as a "living sculpture": not entirely a mummy, not entirely a statue. "This body both is and is not a representation," wrote the Russian anthropologist Alexei Yurchak. "The phrase 'living sculpture' is meant to convey this paradox, as if to say this is a sculpture of the body that is constructed out of the body itself."[14]

The "living sculpture" of Lenin performed all the functions of a statue. It reduced him to a symbol, an object, that was useful to the new leadership, while obscuring a more complicated reality. It was the centerpiece of an array of Lenin idolatry. New images, rituals, and symbols invoked Lenin as "our dear father," harking back to Russian Orthodox and folk practice. Householders were encouraged to create a "Lenin Corner," akin to the "Shining Corner" in which Orthodox Christians display religious icons: the Leninist version included pictures of him and propaganda material. The Commission for the Immortalization of Lenin's Memory enforced new regulations to standardize Lenin's image from 1925.

In 1926, up went the first major nonliving statue: a monumental figure of Lenin outside Finland Station, in the town that had formerly been St. Petersburg and Petrograd, and was now Leningrad. Lenin was sculpted in a pose now familiar from standard-

ized iconography: wearing an overcoat, reaching out with his right hand, holding his lapel with his left.[15]

There was fierce criticism of the Lenin cult from within the Soviet Union and Bolshevik ranks. Stalin did not care. He continued to build the cult as a platform for himself. In 1931, he published a letter attacking those who criticized Lenin, and asserting "the infallibility of the *vozhd*"—which meant "leader" or "boss," a term he would soon apply to himself. Statues of Lenin sprouted up all over the Soviet Union, and soon Stalins began to go up alongside them. At first, Lenin was usually depicted in portraits as a father or teacher figure, with Stalin his faithful pupil. During the early 1930s, this gradually shifted, so the two were positioned as equals. By 1935, Lenin was often relegated to a minor background role, with Stalin the focus of adulation. A journalist spent November 7, 1933 walking up and down Gorky Street (now Tverskaya Street) in Moscow, counting portraits and busts. He found 103 Stalins and 58 Lenins.[16]

In 1931, Stalin blew up the Cathedral of Christ the Saviour in Moscow. In its place, he intended to build a new Palace of the Soviets. The palace was to be 400 meters high, surmounted with a 100-meter aluminium statue of Lenin. At the time, this would have made the palace the tallest building in the world, and its Lenin topper the tallest statue.

The design was displayed in the Museum of Fine Arts in Moscow in 1934. Visitor comments were mixed. One complained that it was not tall enough, fearing that Lenin might not be visible from every point in Moscow. Another expressed views with

which the old, real Lenin himself might well have agreed: "This is not an edifice but a theatrical pedestal for a monument to Lenin. The significance of the leader of the masses, ascending into the clouds far from the people, is utterly lost here. What is more, Lenin is depicted in the pose of a provincial actor. Unbelievably inflated and banal."[17]

Stalin was not discouraged. Construction of the Palace of the Soviets as a plinth for the world's biggest Lenin began in 1937. The Second World War intervened: construction stopped, and the steel foundations were ripped up to be reused in the war effort. In 1958, with Khrushchev in charge of the Soviet Union, what remained of the foundations were converted into a huge open-air swimming pool. In 1994, the pool was filled in, and a precise copy of the Cathedral of Christ the Saviour was rebuilt on its original site.

On Stalin's death in 1953, his body was embalmed and placed next to Lenin's in the Red Square mausoleum. In 1961, Khrushchev had it removed and buried in the Kremlin Wall. Yet Lenin, the "living sculpture," remained. A massive 24-meter statue of Stalin had stood at the mouth of the Volga-Don Canal since it was opened in 1952. In 1961 it was demolished. Twelve years later, in 1973, a Lenin appeared where Stalin had stood. At 27 meters tall, 30 including its plinth, this is the tallest Lenin statue in the world. It still stands today.[18]

Stalin's image could be erased. While Lenin statues were still being put up, though, his influence continued. The only reason that statues of Lenin were uncontroversial was because Stalin's propaganda had deliberately sucked all the personality out of him, turning him into something anodyne and saintly.

All of this pious veneration could not pass without ridicule. The ubiquity of Lenin was often sent up in *anekdot*, subversive jokes swapped by Soviet citizens. One described a competition to choose the best statue of the poet Alexander Pushkin. "Third prize went to a statue of Lenin reading Pushkin; second prize, to a statue of Pushkin reading Lenin; and the first prize was awarded to a statue of Lenin!"[19]

The Soviet leadership knew that this was getting a bit daft. Under the leadership of Yuri Andropov in 1983, new monuments were banned except with "exceptional" permission from Moscow. Just three years later, though, Mikhail Gorbachev loosened these regulations again. Gorbachev hoped to legitimize his reforming program by connecting it back to the founder of the Soviet Union. He was often photographed laying wreaths at Lenin statues and memorials.[20]

In 1987, the poet Yevgeny Yevtushenko wrote "Monuments Still Not Built," asserting that "There can be no rebuilding without rebuilding memory." He called for a true reckoning with Soviet history in "honest marble": for the Soviet Union to tell the truth about its past. Glasnost—"transparency," Gorbachev's key campaign—risked destroying the very illusion of Leninist conformity and continuity that he hoped to employ.

"Communists, you have no illusions. You are bankrupt," read the banners and placards held by protesters outside Lenin's mausoleum in Red Square on May Day 1990. "Down with the cult of Lenin." Gorbachev swiftly realized that the game was up. He stopped styling himself as Lenin's heir, and declared that it was "high time to put an end to the absurd idolization of Lenin."[21]

Fallen Idols

That summer, statues began to be taken down across the Soviet republics of Lithuania, Latvia, Georgia, Moldova, and Ukraine. In Russia itself, 55 percent of those polled in a referendum voted to change the name of Leningrad back to St. Petersburg.

A group called Memorial had been formed in 1987 by Russian activists who wanted to acknowledge the darker side of Soviet history. They placed a stone taken from a gulag right next to the Moscow statue of the secret police chief Felix Dzerzhinsky.[22] The most cathartic statue-felling in Russia in 1991 was probably that of Dzerzhinsky himself. Hundreds watched and chanted "Down with the KGB!" as a crane sent by Moscow authorities pulled down the symbol of Soviet repression one night in August.

Through 1991, statues of Lenin continued to come down. East Berlin's Lenin Square had a colossal Lenin that had stood there since 1970. The Berlin city council resolved that it had to go, but that was easier said than done. This Lenin was 19 meters high and carved out of solid granite. Over three months, it was chipped and chiseled into 129 pieces. The bits were taken outside Berlin and buried in a sand grove. Images of Lenin's removal made an impact on European cinema: gigantic statues of Lenin were later dismantled on-screen in such films as *Gorilla Bathes at Noon* (Yugoslavia, 1993), *Ulysses' Gaze* (Greece, 1995) and *Good Bye, Lenin!* (Germany, 2003).

The city council rejected requests from historians and curators in Berlin to disinter Lenin's head. It argued that the sand grove was home to a protected species of lizard—which had, presumably, already been inconvenienced by having a massive Lenin buried in its habitat. The lizards would have no peace.

In 2015, they were resettled, the council finally relented, and Lenin's head was hauled from the earth. It has been on display at Spandau Citadel since 2016, alongside a host of other discarded statues from German history, including a collection of Brandenberg-Prussian rulers from the late nineteenth century, and Arno Breker's Decathlete, commissioned by the Nazi regime for the 1936 Olympics. Lenin's head is not displayed upright but instead lies on its side, neatly avoiding glorification and reminding visitors of its fate.[23]

After the fall of the Soviet Union at the end of 1991, there was a backlash against communism in general and Lenin in particular. "The people who'd called themselves communists suddenly started confessing that they'd hated communism from the day they were born," one former communist functionary told the writer Svetlana Alexievich.[24]

Psychologically, it was understandable that many of those who had faithfully believed in Lenin's cult of personality during the Soviet period would now feel embarrassment, shame, and in some cases a deep sense of loss. Some took these feelings out on the image of Lenin itself. Many communist monuments were destroyed, melted down for scrap, or sold off. For instance, the nine-ton bronze of Lenin that stood outside the KGB headquarters in Riga, Latvia, was bought by a dealer for its scrap-metal value: then around £10,000. It went into an auction of garden furnishings at Sotheby's, and was bought for £20,000 by the British MP Michael Heseltine, a minister in Margaret Thatcher's Conservative government. It now stands in his garden in Northamptonshire.[25]

Fallen Idols

The sense of embarrassment felt by reformed Lenin cultists sometimes manifested in stealth statue removals. A seated Lenin in a thoughtful pose in the Kremlin courtyard was first moved to a less prominent corner of the garden, then boarded up behind a wooden fence, supposedly while it was being "repaired." When the fence came down, it revealed a disappearing trick. All 2.2 tons of the thoughtful Lenin had been spirited away to Gorki, where the real Lenin had died.[26] Like the man himself, it was shunted out of view when it became inconvenient.

Some statues were dumped in a field behind the Central House of Artists on the south side of the Moscow river, right opposite Gorky Park. This presented a new opportunity: the creation of a statue graveyard. "It called into being a lifelong dream," declared the mayor of Moscow, Yury Luzhkov, "to gather together all of the bronze and granite Soviet leaders, heroes, farmers, to enclose them in a fence and allow children to play there."[27] The park proved less of an attraction for children than it was for tourists, who delighted in photographing themselves high-fiving the outstretched marble palms of idealized workers, scrambling over Stalin, and giving Lenin little bunny ears with their fingers. In the opening credits of *GoldenEye* (1995), the first James Bond movie released after the end of the Cold War, silhouetted female figures gyrated over falling communist statues. At a pivotal point in the film, 007 finds himself facing his nemesis, 006, in a statue graveyard.[28]

The following year, Moscow authorities began to tidy up the real statue graveyard in order to restore the statues, and add identifying plaques that also acted as political disclaimers: "It has historical and artistic value. The monument is in the me-

morializing style of political-ideological designs of the Soviet period. Protected by the state."[29] The statue graveyard was renamed the Park of Arts, though it is usually known as Fallen Monuments Park. Communist statue graveyards were also created in Budapest, Hungary (as mentioned in the chapter on Stalin), and in Druskininkai, Lithuania.

The most enchanting of all statue graveyards, though, must be the Alley of the Leaders, off Cape Tarkhankut in western Crimea. In 1992, local diver Vladimir Borumensky acquired a bust of Lenin, which he placed in this picturesque underwater location, amid corals and shoals of glittering fish. The collection grew, and there are now around fifty old communist monuments down there, visited only by divers and sea creatures. The denizens of this Soviet Atlantis include several Lenins, Stalin, Marx, Dzerzhinsky, and Maxim Gorky. An array of grandees who once were heroes are now gradually becoming unrecognizable, slowly disappearing from memory as they are claimed by barnacles and billowing forests of seaweed.[30]

While many monuments like these were relocated, reused, or destroyed, the great majority of Lenins in Russia itself remained where they were. According to the website leninstatues.ru, there were 7,000 Lenin monuments in 1991; by November 2015, 6,000 were still in place. The same is not true in other former Soviet republics, such as the Baltic states, where they have all gone. In Moscow today, though, visitors may still see Lenins in the wild in dozens of locations.

There is occasional trouble about the remaining Lenins. On April Fool's day in 2009, dynamite was placed on the first major statue of Lenin, the one that had been put up in 1926 at

Finland Station in St. Petersburg. The resulting explosion blew an enormous and unavoidably amusing hole in its backside. Lenin's behind was repaired by the authorities. The following year, a Lenin statue in a suburb of St. Petersburg (itself a replacement for another that had been toppled by vandals in 2004) was also bombed, horizontally displacing his top half. "Anyone who raises their hand to monuments is against history and the feelings of our citizens," St. Petersburg governor Valentina Matviyenko said, in terms strikingly familiar to anyone following Confederate or slavery-related statue debates in the West. "Whatever they may think of Lenin, all the citizens of our city are outraged by this act."[31]

On the evening of December 8, 2013, two hundred men in balaclavas gathered around a marble Lenin statue on a high plinth on Shevchenko Boulevard in Kyiv, Ukraine. This Lenin had gone up in 1946, raised to celebrate the retaking of Kyiv by the Soviet Union from Nazi forces three years earlier. The protesters climbed up the statue with a ladder and put a noose around its neck. As they pulled, Lenin fell—the statue toppling backward off its plinth and bouncing on the ground, its head coming off in the process. The cheering crowd set about its remains with axes and hammers.[32]

The leadership of protests against Russian interference in Ukraine issued a statement making it clear that they had not planned the statue's destruction: "We can say that people organized themselves."[33] While Russians may have had mixed feelings about Lenin since the fall of the Soviet Union, for

Ukrainians, Lenin symbolized Russia. Protesters used Lenin as a proxy for Ukrainian president Viktor Yanukovych—who was pro-Russian, though he was a long way from being a Leninist. Over the course of December, three more Lenins were attacked around Ukraine, and in January 2014 nine more were hit. But it was in February 2014 that the phenomenon known as *Leninopad*, or Leninfall, really took off, with 376 Lenins targeted, mostly across central and western regions of Ukraine.

Not all of the Lenins were toppled. One statue in Zaporizhya was dressed up in a traditional Ukrainian embroidered shirt. Another in Odessa was creatively altered by a sculptor with titanium alloy cladding, transforming him seamlessly into the *Star Wars* villain Darth Vader, his flowing overcoat becoming a cloak. In Siberia, a Lenin statue was painted blue and yellow in solidarity with the Ukrainian protesters, and the words "Glory to Ukraine" were graffitied on it. In Kharkiv, near the Russian border, a crowd formed a human shield around their statue of Lenin in February 2014, warding off the protesters who hoped to pull it down. Ultimately, the protesters prevailed: the statue was hauled down in September and replaced temporarily with a Christian cross.[34]

The Swiss photographer Niels Ackermann and the French journalist Sébastien Gobert collected photographs and stories of Ukraine's Lenin statues, which they later published as a book, *Looking for Lenin*. They tried to track the statues through Google Images. "But it's often very tough because Lenin moves rather quickly for a dead guy," they told *Vice* magazine. "His monuments are moved, transformed, broken, stolen, sold . . . Some-

times we just arrived a few days too late." Lenin, they found, still provoked intense reactions. "Sometimes the people we meet start to talk, tell, complain, scream. The common trend is that each and every one has something to say about Lenin. You say the word 'Lenin,' and people have a reaction to express." One of their most striking images was an open car trunk with five decapitated Lenin heads jumbled up in it.[35]

On February 22, 2014, Yanukovych was removed from office, and the rate of the Leninfall slowed to one or two dozen a month. The new Ukrainian administration banned communist and Nazi propaganda, including statues, on April 9 that year. There had been an estimated 5,500 Lenins in Ukraine in 1991. By November 2015, only 1,300 still stood, and almost all of these were removed by the centenary of the October Revolution in 2017. Now, it is thought that only two Lenins remain in Ukraine: both of them too hot to handle inside the Chernobyl Exclusion Zone.[36]

What of that most striking Lenin statue of all, the "living sculpture" meticulously carved and embellished out of his physical body? In 1993, the guard outside Lenin's mausoleum was reduced, then abolished. Funding for the laboratory that preserves him every eighteen months was slashed. There were rumors he would be removed and buried. Communists set up a vigil around his tomb to protect him.

In 2012, the Russian president Vladimir Putin raised the question of whether the display of a dead body was a violation of Orthodox Christian precepts. In 2017, members of his United Russia Party were among those who introduced a bill to the Russian parliament calling for Lenin's burial. They were strongly opposed by the Communist Party, who described this as "a

provocation" and said it would lead to riots. The Russian news service TASS commissioned a poll, and found that 63 percent of Russians thought Lenin should be buried. These were split roughly half and half between those who thought he should be buried immediately, and those who thought the interment could wait until "the issue ceases to be sensitive for those who cherish Lenin." Only 31 percent wanted to leave things as they were.[37]

Yet, at the time of writing, getting on for a century after Lenin's death, his "living sculpture" remains in the marble mausoleum in Red Square. The real Lenin would surely have been horrified by all of this: by the idolization, the statues, the mausoleum, and by what he has come to symbolize. But the real Lenin fell long ago, swallowed up by his successors.

"The Desert of the Real"

Saddam Hussein

Location: Baghdad, Iraq
Put up: 2002
Pulled down: 2003

The abiding image of the Iraq War in 2003 was the toppling of a statue of the country's dictator, Saddam Hussein. It was an image relayed across the world as a symbol of victory for the American-led coalition and of liberation for the Iraqi people. But was that the truth? Putting up a statue, as we have seen, is an attempt to create a story about history. During the invasion of Iraq, the *pulling down* of a statue was also an attempt to create a story about history. The story of Saddam's statue takes us down a rabbit hole, showing both the possibilities and the limits of making a myth.

Fallen Idols

"Operation Iraqi Freedom," as it was called by those running it, began on March 20, 2003. It was led by the United States at the head of a "coalition of the willing," including troops from Australia, Poland, and the United Kingdom. President George W. Bush claimed that the aims of the operation were "clear, to disarm Iraq of weapons of mass destruction, to end Saddam Hussein's support for terrorism, and to free the Iraqi people." He continued: "The people of the United States and our friends and allies will not live at the mercy of an outlaw regime that threatens the peace with weapons of mass murder . . . It is a fight for the security of our nation and the peace of the world, and we will accept no outcome but victory."[1] This justification for war was hotly disputed at the time and has been ever since.

Despite resistance from Iraqi forces, invading troops moved quickly through the country. They arrived at Baghdad on April 7, two and a half weeks into the ground campaign. It was there that the statue of Saddam stood in Firdos (Paradise) Square, right in the center of the city. Two days later, it would come crashing down.

Saddam Hussein was born into a peasant family near Tikrit in the north of Iraq in 1937. Following an unhappy childhood, he joined the Ba'ath Party at the age of twenty. The party's ideology was pan-Arab nationalism, mixed with bits of socialism, secularism, and Islamic influences. Over the next two decades, Saddam rose through the party, seizing power in 1979. His ambition was great: to assert leadership of the Arab world and control the Persian Gulf. He invaded Iran's oilfields in 1980, leading to a long, expensive, and destructive war. He invaded Kuwait in

1990, earning the condemnation of the United Nations. In January 1991, there was a military response from an international coalition led by the United States, including Egypt, France, Saudi Arabia, and the United Kingdom. Saddam was forced out of Kuwait. Internationally, Iraq was humiliated: slapped with no-fly zones and ruinous sanctions, banned from developing nuclear, chemical, or biological weapons. Internally, it was stricken with rebellions. Saddam put these down brutally.

As president, Saddam modeled himself partially on Joseph Stalin. Both were peasant outsiders who, with exceptional ruthlessness, had made their way to the top. Saddam imitated Stalin's style of propaganda, promoting images of himself smiling and enriching the Iraqi people: a benevolent uncle.[2] He even grew a similar mustache.

Some Islamic traditions ban the representation of human figures, particularly religious figures in recent years, there has sometimes been a violent response to images of Mohammad. In terms of Iraqi history, though, Islam is a relatively recent arrival. Mesopotamia, as the region was once known, has ancient and glorious traditions of art, including statuary, stretching back thousands of years. Representations of figures are deeply embedded in Mesopotamian culture: there could be no ban on them. Under Saddam's rule, it was possible—even necessary—to make images of him. All schools, public buildings, and businesses had to display his portrait.

The historical references in Saddam's propaganda were rooted in the Middle East. Some of his equestrian statues depicted him with sword drawn, pointed in the direction of Jerusalem: his rearing horse was flanked by rockets. He was occasionally

sculpted wearing the Dome of the Rock on his head, the Islamic shrine refashioned as a helmet. His images used costume and props to link him to Hammurabi, the Babylonian lawgiver; Nebuchadnezzar, an enslaver of the Jewish people; various caliphs; Saladin, the defeater of Christian crusaders (who, like Saddam, had been born in Tikrit); and even Mohammad himself. The essence of all these historical figures was supposedly distilled down into Saddam, uniting the Iraqi people and Mesopotamian history, reaching out across the whole Middle East.[3]

From the beginning of his rule, Saddam put up monuments to great Iraqi victories. Sometimes, he was so keen that he put the monuments up *before* winning the victories. The most famous examples are the Victory Arches in Baghdad, formally called the Swords of Qādisiyyah. These were commissioned in 1986 to commemorate the Iran-Iraq war, two years before that war ended. The official name is an allusion to the seventh-century Battle of al Qādisiyyah, in which the Arabs resoundingly defeated the Persians. Unfortunately for Saddam, the Iran-Iraq war would end in a stalemate. The arches are formed of two crossed swords held in two burly forearms. Saddam worked closely with the sculptors: the forearms were modeled precisely on his own, and his own thumbprint appears on one of the hands. The swords, it was said, were cast from captured Iranian weapons.[4]

After the Gulf War in 1991, sanctions imposed by the international community banned all trade with Iraq except in humanitarian circumstances. Among many hardships, this made it difficult for artists and sculptors to access materials. One way to get paint, canvas, bronze, and stone was to paint pictures or

make sculptures of Saddam.[5] If the art was right, the regime would provide.

While the Iraqi people suffered under sanctions, Saddam built vast palaces filled with statues of and monuments to himself. The funds, allegedly, were raised by oil smuggling, and by the resale of humanitarian aid products that had been supplied by the United Nations. The US State Department began to suspect that these palaces were being used to house weapons of mass destruction. They were not: Saddam really was just treating himself.

In 1999, the State Department produced a report estimating that Saddam had built complexes on eight main sites, each of which comprised a village of palaces, buildings, and monuments. Since 1991, they estimated he had built forty-eight new palaces on these sites, in addition to the twenty he had owned before the Gulf War, at a cost of $2.2 billion ("We based it on regional construction costs," one official told NBC News, "and that doesn't include the furnishings").[6] It is unclear how many statues of himself Saddam put up in this period, though there were hundreds in Baghdad alone.

There was nothing special about the statue of Saddam that was put up in Firdos Square in April 2002 to mark his sixty-fifth birthday. In 1982, Saddam's government took down a statue called the Unknown Soldier on the square, and built two new hotels: the Palestine Hotel and the Sheraton Ishtar. Saddam replaced the Unknown Soldier with a trio of much grander new monuments: the aforementioned Victory Arches, a new Monument to the Unknown Soldier, and the Martyr's Monument.

Fallen Idols

These are centered around Great Celebrations Square, the most prominent square in Baghdad.

Firdos Square is a less important location, and for this reason the Saddam statue there was unexceptional: a bronze standing figure, 12 meters high, weighing around a ton. The fact that it was not a big deal may be one reason why, since its destruction, there has been confusion as to who made it. The Iraqi sculptor Khaled Izzat gave an interview about it to the *Guardian* in 2004. Interviews with the Indian sculptor Shraavan Prajapati credited him with the statue in the *Independent* in 2008, the *Indian Express* in 2009, and the *Times of India* in 2010. Izzat went into detail: he claimed to have made the statue based on a photograph, though Saddam, a fearsome critic, often came to his studio in person to comment on works he produced. He complained that he lost money on the Firdos Square statue because a worker botched the first casting. The *Indian Express* suggested that Prajapati made the Firdos Square statue, among several other bronzes of Saddam, after meeting him once in 1997.[7]

The fact that two entirely different people have been claimed as the creator of this statue, though, is characteristic of the story. The boundary between what is real and what is fake would soon disappear altogether.

The French philosopher Jean Baudrillard defined "hyperreality" as a state in which you cannot tell the difference between reality and a simulation, or "simulacrum," of reality. In 1991, at the time of the first Gulf War, he wrote three essays touching on this theme, later published together as *The Gulf War Did Not Take Place*. The assertion in the title seemed ridiculous to many,

and the style of the essays was dense and theoretical. Even so, Baudrillard's ideas turned out to be vital to understanding the internet age that would emerge over the following thirty years.

Despite his provocative title, Baudrillard did not, in fact, argue that the Gulf War did not take place. What he argued was that the relevant events in the first couple of months of 1991 were not really a war, in the sense that "war" was commonly understood: they were a *simulation* of a war.

There were two reasons for this. First, the events were carefully choreographed through the media: the coalition military controlled what images could be shown, and which journalists were allowed to report. The television-watching public in the West was shown nonstop video footage of firework-like bombings, and point-of-view shots of missiles heading to their targets. The effect was like that of playing a computer game: clean, surgical, without consequences. There *were* consequences, but the military chose not to promote images of destroyed homes or wounded civilians—so most of the audience never saw them. The coalition assault was fought largely through remotely controlled weapons, such as missiles, which created a real and emotional distance from the events—for their own forces, at least.

Second, Baudrillard argued, the outcome of the war was never really in doubt: it was "won in advance." The coalition was always going to win and Saddam, for all his posturing, was in no position to fight back. Baudrillard was critical of Saddam's conduct, especially using hostages as blackmail, which he described as "a degenerate form of war." This simulated war was fought on both sides by manipulation, not real combat. It was war "stripped of its passions, its phantasms, its finery, its veils,

its violence, its images: war stripped bare by its technicians even, and then reclothed by them with all the artifices of electronics, as though with a second skin."[8]

The hyperreality of the Gulf War that Baudrillard described caught the imaginations of writers, artists, and filmmakers. It looked ever more prescient as the internet began to connect the world. Excitement and anxieties about real versus virtual experiences grew. A hyperreal war was played out in the 1997 political comedy film *Wag the Dog* (loosely based on a 1993 novel), in which an American president creates a fictional war abroad to distract from a sex scandal at home. Hyperreality was the basis of the action sci-fi blockbuster *The Matrix* (1999). The character Morpheus is quoting Baudrillard when he says, "Welcome to the desert of the real."

In 2003, when American-led forces launched Operation Iraqi Freedom and invaded Iraq, the situation would be different. This war would be fought both in "the desert of the real" and in the real desert. A ground invasion was the focus. Resistance was put up by Iraqi forces, and territory was occupied by the coalition. In these respects, the 2003 war was closer to what Baudrillard would consider a real war than the 1991 war had been, though it too was effectively "won in advance."

Iraqi spokesman Mohammed Saeed al-Sahaf's lively press briefings claimed that Saddam was winning, but it was pretty easy to tell that his attempt to create a simulation of victory was not reality. "Baghdad is safe. The battle is still going on. Their infidels are committing suicide by the hundreds on the gates of Baghdad. Don't believe those liars," he told international camera crews on the roof of the Palestine Hotel. Behind him, viewers

could see Iraqi troops fleeing from American tanks on the other side of the river.[9] Al-Sahaf became something of a celebrity, nicknamed "Baghdad Bob" and "Comical Ali" (a play on "Chemical Ali," Saddam's intelligence chief).

Bringing down Saddam's statue was a greater feat of hyperreality. It would be presented to the world as a climax: the triumph of Operation Iraqi Freedom. The coalition was cast as liberators, allowing the Iraqi people to rise up at last and tear down the most powerful symbol of the dictator who had oppressed them. The reality was not so simple.

Since they had invaded Iraq on March 20, coalition forces had been pulling down dozens of statues of Saddam. For example, on March 29, British forces had blown up a cast-iron statue of him in Basra. "The purpose of that is psychological," said a military spokesperson, "to show the people . . . he does not wield influence, and we will strike at any representative token of that eroding influence."[10] No one filmed this event, so—while it was reported by the BBC and other news organizations—it made little impact outside Basra itself.

On April 7, the day that the Fall of Baghdad began, US soldiers seized the Republican Palace. Their commander ordered his troops to find a statue that could be destroyed, and to wait until Fox News arrived before they began to destroy it. Soon enough, they found an equestrian statue of Saddam. The television crew turned up, and the soldiers duly fired a shell. The footage was not exciting—just Americans destroying stuff, no drama, no crowd of grateful Iraqis—so it did not get much play.[11] That same day, US Marines and Iraqi civilians brought down another Saddam statue in Karbala. The next day, British troops

took out another one in Basra. There were so many statues of Saddam in Iraq that they were literally being felled on a daily basis.[12]

A number of international journalists who were covering the invasion moved into the Palestine Hotel on Firdos Square—the hotel where "Comical Ali" held his amusing press conferences. They had been relocated from the fancier Al Rasheed Hotel, closer to the city's political center, after much of that had been destroyed by bombing. Though the Palestine Hotel was known to be a media refuge, an American tank fired a shell at it on April 8, mistaking a camera on a balcony for an Iraqi spotting device. Two journalists were killed, three were injured, and the rest were outraged.

It was fortunate, then, that a story would come along to distract them from their anger at the Pentagon the next day, and that it would happen on Firdos Square—right outside their hotel. Fortunate, but not planned by the Pentagon. The story was simulated spontaneously by American soldiers on the ground. It was spun into a full-blown global event by the international news media.

On April 9, 2003, Lieutenant Colonel Bryan McCoy, in charge of the 3rd Battalion, 4th Marines, was told by a journalist at the Palestine Hotel that there were no Iraqi forces in Firdos Square. The *Time* reporter Simon Robinson said McCoy knew that journalists would be there, so "there were going to be opportunities."

Captain Bryan Lewis, the leader of McCoy's tank company, blocked the streets leading to the square. Gunnery Sergeant Leon Lambert, in an M-88 armored recovery vehicle, radioed

him with an idea: should they pull down Saddam's statue? Lewis replied: "No way."

McCoy went into the Palestine Hotel to meet reporters. Just after 5 p.m., Lambert radioed Lewis again, telling him that now local Iraqis themselves wanted to pull down the statue. There were a few of them in the square, and a lot of journalists.

Lambert's claim that some Iraqis wanted to pull down the statue is corroborated to some extent by Kadhim Sharif Hassan al-Jabouri, a local mechanic. Kadhim claimed that he had once fixed motorcycles for Saddam and his son Uday, but there had been a dispute over money. Uday had him thrown in prison. Over the time of Saddam's rule, Kadhim told the BBC, "More than fourteen or fifteen people in my own family were executed by Saddam." When he heard American forces were coming, he was happy. He says he took his sledgehammer and left his nearby garage to go to Firdos Square.

Lambert asked Lewis: "If a sledgehammer and rope fell off the 88, would you mind?"

"I wouldn't mind," Lewis replied. "But don't use the 88."

Lambert says he gave the Iraqis his sledgehammer, though Kadhim claims to have brought his own. It is unclear, then, whether the idea to attack the statue came from a relatively low-ranking American soldier, from an Iraqi civilian, or from both.

Kadhim began to hammer at the statue, but all he could really do was get a couple of plaques off the base. Lambert's rope was thrown around the statue's neck. There was little chance of this small crowd toppling such a large bronze. An hour went by. Saddam was not budging. "We watched them with the rope,

and I knew that was never going to happen," Lambert told the journalist Peter Maass, who wrote a detailed investigation of the felling of the statue in 2011. "They were never going to get it down."

At this point, the handful of Iraqis having a go at the statue seemed inclined to give up and go home. Just then, McCoy came out of the hotel. "I realized this was a big deal," he said. "You've got all the press out there and everybody is liquored up on the moment. You have this Paris, 1944, feel. I remember thinking, the media is watching the Iraqis trying to topple this icon of Saddam Hussein. Let's give them a hand." Furthermore, he feared, if journalists filmed Iraqis giving up on pulling the statue down, that might look bad. McCoy radioed a senior officer, who authorized him to involve troops directly in pulling the statue down. McCoy told his troops they could use the M-88 recovery vehicle after all, providing there were no fatalities.

In front of the cameras, the Americans got to work. Corporal Edward Chin climbed up the M-88's crane to Saddam's head with a chain and an American flag. As he was up there, he says, the wind blew it across Saddam's face. The footage was broadcast live on television. Some viewers, and some Iraqis in the square, felt it looked like the flag was deliberately being pulled across Saddam's face.

McCoy looked up to see the Stars and Stripes. This was the wrong image: one of American imperialism. It revealed that what was happening was not really an Iraqi victory. Both McCoy and the Pentagon frantically sent orders for the flag to be taken down. Chin could not hear the orders, but took it down of his own accord. It had been up there for about a minute and a half.

Soon afterward, a new image was created that better simulated an Iraqi victory. Chin held an Iraqi flag up over Saddam's face instead, and tucked it into his collar like a napkin. Whose flag was it? Marine Lieutenant Casey Kuhlman told Maass it was his, and he had passed it through the crowd. Psychological-operations leader Staff Sergeant Brian Plesich said he had asked his interpreter to find one, so thought it was being raised on his orders. Kadhim al-Jabouri claimed the flag was his. If an American did provide the Iraqi flag, this was another element of simulation.

Around 6:50 p.m., the M-88 drove away from the statue, dragging it face forward with the chain around its neck. Slowly, the bronze bent forward at the knee and ankle, Saddam's huge figure bobbing for a few seconds in a horizontal position as the modest crowd of Iraqis whistled and cheered. Finally, the statue snapped off its plinth, leaving its feet behind. Iraqis ran forward, jumped on it and danced. It was crushed to pieces.[13]

That morning, the photojournalist Patrick Baz had been in Saddam City (a neighborhood of Baghdad later renamed Sadr City). There, he had seen an Iraqi man who had pulled down a different Saddam statue. It was tied to the back of his car with a cable. Whenever the man saw a group of people, he would stop. They would all crowd around Saddam and start hitting him with their shoes. (Shoes are considered dirty in the Middle East: it is rude to show someone the bottoms of your shoes, and a terrible insult to hit them with one. In 2008, an Iraqi journalist would make international news when he threw a shoe at George W. Bush.)

"The image was all the more strong because there wasn't an America soldier in sight," Baz later wrote. "Just the locals ex-

pressing what they felt about their country's long-term dicta-tor."[14] Baz hurried back to his room at the Palestine Hotel to send his pictures to his editors, only to hear a commotion outside and witness the Firdos Square toppling. Just one of the Saddam top-plings made the front pages, and it was not the one that Iraqis had done for themselves. There was a real story here about pull-ing down a statue in Saddam City. The world's media preferred the simulation in Firdos Square.

The extent to which the Firdos Square toppling was an Amer-ican or an Iraqi initiative is debatable, though it is very un-likely it would have been achieved as it was without American involvement. Yet that question was not getting asked much on televisions around the world. Instead, the media decided that pulling down Saddam's statue represented something else. For them, it would be the end of the war.

It was, according to many pundits and politicians, Iraq's Ber-lin Wall. "You think about seminal moments in a nation's his-tory," said Bill Hemmer on CNN, "indelible moments like the fall of the Berlin Wall, and that's what we're seeing right now." According to the *New York Daily News*, "a scene reminiscent of the fall of the Berlin Wall began to unspool—and the Iraqis, like the East Germans before them, found some courage." US Secretary of Defense Donald Rumsfeld agreed: "Watching them [pulling down the statue], one cannot help but think of the fall of the Berlin Wall." In the *Mirror*, Anton Antonowicz wrote an impassioned piece: "For an oppressed people this final act in the fading daylight, the wrenching down of this ghastly symbol of the regime, is their Berlin Wall moment." Even two years later,

President George W. Bush would tell troops: "The toppling of Saddam Hussein's statue in Baghdad will be recorded, alongside the fall of the Berlin Wall, as one of the great moments in the history of liberty."[15]

It would not, though, because this was not a moment of liberty: it was a *simulation* of a moment of liberty. Caught in a hyperreality of his own creation, President Bush could no longer tell the difference.

Clearly, though, as two hours of nonstop coverage of Firdos Square was beamed around the world that night, the news networks desperately wanted it to have a meaning. Wolf Blitzer of CNN described the footage as "the image that sums up the day and, in many ways, the war itself." Over on Fox, the anchors agreed. "This transcends anything I've ever seen," said Brit Hume. His colleague agreed: "The important story of the day is this historic shot you are looking at, a noose around the neck of Saddam, put there by the people of Baghdad." It was an American rope, put there by American soldiers.

Journalists on the ground tried to report facts that undercut these grand claims. "There are so few people trying to pull down the statue that they can't do it themselves," said Anne Garrels of NPR. Journalists from the *San Francisco Chronicle*, *Newsweek*, and Channel 4 News, who were in Firdos Square and reported skeptically on the statue toppling, were told off by their editors in the US and UK for failing to see how important it was.[16] Between 11 a.m. and 8 p.m. on April 9, Fox News replayed the footage of Saddam's statue coming down every 4.4 minutes. CNN replayed it every 7.5 minutes.[17]

The coverage of Firdos Square—which heavily implied that

the statue had been pulled down by a large crowd of cheering Iraqis—suggested that the war was over. The hated dictator was symbolically ousted when his statue fell. In reality, it was not the end. The fighting was still going on. Armed engagements were underway in Baghdad and northern Iraq while the pageant was proceeding in Firdos Square.

Saddam would not be captured for another seven months. Stories abounded that he had body doubles: a German TV show concluded in 2002 that there were at least three of them. An Iraqi doctor claimed that the real Saddam had died in 1999 and had been played by doubles ever since. The Dutch researcher Florian Göttke wrote: "Saddam had already multiplied his body and extended his presence throughout the country through his statues, and by the same token, by living through the multiple living bodies of his doppelgängers he would become more than human, he would extend his presence into the realm of myth—he would even be able to survive his own assassination."[18]

Saddam's omnipotence was an illusion too. When the real Saddam was dragged out of the hole he had been hiding in, it was like the moment in *The Wizard of Oz* when the curtain is pulled back. Suddenly everyone can see that the Wizard is not some all-powerful demigod, but an ordinary little man who has made his own myth. The real Saddam—scruffy, hairy, and wizened—was a world away from the proud statues showing him astride rocket-powered horses.

At the time, though, the statue's fall was presented as a satisfying resolution. In the weeks after it came down, coverage of the Iraq War on Fox News and CNN decreased by an astonishing 70 percent.[19] As far as they were concerned, the story

was over. On May 1, 2003, President Bush stood on the deck of the USS *Abraham Lincoln*, nowhere near Iraq but safely off the coast of San Diego. He delivered a speech announcing that major operations in Iraq had ceased. It was, he said, in front of a giant Stars and Stripes banner repeating the message: "Mission accomplished."[20] (There was a historical echo here of Joe Rosenthal's iconic shot of United States Marines raising the American flag on Iwo Jima in February 1945. The photograph was widely assumed to signify that victory in the Pacific was imminent: in fact, the Battle of Iwo Jima would go on for another month, and three of the six marines in the picture would die in it. The war in the Pacific did not end until September 1945.)[21]

Baudrillard's argument that the 1991 Gulf War did not take place was not an exact fit for the 2003 invasion of Iraq. This time, a real war had taken place, and was still taking place during and after Bush's speech. But the *end* of that war, as signified by pulling down the statue of Saddam in Firdos Square, was a perfect Baudrillardian simulation. The media turned an impromptu performance by a few American soldiers into a highly convincing television series finale in which the Iraqi people defeated their dictator. It was repeated in broadcasts and newspapers across the world. It was not true.

For those troops fighting the war, and those civilians living through it, the war had only just begun. The coalition had no plan for how to end it: no coherent vision of the Iraq they wanted to emerge. Saddam would be tried and hanged at the end of 2006. American troops would remain in Baghdad until October 21, 2011, eight and a half years after the statue toppling. Thousands of dead coalition soldiers and hundreds of thousands of

dead Iraqis later, Iraq remained divided, damaged, and unstable when they left. In 2014, American soldiers would return to take on the threat posed by the Islamic State, which had emerged from the wreckage to make things even worse.

"Now, when I go past that statue, I feel pain and shame," said Kadhim al-Jabouri in 2016. "I ask myself, Why did I topple that statue?" He regretted the fall of Saddam's regime. What came after, in his opinion, was a disaster: "Saddam has gone, but in his place we now have one thousand Saddams." Kadhim even wanted the statue back. "I'd like to put it back up, to rebuild it," he said. "But I'm afraid I'd be killed."[22]

In the state of hyperreality, it is impossible to tell the difference between reality and a simulation of reality. The thing about reality, though, is that it continues to evolve. Sooner or later, the simulation begins to glitch, then ultimately falls apart.

Colossus

Cecil Rhodes

Location: Cape Town, South Africa
Put up: 1934
Pulled down: 2015

Thomas Carlyle put forward his Great Man theory of history in 1840. Cecil Rhodes was not born until 1853—yet he would embody the idea of a Great Man who made history through the force of his will. Rhodes was born a vicar's son in Hertfordshire. Over the course of a short, dramatic life, he went on to unimaginable wealth and power in southern Africa. He told Leander Starr Jameson, his longtime companion, that he expected to be remembered for "four thousand years."[1]

Rhodes was nicknamed "the Rhodes Colossus" by *Punch* magazine: a spin on one of the Seven Wonders of the ancient world,

the Colossus of Rhodes. The original Colossus was a bronze-and-iron statue of the god Helios by the harbor at Rhodes. It was built between 292 and 280 BC, but stood for only fifty-four years before collapsing in an earthquake. Rhodes's ambition to be remembered for four thousand years may not be going quite the way he would have hoped, but he might have been comforted to know that his statues mostly stood for longer than the Colossus. The one at the University of Cape Town lasted for eighty-one years—before being showered in human excrement and dragged away in disgrace.

This story is about how those who seek to become a symbol might be careful what they wish for.

The Rhodes statue at the University of Cape Town was commissioned to commemorate Rhodes's bequest of land to the university. Its unusual seated pose was suggested by the former viceroy of India, Lord Curzon, to solve "the difficulties of modern dress associated with the standing effigies of Rhodes."[2] To many people, statues in suits just looked weird. Eighteenth- and nineteenth-century dress, with cloaks, frock coats, and hats, had played to the form: these costumes added volume to the figure, making it appear grand. In the twentieth century, kings and potentates were often depicted wearing their flowing robes of office. Lenin was habitually sculpted in his billowing greatcoat. By contrast, a man in a suit could look small and comically ordinary. One alternative, common in the eighteenth and nineteenth centuries, was to depict contemporary figures in classical dress, like ancient statues. By the turn of the twentieth century, this had fallen out of fashion. If a man had lived to see telephones, automobiles, and the cinematograph, it seemed pretentious to

doll him up in a toga. Heroic nudity was, of course, right out. The suit had to work.

Rhodes himself had encountered this problem with the only statue he ever posed for, which showed him in a suit with his hands clasped behind his back. The sculptor, John Tweed, tried to make the fabric billow to add volume. The regrettable result was that Rhodes appeared to be wearing baggy clothes and facing down a high wind. Nevertheless, Rhodes liked the clay model when he first saw it, until one of his admirers—trying to be nice—described it as "almost plain." This was the kiss of death. Immediately, Rhodes decided he loathed the statue after all, writing to Tweed in 1899: "As to the Guy Fawkes of myself you are creating I simply say I shall do my best to prevent its being located in my country."[3] Still, he was dead by the time it was finished, so they put it up anyway in Bulawayo, Matabeleland, in 1904.

Curzon's solution for the University of Cape Town statue was a stroke of brilliance: seat Rhodes in a throne-like chair and the suit no longer diminishes him. The sculptor Marion Walgate posed him with a nod to Auguste Rodin's *The Thinker*: leaning forward, resting his chin on his right hand. Rhodes was no thinker, though: he was a doer. Appropriately, his statue did not look down in contemplation, but up and out, gazing hungrily over the landscape.

The statue was unveiled in 1934. It was positioned to interrupt the view from campus to the mountain range around Cape Town. It was impossible to photograph the campus and the mountains together without Rhodes in the center. In 1962, the statue was repositioned slightly to widen a driveway, but the ef-

fect was unchanged. It is not surprising that any student protest would focus on the statue—whether as a place to congregate, an icon of the university, or a symbol of one extremely controversial man.

To understand why Rhodes was so loved and so hated, we can take a look at his life story. His weak lungs kept him out of school in Britain, and he was sent as a youth to work on a cotton farm in the healthier climate of southern Africa. There was a diamond rush, and he moved to Kimberley to pursue it. During the 1870s and 1880s, Rhodes traveled back and forth between Kimberley and Oriel College, Oxford. He was seen in both places as an oddball.

Rhodes set out his imperial ambition in 1877, with his "Confession of Faith." Though he was only twenty-three, this document was no mere youthful fancy: Rhodes would spend the rest of his life pursuing its ideas. For that reason, as the historian Duncan Bell has said, "It is one of the most consequential utopian texts of the Victorian era."[4] The Confession is rooted in Rhodes's belief that the "Anglo-Saxon race" was superior. "I contend that we are the finest race in the world and that the more of the world we inhabit the better it is for the human race," he wrote. "Just fancy those parts that are at present inhabited by the most despicable specimens of human beings what an alteration there would be if they were brought under Anglo-Saxon influence." Rhodes wanted to form a "secret society" to promote the British Empire. A particular obsession of his was to "recover" the United States of America as a British colony. He contended that the United States had been spoiled by "low class Irish and German emi-

grants" and that Englishmen would have "made a finer country of it." The will he made the same year bequeathed his wealth to establish this secret society.[5]

Rhodes was not academically gifted and scraped by at Oxford, where it took him eight years to finish his degree. Yet he was incredibly good at making money. His investments in diamond and gold mines prospered as he bought up small companies and consolidated them into his own. By 1891, his De Beers mining company controlled 90 percent of the world's diamond production. He founded the British South Africa Company in 1889, securing for it a royal charter. Both of these enterprises aimed to expand north, into Bechuanaland (now Botswana) and Mashonaland and Matabeleland (both now in Zimbabwe).

Rhodes mostly had the support of the British government— though his tactics for bringing the territory of African chiefs under control were widely considered manipulative and legally dubious. Rhodes offered chiefs such as Lobengula of Matabeleland British "protection" in exchange for mining rights, which his company would exploit. Once agreements were concluded, though, he pushed for further colonization and control. This was reinforced by military action and what we would now call ethnic cleansing. Rhodes sent mercenaries to attack the Matabele and Mashona people, and took their land. He used dynamite from his mines to blow up caves in which Mashona women and children took refuge: one of Rhodes's men recorded the survivors emerging "all covered with blood and the dinamite [*sic*] had skinned them or burned the skin off their bodies."[6] As the *Manchester Guardian* later put it in a stinging obituary, Rhodes was "constantly concerned in financial schemes which implicated

him with all sorts of unscrupulous spirits, with the result that he became in many respects as unscrupulous as they."[7]

The British South Africa Company acquired control over a huge area of southern Africa. It renamed these lands after Cecil Rhodes. Southern Rhodesia (now Zimbabwe) lay south of the Zambezi river, and North-Eastern Rhodesia and North-Western Rhodesia north of it (united in 1911 as Northern Rhodesia, now Zambia). One of Rhodes's ambitions was to connect Cairo to Cape Town by a railway running through British territory all the way up the continent of Africa. The entire route was not then British territory. He planned to change that.

Rhodes served as prime minister of the Cape Colony from 1890 to 1896. During those years, he took steps to discriminate against the Black majority. The Franchise and Ballot Act (1892) limited the Black vote by raising financial and educational qualifications. The Glen Grey Act (1894) limited the number of Black Africans who could live on and own the land, and forced those who did not qualify to leave. This further shrunk the Black vote. The act initially covered one district, Glen Grey—but Rhodes, who drafted it, called it a "Bill for Africa" and hoped to see it used broadly as a model for colonization. This was explicitly a move toward segregation: "I hold that the natives should be apart from white men, and not mixed up with them," said Rhodes, recommending the act to the Cape Colony parliament. Some historians have seen it as a building block of what would later become apartheid.[8]

At the end of 1895, Rhodes went too far. He supported the Jameson Raid, an invasion of the Boer republic of the Transvaal. The raid aimed to provoke an uprising and overthrow the pres-

ident of the Transvaal, Paul Kruger. Rhodes did not have authorization from the British government for this invasion. It failed disastrously. Rhodes had to resign from the prime ministership and from the British South Africa Company—but he stood by the raid's leader, Leander Starr Jameson. Jameson returned to Britain, where he was imprisoned for his actions, but he too refused to implicate Rhodes. Rhodes and Jameson lived together. Some historians believe they were romantic partners.[9]

Though Rhodes continued to dabble in southern African politics after the Jameson Raid, his health failed. He died in 1902, aged just forty-eight. According to W. T. Stead, a journalist and friend of Rhodes, "He was attended constantly by his old and faithful friend, Dr. Jameson, whose name was the last articulate word which escaped from his lips."[10]

One of the greatest lies told about Cecil Rhodes—repeated again and again in books and the media—is that he was a Man of His Time. This phrase is worth digging into. It is usually used in his defense, against accusations that he was racist and imperialist. The implication is that the *times themselves* were racist and imperialist, and Rhodes could not have thought differently. Times, of course, do not have opinions, so this is nonsense.

What people who defend Rhodes as a Man of His Time mean is that he was a product of his society. Even that, though, is misleading. The same society that produced him produced many who disagreed with him. His fiercest critics included British contemporaries such as G. K. Chesterton and J. A. Hobson. The historian G. P. Gooch wrote in 1901 that Rhodes's "theory of civilisation is so crude and his ethical standard so low that he is utterly unfit to control the destinies of any country."[11] W. T. Stead

wrote after his death that "it must be admitted that the dread he inspired among those who disliked him was more widespread than the affection he commanded from those who came within the magic of his presence."[12]

The crucial thing about Rhodes is that he was *not* a Man of His Time, because he was in no way ordinary. This is one thing that Rhodes's admirers and his critics agree on. He was singularly driven and disruptive. He broke rules, social and cultural as well as political: he never married or had any intimacy with women, but cohabited with a series of men, including Jameson, to whom he was powerfully devoted.[13] Rhodes took charge of companies, armies, and whole countries. He changed the map and changed the world.

There are different interpretations of the exact nature of Rhodes's racism. Some historians have noted that he could behave decently to individual Black people—though the paternalistic "friend to the natives" spin, which appeared in many of his early biographies, has been debunked.[14] His opinions and actions shocked many contemporaries. The South African novelist and activist Olive Schreiner was impressed by him at first, but during the 1890s grew to dislike him more and more. "We fight Rhodes because he means so much of oppression, injustice, & moral degradation to South Africa," she wrote in 1897, "but if he passed away tomorrow there still remains the terrible fact that something in our society has formed the matrix which has fed, nourished, & built up such a man!"[15] If Rhodes *was* a product of his society, she argued, then that society must be rotten.

Despite Rhodes's fall from grace, there was an outpouring of public mourning after his death. His body was laid out in Cape

Town: 45,000 people filed past to pay their respects. He was buried in the Matoppos Hills (now the Matobo Hills, Zimbabwe), in a spot he had chosen with a spectacular view. Some Matabele people participated in his funeral, even though he and Jameson had conquered Matabeleland.[16] A couple of decades later, when Jameson died, he would be buried near Rhodes, in a matching grave on the same hilltop.

Rhodes's "Confession of Faith" shows he had always been conscious of his place in history. His desire to set up a "secret society" to extend British rule had not waned with age—he had still been pushing it to Stead in the 1890s.[17] He believed that Oxford University was the best vehicle for such influence. In his will, he gave £100,000 to his alma mater, Oriel College. He left millions more to Oxford University and set up a program of Rhodes Scholarships, to strengthen imperial feeling in future leaders around the world: "I consider that the education of young Colonists at one of the Universities in the United Kingdom is of great advantage to them for giving breadth to their views for their instruction in life and manners and for instilling into their minds the advantage to the Colonies as well as to the United Kingdom of the retention of the unity of the Empire."

He no longer explicitly stated that his goal was to return the United States to colony status, but instead wrote of "the advantages I implicitly believe will result from the union of the English-speaking peoples throughout the world." Rhodes scholars had to be unmarried young men: they were to demonstrate scholastic achievements, but should not be "merely bookworms." He stated they should have a "fondness of and success in manly outdoor sports" and the "qualities of manhood."

Notably, Rhodes's will stated: "No student shall be qualified or disqualified for election to a Scholarship on account of his race or religious opinions."[18] Much is made of this by his defenders today as evidence he was not racist—but the racial distinction Rhodes had in mind was probably that between white British and white Boers in southern Africa. It is unlikely that he imagined the scholarships ever benefiting people who were not white: he stated that they were for "young Colonists," with no mention of native peoples. No Black Rhodes scholar was elected from Africa until the 1960s.[19] The first Black Rhodes scholar was American: Alain LeRoy Locke of Harvard University in 1907. After him, the next Black Americans selected were Stan Sanders and John E. Wideman in 1963. A handful of Black or mixed-race scholars were accepted from other nations before the 1960s, such as Norman Manley (1914), who went on to be the first premier of Jamaica.[20] To say there was no race discrimination in the scheme as Rhodes set it up, though, is plainly untrue.

Throughout his adult life, Rhodes aimed to extend the reach of the "Anglo-Saxon race" and British power throughout the world. He had been astonishingly successful, at least until the catastrophe of the Jameson Raid. With his will, he meant to make himself a permanent symbol of these aims—creating Rhodes Scholarships, a Rhodes Trust, Rhodes House, the Rhodes Building, and so on, in addition to the large parts of Africa that were now called North-Eastern Rhodesia, North-Western Rhodesia, and Southern Rhodesia. According to his former private secretary, Gordon Le Sueur, Rhodes was "obsessed by the thought of living after death in the country named after him."[21]

Rhodes did not need to put up statues of himself. If you are rich enough to buy a legacy that big, other people will do it for you.

After Rhodes's will was made public, his charitable bequests were widely praised. A massive bronze equestrian statue went up in Kimberley in 1907. Another statue went up at Company's Garden in Cape Town in 1908. In 1912, the Rhodes Memorial Monument was installed on the slopes of Devil's Peak: a Grecian-style temple containing a bronze bust of Rhodes.

Oriel College, Oxford, completed its Rhodes Building in 1911. The facade was topped with a mousy little statue of Rhodes wearing a suit, recalling the "difficulties of modern dress" that had vexed Lord Curzon. Six lesser dignitaries stood below Rhodes's feet: King Edward VII, King George V, and four former heads of the college. Oriel was criticized for demolishing seven picturesque old houses on the site to make way for this grandiose lump of architecture. Some students and staff at the time commented on the undesirability of Rhodes as a symbol. Looking at the plans in 1906, one alumnus wrote that he "wished it were not Rhodes's statue that should appear above the gate into the High [Street]. I am not in love with the 'Imperial' spirit."[22]

Interest in Rhodes dropped during the First World War, but his myth was revived in the 1920s and 1930s as part of a concerted push to drum up enthusiasm for the British Empire. The then Prince of Wales was sent on a series of long publicity tours of the colonies. A much-trumpeted Empire Exhibition was staged in London from 1924 to 1925. The British Empire Film In-

stitute was established in 1926 to counter criticism of the empire by rewarding positive depictions. Rhodes received his first biopic in 1936: *Rhodes of Africa*, starring Walter Huston. It began with a voice-over: "In 1870, South Africa was a largely unexplored territory of a million square miles, peopled by a handful of white men." Schoolchildren were given new textbooks that valorized Rhodes alongside other imperial heroes such as Robert Baden-Powell, Henry Morton Stanley, and T. E. Lawrence. And, of course, yet more statues of Rhodes went up, including one in Salisbury (now Harare) in 1928, and at Mafeking (now Mahikeng) in 1932.

The reason for this propaganda was that serious cracks were appearing in the empire following the First World War and atrocities such as the Amritsar Massacre of 1919. Mohandas K. Gandhi's noncooperation campaigns in India strengthened opposition to British rule. Meanwhile, in Britain itself, we might wonder whether the fact that this effort was thought necessary indicates that there was not much natural enthusiasm for the empire. British filmmakers largely ignored the British Empire Film Institute, preferring to cater to an American audience that was twice the size of the imperial market. The Empire Exhibition lost £600,000 on its first season in 1924, and announced a second season in 1925 to attempt to recoup its losses—only to see attendance halve and those losses increase.[23] Touring the empire made the Prince of Wales grumpy ("I haven't landed yet sweetheart but it looks a proper bum island this Barbados," he wrote to a married woman with whom he was having an affair).[24]

The first critical biography of Rhodes was published in 1933 by William Plomer. This provoked panic among Rhodes devotees, and seven laudatory biographies were published over the

following three years. As Britta Timm Knudsen and Casper Andersen of Aarhus University have pointed out, "during this period, Rhodes' supporters used their substantial political, financial and cultural power to produce perhaps the biggest wave of paraphernalia, publications, and monuments to promote and protect Rhodes' legacy and the values he symbolized." When the statue of Rhodes went up at the University of Cape Town in 1934, they note, "it was part of an already very self-conscious form of memory politics."[25]

Rhodes had wanted to represent a future of "Anglo-Saxon" racial and imperial unity. He achieved that. The problem for him was that the real future would turn out quite differently.

The Union of South Africa was formed in 1910, and—along with other British dominions—became fully independent in 1931. Its notorious system of apartheid (in Afrikaans, literally "apartness": segregation) was brought in following the National Party's election victory in 1948. Under the Population Registration Act of 1950, South Africans were divided into groups: White, Black, Coloured, and Indian. Everything depended on your group: where you could travel or live, who you could marry or have sex with, which school you and your children could attend, what job you could do, what recreations you were permitted, whether you could vote, and so on. These rules were enforced with violence. They were resisted with strikes, boycotts, civil disobedience, and sabotage.

Cecil Rhodes was not responsible for apartheid: it was introduced more than four decades after his death. Yet he was a white supremacist, and a key figure in the movement toward white mi-

nority rule. Under apartheid, Black students were barred from the University of Cape Town. In 1979, the Rhodes statue there was painted pink by (white) student protesters, "because he is representative of what U.C.T. has done and is still doing, namely facilitating the exploitation of the majority of South Africans."[26]

This attack on Rhodes was unusual in South Africa at the time. Statues were not a high priority when people were being forcibly removed from their homes; activists were being imprisoned, tortured, and murdered; and police were shooting schoolchildren. Moreover, Rhodes was not really a hero to the apartheid regime. That regime was primarily Afrikaner—descendants of the Boers, whom Rhodes had fought. He may have been a symbol of white supremacy, but he was not *their* symbol.

In neighboring Southern Rhodesia, where the dominant white minority was of British origin and Rhodes's name was that of the country, his memory was much more controversial. In 1961, a young activist called Robert Mugabe threatened to dig up Rhodes's grave and send his body back to Britain. A white minority regime in Southern Rhodesia unilaterally declared independence from Britain in 1965, renaming itself Rhodesia— though the rest of the world refused to recognize it. After years of civil war, British rule was briefly reimposed in 1979. Southern Rhodesia became independent under Black majority rule, as Zimbabwe, in 1980, with Mugabe as its first prime minister. Rhodes's statues were removed—including that one in the baggy suit in Bulawayo. The bringing down of that particular statue might have pleased Rhodes himself.

In the late 1990s, another young Zimbabwean activist, Lawrence Chakaredza, took up the campaign against Rhodes, telling

the British people: "Rhodes' remains will be fed to the crocodiles of the Zambezi river if somebody does not collect them."[27] Rhodes had by then been dead for nearly a century: the crocodiles might have turned up their snouts at him. Yet he was still a powerful symbol in the country that had until recently borne his name. "Rhodesia became in itself an identity that was tied to white supremacy, but particularly to white settler colonial capitalism," explains Simukai Chigudu, who grew up in Zimbabwe during those years. "Rhodes belonged to that tradition and embodied it."[28] In the 1980s and 1990s, Zimbabwean slang referred to racist white people as "Rhodies." Yet some local Ndebele people (formerly known as the Matabele) opposed the grave's removal on the grounds that it brought tourism to the region. "Rhodes had ceased to be venerated," the historian Paul Maylam observed, "but he was still of some commercial value."[29] For now, Rhodes is still in his grave, with Jameson at his side.

In South Africa, apartheid finally fell in the early 1990s. The activist Nelson Mandela, imprisoned since 1964, was freed in 1990. The Population Registration Act was repealed in 1991. South Africa had its first post-apartheid elections in 1994. Mandela became its first Black president. Statues of apartheid figures were pulled down: many officially, though there were instances of ad hoc removal. One Friday afternoon in 1994, a statue of the former prime minister Hendrik Verwoerd was hauled down by Black protesters, who danced on its chest.[30]

In 2002, three years into his retirement, Mandela announced the creation of a new organization with a startling name: the Mandela Rhodes Foundation. The Rhodes Trust, set up by Rhodes in his will, had itself gone on something of a journey

since his death. It no longer aimed to promote British imperial ideals, because the British Empire no longer existed. In fact, it had shifted to an inclusive vision of the future that would have horrified Rhodes, embracing diverse scholars from all over the world, and even women.

"Forming the partnership [with Mandela] was a considered act of reconciliation and, specifically, reparation," declared the Rhodes Trust, "a way to return some of Cecil John Rhodes' wealth to its origins in Africa." Linking the names of Mandela and Rhodes would shock some, but that was the point: "The eternally provocative name of The Mandela Rhodes Foundation is a call for the beneficiaries of colonialism to participate in and contribute to repairing the damage of colonial times and building a more just society."[31]

Mandela described Rhodes as an "imperialist so-called 'robber baron'" who had enriched himself "at the expense and exclusion of others." He noted: "We represent radically different eras in the history and development of our country—epochs and approaches in fundamental historical opposition and contradiction to each other." Yet he praised the work of the Rhodes Trust, and emphasized his hope that the new partnership would help develop South Africa.[32]

The Mandela Rhodes Foundation clearly did not intend to rehabilitate Rhodes's reputation. If there was anyone who hoped Rhodes might now fade quietly into history, though, they would be disappointed. A little over a decade later, when a post-apartheid generation at the University of Cape Town began to examine its past, criticism of him would explode.

※ ※ ※

There had been calls to remove the Rhodes statue from the University of Cape Town in 2005, but the issue did not gain traction until a decade later. In May 2014, staff and students debated whether the statue should be pulled down. The following year, a concerted campaign began, under the name Rhodes Must Fall. "When I looked at it," said Ramabani Mahapa, one of the leaders of the campaign, "I felt a sense of displacement. The statue was telling me that I didn't belong there."[33]

On March 9, 2015, a group of protesters gathered around the Rhodes statue, calling not only for its removal but for a broader change in social attitudes at the university. "When we say 'Rhodes Must Fall,'" said student Kealeboga Ramaru, "we mean that patriarchy must fall, that white supremacy must fall, that all systematic oppression based on any power relations of difference must be destroyed at all costs."[34] What caught the attention of the media, though, was another student, Chumani Maxwele, who walked up to Rhodes's statue and hurled a bucket of human excrement over it. This was reported everywhere as the "poo flinging." An unmissable detail was that Maxwele had brought the poo specially from a portable lavatory in a poor township outside Cape Town, representing the inequalities left behind by colonialism and apartheid.[35]

Rhodes's statue, protesters said, was "a constant reminder for many black students of the position in society that black people have occupied due to hundreds of years of apartheid, racism, oppression and colonialism."[36]

Fallen Idols

On March 20, students stormed a building at the university, interrupting a speech by the vice-chancellor. They stayed there for days, singing, drumming, dancing, and staging art demonstrations. At the university library, they protested against a nude sculpture of Sara Baartman, the Khoikhoi woman who had been exhibited in European freak shows as the "Hottentot Venus" in the early nineteenth century.

This sculpture was not a conventional statue: it was made from welded steel objects by the distinguished Black South African artist Willie Bester. Nonetheless, it provoked a range of reactions. "We reject that her standing naked commemorates her and retains her dignity," declared one protester, Leigh-Ann Naidoo. "Further, we see no difference in the racist, sexist methods used by the French and British in the freak show attraction, than her presentation in the UCT Oppenheimer library."[37] They clothed the sculpture of Baartman in a traditional headwrap and kanga.[38] Thus Rhodes Must Fall demonstrated the breadth of its ambition: not only to fell Rhodes but to "decolonize" hearts and minds. The students aimed to reshape the university's whole culture, freeing it from the baggage and even the patriarchal gaze of its colonial past.

The university moved fast. On March 27, 2015, a week into the occupation, its senate voted to remove the statue of Rhodes. There was no significant resistance. The statue was boarded up, and was taken away by the university authorities on April 9, 2015. The whole process, from poo flinging to removal, had taken just a month. A poster put up that day read: "Next, the invisible statues."[39]

The striking success of Rhodes Must Fall inspired students at Oxford University, who had already been working on their own campaign for racial justice. That mousy little statue of Rhodes still stood on Oriel College's facade, now behind a veil of netting to discourage the pigeons. On November 6, 2015, 250 students gathered outside that facade to present the college authorities with a petition of 1,900 signatures asking for the statue's removal. The movement in Oxford was begun in support of Rhodes Must Fall, and had similarly wide-ranging aspirations. There was debate in Oxford about whether using the name Rhodes Must Fall Oxford was too limiting, and would focus attention on the statue rather than broader questions about the culture of the university. Simukai Chigudu, then a student at Oxford and part of the campaign, was among those who had these reservations: "But because Rhodes fell in South Africa, there was all this energy. So the conclusion was let's use the moniker of Rhodes Must Fall in honour of and in solidarity with the people in South Africa. It's a powerful framing device."[40]

A South African Rhodes scholar, Ntokozo Qwabe, read out the petition. "The University of Oxford continues to colonise the minds of future leaders through its visual iconography, the concepts and histories on its curricula, the gross underrepresentation of people of colour and other marginalised groups in its staff and student community, the exclusionary networks of power, the cultural capital," it declared. "This will never be able to change if statues of racist and murderous men maintain their position and visibility as part of Oxford."[41]

There was an angry backlash in the right-wing press. Attacks were made on Qwabe personally for complaining about Rhodes's legacy, when he himself had benefited from it as a Rhodes scholar. "I'm no beneficiary of Rhodes," Qwabe responded. "I'm a beneficiary of the resources and labour of my people which Rhodes pillaged and slaved."[42]

The usual arguments about historical erasure were made. Rupert Fitzsimmons, a history teacher at St. Paul's School, argued in *History Today* that removing the statue of Rhodes at Oxford would "amount to a censorship of history."[43] The Cambridge classicist and television presenter Mary Beard described it as a "dangerous attempt to erase the past." Instead of removing the statue, she suggested that Black students at Oxford should look upon it "with a cheery and self-confident sense of unbatterability."[44]

Simukai Chigudu said, "People would say, 'You're shutting down debate,' and we would say, 'No, actually, we're opening up debate. We're the ones who are saying that we need to debate Rhodes' legacy.'"[45]

Oriel College itself issued a statement on December 17, acknowledging that the Rhodes statue could be seen as a celebration of colonialism and the oppression of Black communities. It pointed out that removing or altering the building, even adding a plaque, would require planning consent, because the facade was listed by Historic England—"in part precisely because of the controversy which surrounds Rhodes." It promised a six-month "listening exercise" beginning in February 2016, which would survey students, staff, alumni, heritage bodies, the council, and local residents.[46]

This appeared to be an eminently reasonable response. Yet before that listening exercise could start, at the end of January 2016, Oriel abruptly canceled it. The statue would stay. Documents leaked to the *Telegraph* indicated that the reason for this reversal was that unnamed donors had threatened to withdraw bequests from the college amounting to more than £100 million.[47] Rhodes Must Fall Oxford activists were shocked and disappointed that there would now be no debate, but much of the right-wing press approved of this decision—as did the general public. A 2016 survey for the pollsters YouGov suggested that 59 percent of British people did not want the statue to be removed, and 44 percent thought that "we should be proud of British colonialism."[48]

Before they asked their respondents about his statue, the pollsters primed them with three paragraphs of information on who Cecil Rhodes was: "an important British colonialist, politician and businessman." They were told that he founded De Beers diamonds and the Rhodes Scholarships. They were also told: "Some people think that Rhodes is symbolic of the racism and unfairness of British colonialism," though they were not told why. The reason respondents had to be told all these things before they could be asked about Rhodes's statue is that, in Britain, he has more or less dropped out of public historical memory. He has not been on the school history curriculum for many years. Since the turn of the twenty-first century, there have been no new popular biographies of him by British authors. There has been no film or TV biopic about him since the BBC miniseries *Rhodes*, starring Martin Shaw, in 1996. Had it not been for Rhodes Must Fall Oxford in 2016, it is unlikely that anyone

in Britain (aside from a handful of academics) would have been talking about him at all.

In South Africa, Rhodes Must Fall had won mainstream support. Rhodes Must Fall Oxford did not. Anuradha Henriques, an editor of *Skin Deep* magazine, argued that this illustrated the need for a debate was greater in Oxford: "You have an indigenous majority in South Africa, you have people who already know something is a problem and that action is needed. In 2015 South Africa it's a no-brainer that that statue's got to go. In Oxford, you still have to talk about what racism is!"[49]

Moreover, as the YouGov poll had indicated, in Britain this had become a question that was only tangentially about Rhodes himself. It was a test of patriotic pride in British history. Yet the matter would not remain closed for long.

In 2020, following Black Lives Matter protests in the United States, statues were suddenly pulled down from Britain to New Zealand. In Oxford, attention once again turned to Rhodes's statue. There were two large, peaceful protests outside Oriel College in June 2020 calling for its removal. Many university staff and senior academics now openly supported the students. Some of the students involved in the original campaign were by this time academics themselves—such as Simukai Chigudu, now an associate professor of African politics at St. Antony's College. "The ultimate point was never to weigh the soul of Rhodes, and find out whether he was 'really' a racist," he wrote. "It was to try to uproot the racism in the soul of the institutions built in his image."[50]

This time, they appeared to be getting closer. About a week

after the protests, to the shock of many, Oriel's governing body voted in favor of removing the statue. It established an independent commission of inquiry to determine how this could be done.

"I think many of us had resigned ourselves to the idea that it was a lost cause," said Sizwe Mpofu-Walsh, who had been part of the 2015 campaign. "So now to see this renewed wave, which is gaining far more momentum, far more sympathy and being treated with far more nuance than our original cause, it's quite frankly miraculous."[51]

The reaction from Britain's political leadership, though, echoed 2015. "We cannot rewrite our history," said the Universities Minister, Michelle Donelan.[52] Oxford's vice-chancellor, Louise Richardson, took a similar view, telling the *Daily Telegraph* that taking the statue down would be "a refusal to acknowledge our past." She attempted to use Nelson Mandela's 2003 remarks on Rhodes as an argument for keeping the statue, saying that Mandela "was a man of deep nuance who recognised complex problems for what they were. I don't think he sought simplistic solutions. Hiding our history is not the route to enlightenment."[53] Fourteen Oxford professors wrote to the newspaper to deplore her "inappropriate ventriloquising" of Mandela.[54] The Mandela Rhodes Foundation issued a critical statement: "To use the partnership to justify the continued display of colonial symbols is to fundamentally misunderstand it."[55]

"I would take it down," said Valerie Amos, the incoming master of University College, and the first Black person to become head of an Oxford college in the institution's 900-plus year history. "He founded a company that made money through slave

labour in the mines, and you're telling me that we have to put up a statue of this person, glorify their memory, to have a conversation about our history?"[56]

We do not, but it seems that in order to provoke that conversation some people must threaten to take one down. In May 2021, Oriel College's independent commission recommended that the statue be removed. Yet the college swiftly announced it would not do this, and would look instead at "options for contextualisation."

The story of Cecil Rhodes's statues shows us that even one of the richest men in history could not control how he was remembered. He may, in the end, have achieved a sort of immortality. It just might not be the sort he wanted.

Dedicated to a Lost Cause

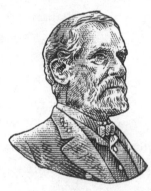

Robert E. Lee

Location: New Orleans, Louisiana, USA
Put up: 1884
Pulled down: 2017

Even when he was alive, Robert E. Lee had a monumental look to him. As a cadet at West Point, he had been nicknamed "Marble Man" for his unflappable composure. This was apt: he went on to become the most memorialized of all Confederate figures, with hundreds of statues dedicated to him. Most were raised decades after his death. It is often said that history is written by the victors. This is a story of how it was rewritten by the losers.

On February 22, 1884, a gathering of thousands was planned in Tivoli Circle, New Orleans. Almost two decades after the Confederacy had been defeated, some of its remaining sympa-

thizers were dedicating one of the first statues of its most celebrated general, Robert E. Lee. Guests included Jefferson Davis, the former president of the former Confederacy.

As the crowd filled the seats, the sky darkened. Just as the ceremony was about to begin, a storm burst forth, with sheeting, torrential rain. One disappointed observer reported that the artillery salute could not compete with "Heaven's artillery," with interesting implications for which side he thought Heaven might be on. The crowd fled. The ceremony was abandoned.[1]

A few hours later, the Robert E. Lee Memorial Association met at the Washington Artillery Hall to try to salvage the day. Justice Charles E. Fenner, the association president, had written a florid and amazingly long oration to deliver in front of Lee's statue. Had the rain not deterred the crowds, they would have been treated to around two hours of Judge Fenner's speech. Fenner began by tracing General Lee's heritage all the way back to the Middle Ages: Launcelot Lee, who "landed with the conqueror"; Lionel Lee, who "fought with Coeur de Lion"; Richard Lee, "a cavalier of Charles the First"; and so on.

Fenner took a common charge head-on. "What do we do here today; erecting a monument to a deserter or a traitor?" Far from it, he argued: "Lee loved the Union." Fenner recounted a one-sided military history of the Civil War, exalting the Confederacy, harking back to more of the chivalry that had apparently descended to Lee from a fantasy Arthurian version of medieval England. At last, he concluded that Lee's failure was really success—noting that Hannibal and Napoleon had also ended their careers in defeat. Lee, he claimed, was "the highest type of

gentleman . . . It is fitting that monuments should be erected to such a man."

The mayor of New Orleans responded with yet more gushing praise, though he concluded—rhetorically—that Lee required no statue: "his deeds are his monument, and they will survive and continue in remembrance long after this marble shall have crumbled into dust."[2]

Unwittingly, the mayor had hit upon the point. If Lee's virtues were so universally accepted, if the cause of the Confederacy was so noble, what was the need for all this justification?

The fact was that neither the Confederacy's cause nor Lee's virtues were universally accepted: not in 1861, not in 1865, not in 1884, not in the 1950s, the 1970s, the 1990s, and clearly not in 2017, when Lee's statue in New Orleans would be taken down in front of a crowd cheering its removal. The real story of why Lee's statue went up, why so many other Confederate statues would go up afterward, how it became a flashpoint for groups that included the Ku Klux Klan and Black Lives Matter, and finally why it came down, is all about an issue that runs through the whole of American history—though for some reason Judge Fenner found no opportunity to mention it in his two-hour speech. The story is, of course, about race.

In 1861, eleven Southern states seceded from the United States and formed the Confederate States of America, or the Confederacy. The secession was prompted by the electoral success of Abraham Lincoln as president and of his Republican Party, which was opposed to slavery. (Readers outside the United

Fallen Idols

States who are used to the 2020s configuration of American politics may be surprised to learn that, in the 1860s, the Radical Republicans were in effect liberal and progressive, while the Southern Democrats supported white supremacy.)

Though there has been a lot of mythmaking about the causes of the Civil War, there was no doubt at the time what the divisive issue between Union and Confederacy really was. "For the last ten years we have had numerous and serious causes of complaint against our non-slave-holding confederate States with reference to the subject of African slavery," declared Georgia.

"Our position is thoroughly identified with the institution of slavery—the greatest material interest of the world," declared Mississippi.

Describing itself bizarrely in the third person feminine, Texas declared of its accession to the Confederacy: "She was received as a commonwealth holding, maintaining and protecting the institution known as negro slavery—the servitude of the African to the white race within her limits—a relation that had existed from the first settlement of her wilderness by the white race, and which her people intended should exist in all future time."[3]

The vice president of the Confederacy, Alexander H. Stephens, laid it out with perfect clarity in his speech of March 21, 1861 at Savannah, Georgia. "The new constitution has put at rest, forever, all the agitating questions relating to our peculiar institution—African slavery as it exists amongst us—the proper status of the negro in our form of civilization. This was the immediate cause of the late rupture and present revolution." Stephens went on to describe the new Confederate government: "its foundations are laid, its cornerstone rests, upon the great

truth that the negro is not equal to the white man; that slavery—subordination to the superior race—is his natural and normal condition. This, our new government, is the first, in the history of the world, based upon this great physical, philosophical, and moral truth."[4]

Robert E. Lee, the commander of the army of Northern Virginia and later the general in chief of the Confederate forces, would become the icon of the Southern cause. He was handsome and charismatic; his military skills were acclaimed even by his opponents. Lee presented himself as an "Olympian," above mere politics, devoted to honor. Stories came out at the time that revealed a much crueler streak. One of his slaves, Wesley Norris, recalled Lee's brutal torture of him after he escaped and was recaptured. Lee ordered that the runaways each be given fifty lashes. The overseer refused to carry this out, so a constable, Dick Williams, was called in. "Gen. Lee, in the meantime, stood by, and frequently enjoined Williams to 'lay it on well,' an injunction which he did not fail to heed," remembered Norris; "not satisfied with simply lacerating our naked flesh, Gen. Lee then ordered the overseer to thoroughly wash our backs with brine, which was done."[5] There was not much sympathy for runaway slaves like Norris in the South, so testimonies like his had little effect. Some later biographers simply dismissed them.

To many Confederates, Lee became their ultimate hero. Though Confederate soldiers and supporters were drawn from across the social spectrum, Lee's aristocratic image, steeped in Arthurian chivalry, was how the Confederacy saw itself. This heavily romanticized view would be summed up decades later in the 1939 film adaptation of *Gone With the Wind*: "There was a

land of Cavaliers and Cotton Fields called the Old South. Here in this pretty world, Gallantry took its last bow. Here was the last ever to be seen of Knights and their Ladies Fair, of Master and Slave."

On April 9, 1865, after four years of fighting, Lee surrendered to the Union general Ulysses S. Grant at Appomattox, Virginia. After the final cease-fire on November 6 of that year, the Southern states returned to the Union. Slavery was abolished by the Thirteenth Amendment to the Constitution.

The Confederacy was defeated on the battlefield. Slavery was defeated in the legislature. But this society, which was, in its own words, "thoroughly identified" with slavery, had been built on a foundation of white supremacy and the suppression of Black people's rights. That foundation had not been destroyed. Its values would resurge with startling force over the next century and beyond.

After the war, Robert E. Lee and Jefferson Davis were both indicted for treason. Neither case ever came to trial. The victorious General Grant intervened to save Lee. Davis was imprisoned for two years, then released. On Christmas Day 1868, President Andrew Johnson issued a blanket pardon and amnesty to all who had participated on the Confederate side.

Many at the time thought that years of treason trials and recriminations would only deepen division. In retrospect, though, the amnesty was a disaster. Had the traitors faced justice, had they been made to accept the consequences of their actions, that might have ended the matter. Instead, they were forgiven—though they were plainly not in the least bit

sorry. As free men, Lee and Davis continued to promote the cause of white rule. Davis was outspoken about it; Lee more subtle. Yet his view remained that white rule was appropriate for the South, and that Black people were lazy and irresponsible, intellectually incapable of voting or participating in politics.[6] Taking an ostensibly conciliatory line with the North, he told Davis, was a sure route to restoring white rule: "I have thought, from the time of the cessation of hostilities, that silence and patience on the part of the South was the true course."[7]

The South was not silent or patient, though. Shortly after the end of the Civil War in 1865, Confederate veterans formed the Ku Klux Klan in Tennessee, aiming to restore white supremacy by vigilantism. It is part of Klan legend that Lee himself suggested the nickname "Invisible Empire" for their group, and that he only refused to be their first Grand Wizard owing to the conditions of his surrender. There is no evidence Lee was involved with the Klan, but plenty of evidence that they idolized him.[8]

Reconstruction offered an array of government initiatives to improve political, economic, and social opportunities for African Americans across the United States.[9] Some white conservatives found this impossible to accept, because they believed passionately that Black people were inferior to them. In New Orleans, after the end of the Civil War, Black men served as jurors and police officers. Black men and women demanded integration in schools, theaters, restaurants, and saloons. This horrified white conservatives. Some turned to terror and murder.

In New Orleans, on July 30, 1866, a white supremacist mob—aided by police and firemen—massacred around forty Black men and three whites at a convention on universal suffrage.[10] The

assassinations, political violence, and guerrilla warfare of this period went beyond criminal activity and could be described as an armed insurgency: some historians say a "Second Civil War."[11] Around 1,000 people were killed in Louisiana between November 1867 and November 1868 in paramilitary attacks. Many more were harassed, beaten, or whipped.[12]

Alongside the violence came the propaganda—and it was focused on historical memory. In 1866, Edward A. Pollard published *The Lost Cause: A New Southern History of the War of the Confederates*. It was one of several books to present the "Lost Cause" myth: that secession had not really been about defending slavery, even though seceding states and leaders had said loudly and often at the time that that was exactly what it was about. Instead, the Lost Cause myth found ways to blend slavery into the background, arguing that secession had been a justifiable response by Southern states to an oppressive federal government: that what it was really about was states' rights to make their own laws. This story held that the South, represented by Lee, was a place of gallantry and honor; Confederates were in the right, but had been defeated by the better-equipped Union. Slavery, the myth suggested, was merely incidental, and barely worth making a fuss about.

Lee died on October 12, 1870. There was competitive grieving among white conservatives. Shops, banks, and theaters closed; homes, businesses, and churches draped their premises in mourning cloth. "What's the use in all this nonsense?" asked the Republican mayor of New Orleans, who refused to close city hall to honor a man he believed to be a traitor. For Southern Democrats and Confederate sympathizers, the use

was that mourning rallied their community around Lee and the Lost Cause.[13] A Robert E. Lee Memorial Association of New Orleans was formed, hoping to build him a permanent memorial—perhaps a statue—in the city.

Some white Southerners, including Confederate veterans, distanced themselves from white supremacy after the war. Lee's former comrade James Longstreet, an ex-Confederate general who settled in New Orleans, accepted Reconstruction and joined the New Orleans Metropolitan Police Force. The Lost Cause movement loathed him, and tried to discredit his war record. In 1874, he would get caught up in perhaps the most dramatic outbreak of white supremacist violence in New Orleans: the Battle of Liberty Place.

The battle was an armed insurrection against the Republican state government of Louisiana, led by members of the Crescent City White League. The White League was a paramilitary group that had been formed by well-to-do young gentlemen in response to scare stories about Black men assaulting white women. They had already turned to terrorism: in August 1874, they murdered six white Republicans and up to twenty Black witnesses in what became known as the Coushatta Massacre. Two weeks later, they attempted a coup in New Orleans itself.

The 1872 election in New Orleans returned a Republican governor, William Pitt Kellogg, but the result had been disputed. Now, the White League planned to overthrow Kellogg and install their preferred Democratic candidate. On September 14, the White League, commanded by former Confederate General Frederick Ogden, faced down the New Orleans militia and police, commanded by former Confederate General James Long-

street. There was a twenty-minute battle, but the 8,400 men of the White League easily overwhelmed 3,600 militia and police. Thirty-two lay dead, with seventy-nine wounded.

Longstreet fought valiantly, but was pulled from his horse and wounded by a spent bullet. Kellogg managed to telegraph a message to President Ulysses S. Grant, who sent warships and federal troops. The White League backed down. The white conservative regime had lasted only a few days.[14]

Though the coup failed, the Battle of Liberty Place was exalted by white supremacists as a symbolic victory against "Northern tyranny." Its anniversary became a day of celebration, with a mass in St. Louis Cathedral, ceremonies at the graves of the White League dead, and a parade to toe-tapping hits such as the "Ku Klux Klan Polka" and the "White League Waltz."[15]

In the middle of this insurrection, Charles Fenner took over the Robert E. Lee Memorial Association of New Orleans. Fenner had one goal in mind: to put up a statue of Lee in the city.

Fenner was a lawyer and Confederate veteran, who had led an artillery unit of elite white families during the Civil War.[16] He was close friends with Jefferson Davis. When Davis fell ill during a visit to New Orleans, he stayed at Fenner's mansion: he did not recover, and died there. Fenner's home became a shrine for Confederate sympathizers.

Fenner dismissed accounts of "intolerance" toward Black people and Republicans as "grossly exaggerated." He spoke in defense of white insurrection in New Orleans: "people when they find themselves deprived of any regular and peaceful means of redress become indignant, and their minds are naturally turned

toward violence and extraordinary remedies."[17] He raised $1,000 so that the Robert E. Lee Memorial Association could begin work on a statue. He also persuaded the city council to rename the center of Tivoli Circle: henceforth, it would be Lee Place.

Fenner hired a local architect to design a column, its base in Georgia granite and its pedestal in Tennessee marble. The cost was nearly $26,500. He commissioned a young sculptor from New York, Alexander Doyle, to produce the statue itself for an additional $10,000. Doyle was not yet a distinguished name, but his fee was low and he was eager to please.[18] The final statue stood nearly 25 feet tall, including its pedestal, on a 60-foot column.

Lee was sculpted in uniform and hat, a sword in his belt, his arms crossed over his body. This peculiarly introverted pose was a cheap option. The statue was made as a plaster model. A mold was created around it, the plaster removed, and the bronze poured in. Had Lee been sculpted in a more dynamic stance—say, with an arm outstretched or his sword drawn—that would have made the casting process much more difficult. Narrow, outstretched sections of the mold were likely to block or break. Keeping Lee's form more or less cylindrical avoided this. It did mean, though, that from the ground he appeared to be standing on his column defensively and tentatively—as if he were afraid he might fall off.

The unveiling of Lee's statue in 1884 may have literally been a washout thanks to the weather, but the statue was a landmark for the Lost Cause myth. Before it went up, there had been few Confederate monuments, and they were relatively discreet. This statue elevated Lee almost to the heavens, dominating the city.

During his lifetime, Lee had barely visited New Orleans. Some said he had spent only one night there, though in fact he had passed through a few times. Now, he was positioned as its master. In 1891, another monument to white supremacy was placed nearby on Canal Street: a massive obelisk commemorating the Battle of Liberty Place.

Reconstruction ended in 1877, the same year Lee's statue was commissioned. The Black activist and writer W. E. B. Du Bois summed up the experiment of Reconstruction, and what would come next: "The slave went free; stood one moment in the sun; then moved back again toward slavery."[19] Over the following decades, Jim Crow laws across the South would bring in segregation. ("Jim Crow" was a pejorative term for Black people, drawn from an 1828 minstrel song.)

Fenner's role in the racial history of the South was not over. In 1892, he was the judge who handed down the verdict in the Louisiana Supreme Court case *Plessy v. Ferguson*. An 1890 law had segregated railway carriages in Louisiana. Homer Plessy, a thirty-year-old Black shoemaker, deliberately boarded the white carriage to challenge it. Fenner argued that "separate but equal" segregation, as it was euphemistically termed, promoted public welfare, and therefore judged that the law was constitutional.[20] The case was upheld at the United States Supreme Court. It was a major victory for proponents of Jim Crow laws throughout the South. For Black Southerners, it was another step backward from freedom.

During the 1880s and 1890s, only a handful of Confederate monuments were raised every year. Confederate statuemania really

kicked off between 1900 and 1920, decades after the end of the Civil War. The generations who put them up had not grown up with slavery, nor even necessarily with Reconstruction. Yet the nostalgia for the former and fear of the latter grew among white conservatives as those events receded further into the past.

Lost Cause adherents promoted their version of history in four main ways. First, they created communities of veterans and their descendants, including the United Confederate Veterans, the United Daughters of the Confederacy, and the Sons of Confederate Veterans. Second, they wrote books and articles to skew the historical narrative in favor of the South, and attacked books and articles that did not. The United Confederate Veterans condemned the *Encyclopaedia Britannica* for anti-Southern bias: they were enraged by its assertion that Harriet Beecher Stowe's *Uncle Tom's Cabin* demonstrated a "wonderful spirit of fairness." Third, they went after schools, lobbying to alter curriculums and textbooks, running after-school clubs promoting their own version of history. Fourth, they made the memory of the Confederacy part of the public landscape through monuments and statues.[21]

As more Jim Crow laws were enacted and enforced across the South, Confederate monuments went up at a rapid rate. In 1914, *Confederate Veteran* magazine estimated that there were around 1,000 of them. Some linked the Confederate cause to Christian iconography. In El Dorado, Arkansas, a marble drinking fountain dedicated to Confederate memory declared, in a phrase drawn from the Bible, that it symbolized the "loving stream of blood" shed by Confederate soldiers. Drinkers were therefore performing a communion that verged on idolatry. Oth-

ers appropriated classical imagery. New Orleans got a statue of Jefferson Davis to complement its statue of Lee in 1911. It was modeled after the Roman statesman Cicero, and showed Davis reaching out one hand to his audience while another rested on an open book of history. White communities bonded around these statues. In 1907, 200,000 people turned up to dedicate another statue of Davis in Richmond, Virginia.[22]

Back in New Orleans in 1932, the Battle of Liberty Place obelisk was amended with a new inscription. This was not a plaque that softened or contextualized the message of the memorial, but one that revised it to be even more racially aggressive. Even though the coup failed, the inscription claimed, the 1876 election "Recognized White Supremacy in the South and gave us our state."[23]

By the 1950s, the civil rights struggle was beginning—and the original Lee statue in New Orleans was beginning to fall by itself. The wooden pilings that underpinned its base rotted, and it sank six inches on one side. Fearful that Mardi Gras revelers might be crushed by the pride of the South as the Marble Man toppled from his pedestal, city authorities removed it for restoration. While it was down, some proposed that Lee be permanently relocated. One anonymous resident wrote to the New Orleans *Item* suggesting the statue be moved out of the city center: "This means progress for our city, let's not live in the past, especially for a lost cause."

Voices like this were drowned out by much louder ones speaking out *against* civil rights. The statue was restored, and was rededicated on the anniversary of Lee's birth, January 19, 1954. "Today, we in the South are being tried in so many ways,"

said Mrs. A. D. Carter of the United Daughters of the Confederacy at the ceremony. "There are forces that are doing much to tear down the ideals and traditions of our Southland, but this is where this heritage of courage and dignity comes to the front."[24] The statue had gone back up where it had always stood, shoring up white resolve against the coming threat of integration.

This time, though, the supremacists would not win. That same year, the Supreme Court's ruling in *Brown v. Board of Education* effectively began to dismantle the "separate but equal" laws for which Fenner had fought. Following an extraordinary series of campaigns in the 1950s and 1960s, segregation was ended in schools and public accommodations, and discrimination on grounds of race or other characteristics was banned.

As with Reconstruction a century earlier, there were those who did not accept these changes. White supremacists in New Orleans continued to celebrate at Lee's statue on January 19 every year. In 1972, Roswell Thompson, the Imperial Wizard of the New Orleans Klan, organized a march to the statue with his Imperial Kludd (chaplain), Rene LaCoste.

Dressed in their long white robes, the Wizard and the Kludd processed with their fellow Klansmen to Lee's statue, and draped a Confederate battle flag at its base. At this point, according to LaCoste, a group of Black Panthers threw bricks at them.

"I'm the only one that evah put the Panthahs on the run," La-Coste claimed in 1976 (there is only one written record of his remarks, and it uses these colloquial spellings). It is difficult to verify his claim that the protesters were Black Panthers. La-Coste claimed that a Klansman pulled a pistol and fired into the air. A brawl broke out. "Then I gashed a niggah that threw two

bricks at me," LaCoste remembered. "I gashed him and he went *allll* the way down the steps and he ran into the police."

"Which one of these men threw bricks at you?" LaCoste claimed a policeman asked.

LaCoste replied: "Men? You call that niggah a man?"[25]

LaCoste's account sounds like it has a few fantastical touches. The part that is true, though, is that white supremacists and neo-Nazis were increasingly rallying around Confederate monuments such as the Lee statue and the Battle of Liberty Place obelisk during the 1970s. "The mayor and others have said the monument doesn't pose any problem, that it's just a historical structure," said a council adviser in 1976. "But if the Klan is going to rally around it, and we know what the Klan stands for, then it must represent some of those things."[26]

In 1978, David Duke, the Grand Wizard of the Louisiana-based Knights of the Ku Klux Klan, led another march to the Battle of Liberty Place obelisk. "Our people are suffering every day," he told a crowd of between 85 and 125 Klansmen. "We stand here because we're a few white people who will not be intimidated, who will not back down. We are here and we are here to stay." A counterprotest about twice the size waved placards that read "Fight Klan Terror" and "Tear Down the Liberty Monument."[27]

The city's compromise in the 1970s, as so often in these cases, was to add another plaque. This one declared that, while the Battle of Liberty Place was significant in the history of New Orleans, "the sentiments in favor of white supremacy expressed thereon are contrary to the philosophy and belief of present-day New Orleans." This prim footnote did little to offset the effect of

a 35-foot white column inscribed lovingly with the words "white supremacy."

In 1981, the first Black mayor of New Orleans, Ernest N. Morial, said that the obelisk would be removed. This provoked an angry response from city councilmen and from some sections of the public. "He's trying to rewrite history," said one caller to a local radio show.[28] The obelisk remained.

In 1993, the city attempted another compromise, relocating the obelisk off Canal Street next to a parking garage. The pro-white supremacy inscription and the later plaque went: now, there was a marble slab with the names of police officers killed in the battle, and a new inscription honoring "those Americans on both sides of the conflict who died in the Battle of Liberty Place . . . A conflict of the past that should teach us lessons for the future."[29]

Once again, the compromise did not work. At the rededication ceremony, David Duke turned up with a crowd of white supremacists flying the Confederate battle flag. Again, there was a counterprotest by anti-racists and a clash. One eighty-two-year-old veteran of the civil rights struggle, Avery Alexander, was dragged away in a headlock by police officers wielding side-handled batons. Four Black protesters were taken away in handcuffs.[30]

The historical legacy of racial divides in terms of monuments to the Confederacy was proving extremely hard to shift.

The event that finally began to tip the balance against Lee's statue did not take place in New Orleans, but in Sanford, Florida. On February 26, 2012, a seventeen-year-old boy named

Trayvon Martin went to a convenience store to buy some sweets and a drink. He was walking back to his father's fiancée's house when he was spotted by George Zimmerman of the local community watch. Accounts differ as to what happened, but all agree that Zimmerman shot and killed Martin. At his trial for second-degree murder and manslaughter, Zimmerman pleaded self-defense. He was acquitted.

Zimmerman was Hispanic; Martin was Black. The killing sent shock waves through America. In March 2012 in New Orleans, the plinth of Robert E. Lee's statue was painted with the words "For Trayvon Martin" and "Jail all Cops." The Battle of Liberty Place monument and the Jefferson Davis memorial were similarly defaced.[31]

Three Black women, Patrisse Cullors, Alicia Garza, and Opal Tometi, started a hashtag: #BlackLivesMatter. This would become a national, then international movement of loosely aligned groups advocating for justice and against racial discrimination.

It was not long before Black Lives Matter protests began in New Orleans. On November 30, 2014, in response to the decision not to indict police officer Darren Wilson for the fatal shooting of Michael Brown in Ferguson, Missouri, activists marched on Lee Circle. Around 300 protesters formed a ring around Lee's statue, holding signs that said "Black Lives Matter" and "Free Hugs."

"Monuments like these poison the democratic minds of the people," one activist, Leon Winters, said to the crowd. "Not another penny of state money must be spent to maintain these racist symbols." A petition to remove Lee's statue was circulated.[32]

A few months later, a twenty-one-year-old white supremacist

called Dylann Roof gunned down nine Black people during Bible study at a church in Charleston, South Carolina. In response, three New Orleans activists, Angela Kinlaw, Michael "Quess" Moore, and Malcolm Suber, formed a pressure group called Take 'Em Down NOLA (standing for New Orleans, Louisiana). Suber, a history professor, was a vete'ran of this fight: he had been involved in efforts to remove Lee's statue in the 1970s. "These monuments represent a perpetual act of psychological warfare on Black people in America as symbols of the direct and physical warfare on Black people throughout this country's history of slavery and genocide," Take 'Em Down NOLA declared. The statues, they said, justified the "toxic notions of racial superiority that cause the Dylan [sic] Storm Roofs, Darren Wilsons and George Zimmermans of the world to maintain belief in Black inferiority."[33]

Historically, it was certainly true that the statues were intended as symbols of white supremacy—even if the Battle of Liberty Place obelisk no longer bore those actual words—and that they had become rallying points for generations of white supremacists. What had changed was the willingness of many white people to defend or ignore that. On July 9, 2015, the white mayor of New Orleans, Mitch Landrieu, requested the city council work toward removing four Lost Cause statues: Robert E. Lee, Jefferson Davis, the Battle of Liberty Place obelisk, and a statue of General P. G. T. Beauregard.

"This is about more than the men represented in these statues," Landrieu said. "This discussion is about whether these monuments, built to reinforce the false valor of a war fought over slavery, ever really belonged in a city as great as New Orleans whose lifeblood flows from our diversity and inclusiveness."[34]

A public consultation followed. Critics of the statues included the jazz trumpeter Wynton Marsalis, who remembered his great-uncle, born on a plantation the year before Lee's statue went up, expressing his distaste for it. The consultation backed the removal in August. In December, the city council voted six to one to remove all four statues. The lone dissenter, a white councillor, argued that due consideration had not been given to the historical significance of the monuments: "I think all we will be left with is pain and division." The council president disagreed: "If anybody wins here, it will be the South, because it is finally rising."[35]

Though the decision to remove the statues had been made by democratic process, legal battles ensued. Four organizations, the Monumental Task Committee Inc., Louisiana Landmarks Society, Foundation for Historical Louisiana Inc., and Beauregard Camp No. 130 Inc., filed a lawsuit to prevent removal, arguing that it would violate the National Historic Preservation Act. A district judge rejected the claims, but the statue supporters appealed. Meanwhile, activists including Take 'Em Down NOLA collaborated with the Southern Poverty Law Center (SPLC) to file an amicus brief in response to the lawsuit. "Those who are trying to block the city from taking down the monuments are relying on a distorted view of American history," said Rhonda Brownstein, the legal director of the SPLC. "The fact is that these monuments were built during the Jim Crow era to announce the return of white supremacist rule and racial subordination in the South. It is past time to put this racist history behind us, and taking monuments down is a good step."[36]

A Republican state senator tried to save the statues with a bill

to create a state commission that could review any decisions to remove monuments. "History is bigger than a single community or the mood of a moment," she said. Supporters of the bill compared the democratic removal of Confederate statues to the destruction of historical monuments in the Middle East by the Islamic State a few months before. The committee of five Democrats and four Republicans split along party lines to defeat the bill five to four. Another attempt in the Louisiana House of Representatives stalled.[37]

While the courts and legislatures fought it out, it was announced that H&O Investments in Baton Rouge had been selected as the contractor to remove the monuments. Immediately, David Mahler, the head of H&O, received numerous telephone calls threatening his life and those of his wife and family. These would have been unsettling enough, but it was impossible to brush them off after someone torched his Lamborghini Huracán, reducing a flashy $200,000 sports car to four tire rims, two seat frames, and a pile of ash.[38] Mahler and H&O quit the project in January 2016.

Finally, in March 2017, the court of appeals rejected the statue defenders' lawsuit. Pierre McGraw, the president of Monumental Task Committee, responded with dismay and mixed metaphors: "This is a true slippery slope, in fact, it's a highly lubricated vertical plane where nothing's going to stick on it and people don't realize it but the monumental Pandora's Box is open." McGraw tried to argue that the monuments should remain but have new plaques added to them, or that more statues should be put up to new heroes. These things had been tried before, though, and had done nothing to change the way white supremacists ven-

erated the monuments. Take 'Em Down NOLA activist Quess replied: "When people talk about a slippery slope, I contend that those who have been subjugated, the majority of Blacks in the city have been on the bottom end of a slippery slope for the past hundred plus years anyway."[39]

The city administration continued to receive death threats from statue supporters. On April 24, 2017, the Battle of Liberty Place obelisk was taken down under cover of darkness, with workers wearing masks to hide their identities and full-body flak suits for protection. A small but vocal group staged a candlelit vigil for the obelisk.

The following month, the statues of Davis and Beauregard were removed, also at night. By this point, several other states were also discussing the removal of Confederate monuments. On May 13, white supremacists led a torchlit rally in the quiet college town of Charlottesville, Virginia, protesting the suggested removal of the statue of Robert E. Lee in that town. An anti-racist counterprotest the following evening saw hundreds take to the streets.

Five days later, back in New Orleans, the mayor's office announced that it would remove the statue of Robert E. Lee the following day. In the early hours of May 19, the streets around Lee Place were blocked off. Work began on removing the statue from its pedestal just before dawn. As the day went on, hundreds gathered—mostly this time in support of the removal. There was a party atmosphere, with spectators sharing mimosa cocktails, and dancing to James Brown's "Say It Loud—I'm Black and I'm Proud" and Public Enemy's "Fight the Power."

"It's a sad day for Louisiana history," said the Republican lieu-tenant governor of Louisiana, Billy Nungesser. "People come to Louisiana for our rich culture and history. Some of it is unpleas-ant, but it is history. You're not going to right a wrong by taking down a monument."

Work continued on Lee's statue throughout the day until, at last, that evening, a crane removed the figure. The crowd cheered and sang "na na na na, na na na na, hey, hey, hey, good-bye." The crane lifted the statue into a truck, and Robert E. Lee, arms crossed defensively forever more, was driven away.[40]

Mayor Landrieu made a powerful and emotional speech about the statue. He encouraged his audience to imagine explaining the purpose of the Lee statue to a young Black child. "Can you look into that young girl's eyes and convince her that Robert E. Lee is there to encourage her? Do you think she will feel inspired and hopeful by that story?"

He refuted any charge of trying to change history: "To literally put the confederacy on a pedestal in our most prominent places of honor is an inaccurate recitation of our full past, it is an affront to our present, and it is a bad prescription for our future."[41]

Landrieu's speech was praised around the world. He later ex-panded its themes into a memoir, *In the Shadow of Statues: A White Southerner Confronts History*. The activists of Take 'Em Down NOLA were not impressed with Landrieu making the story about himself. "The Mayor has gotten accolades for tak-ing down the statues but it was our prodding and pushing that made it possible," said Suber. Quess remarked that Landrieu was "taking nearly all the credit for removing the monuments by his own valiant self."[42]

The four monuments that were removed in 2017—the statues of Lee, Beauregard, and Davis, plus the Battle of Liberty Place obelisk—were all taken to a warehouse at a secret location, supposedly while a permanent location was sought. In 2020, Mayor Landrieu gave a television interview at this warehouse, but it has otherwise remained closed. There has been no hint as to where or when these statues might be seen in public again. It is possible they never will be. Their huge size makes it impractical to install them in museums.

Though Robert E. Lee no longer stood in New Orleans, scores of his statues remained across the South in 2017. But a principle had been established, and many would not remain for long. In August 2017, attention moved back to Charlottesville, Virginia, when white supremacists and neo-Nazis held another rally in defense of the Robert E. Lee statue there. A white supremacist drove his car into a crowd of anti-racist counterprotesters, injuring nineteen people and killing one young woman.

This provoked international news coverage, especially after President Donald Trump defended those who protested in favor of Lee's statue. At a press conference on August 15, he asked whether statues of George Washington and Thomas Jefferson might now be taken down because they were slave owners. "So you know what, it's fine. You're changing history. You're changing culture." He continued: "There are two sides to a story. I thought what took place was a horrible moment for our country—a horrible moment. But there are two sides to the country."[43]

Trump may have meant to conclude that remark by saying "there are two sides to the story" again. Still, the expression he

used—"two sides to the country"—is apt. While the president continued to defend statues, another America moved forward with getting rid of them. In the two months after Charlottesville, fifteen more communities across the South removed Confederate monuments. Statues of Robert E. Lee were taken down in Baltimore, Maryland, and Dallas, Texas. One statue was pulled down by a crowd—a figure of a Confederate soldier in Durham, North Carolina—but the rest were removed by authorities. Lee's statue in Charlottesville, the focus of the white nationalist protests, was temporarily covered with black cloth. The historian Thomas J. Brown argued that the surge in the removal of Confederate statues in 2017 "was the most important American revival of iconoclasm since July 1776."[44]

Professor Brown was right when he wrote those words in 2019. No one knew then what the following year would bring.

Making a Splash

Edward Colston

Location: Bristol, United Kingdom
Put up: 1895
Pulled down: 2020

As we saw with both Lenin and Robert E. Lee, a historical fig-
ure's life story can be revised by his successors. In the case of
Edward Colston, so much myth built up that little of the original
man remained. The tale of Colston and his statue evolved as the
British Empire itself evolved over centuries. It is the story of a
community's long and bitter fight over civic identity and who
gets to control it.

As 2020 began, a novel coronavirus spread across the world.
On March 11, the World Health Organization declared it a pan
demic. In early April, in Minneapolis, Minnesota, George Perry

Fallen Idols

Floyd Jr., African American, forty-six years old, a father of three—came down with the symptoms of COVID-19, the disease caused by the coronavirus. He was ill for several weeks, and was laid off from his job as a restaurant doorman.[1]

On May 25, 2020, just before 8 p.m., Floyd walked into a grocery store and bought a pack of cigarettes with a $20 bill. The cashier believed the bill was fake. The police were called. Security camera videos and witness videos show police struggling with Floyd inside a car, before pulling him out onto the ground. Officer Derek Chauvin knelt on Floyd's neck for nine minutes and twenty-nine seconds. Again and again, Floyd gasped "I can't breathe." Members of the public watched with increasing alarm. Floyd's pleas stopped. He lay silent and motionless for a long time before Chauvin took his knee off his neck. Floyd was taken to the hospital, where he was described as "unresponsive and pulseless" and pronounced dead a little under an hour later.[2]

Videos of the incident went viral on social media. A wave of public outrage began in Minneapolis and spread across the United States. Floyd's words "I can't breathe" became a slogan for the Black Lives Matter movement. Despite the continuing threat of the pandemic, protesters against police violence poured into the streets by the hundreds of thousands—many wearing face masks, which offered protection against both infection and identification. Often, police responded with yet more violence.

Anger spread beyond the United States itself. On the morning of June 7, 2020, thirteen days after Floyd's death, protesters marched to The Centre, an open space and transport interchange in Bristol, in the west of England. They crowded around a bronze statue of the bewigged seventeenth-century merchant

Edward Colston, standing high on a stone plinth. As the crowd whooped and cheered, it was pulled down.

The stories of this seventeenth-century merchant in Bristol and the twenty-first-century security guard almost 4,000 miles away in Minneapolis were connected. Together, they tell a story of empire, slavery, and how history is made.

Prince Rupert of the Rhine was King Charles I's nephew and a general in his army. It is not clear if he and Edward Colston ever met, but their fates would be entwined. Their paths first crossed in the middle of July 1643. Edward Colston was then six years old and living in Bristol. Rupert, twenty-four, was with the royal household in Oxford, enjoying a flirtation with a young lady known as "Butterfly." With the English Civil War raging on, he was ordered to the west country and besieged Bristol. It surrendered. This was good news for the Colstons, who were royalists.

Two years later, the king's fortunes had turned. So had those of Prince Rupert and the Colstons. Parliamentary forces besieged Bristol. Rupert rode out to surrender on a black Arabian horse, clad dramatically in scarlet and silver, the angry shouts of Bristolians ringing out behind him.[3] With Bristol under Oliver Cromwell's control, the Colstons fled to London.

Prince Rupert went off to fight as a mercenary for Louis XIV of France. When the second English Civil War broke out in 1648, though, he pledged to fight for his uncle Charles I again. Charles was beheaded at the beginning of 1649. England became a republic. Rupert was then off the south coast of Ireland with the royalist navy. Edward Colston was twelve years old.

In 1652, Rupert sailed down the West African coast. Intrigued

by local stories of "a firm rock of gold of a great bigness" deep in the interior, he ventured up the Gambia River. It seems possible the locals were winding him up about what he might find: "The natives affirm that there are many unicorns in their country," his tour diary recorded, "relating their shape, and how they go, accompanied by other beasts, to the water, who will not drink till he hath dipped his horn therein."

Prince Rupert found neither unicorns nor gold in the African interior, though he did loot a few European ships. But a fateful association had been formed in his mind: Africa was a source of riches.[4]

The English Republic fell and, in 1660, Charles II was restored to the throne. Edward Colston was then twenty-three, apprenticed to the London Mercer's Company, beginning his career as a merchant. Prince Rupert returned to London too: he was intermittently in with the new king, and very close to Charles's brother James, Duke of York. Rupert was a driving force behind the Company of Royal Adventurers, set up with investments from Charles and James, and granted a royal charter that gave it a monopoly over all English trade with Africa.[5] The company's initial purpose was to find that "firm rock of gold of a great bigness" that Rupert still believed to be up the Gambia River. Instead, it found slaves.

The transatlantic slave trade had begun more than a century earlier. At first, most demand for African slaves came from the Spanish Caribbean and Brazil. Slaves were seen in Bristol docks by the 1620s, though there were also free Black people living in the city at the time.[6] In the early seventeenth century, English Caribbean colonies began to import slaves in greater numbers,

mostly to work on plantations. Slavery had existed in some African societies for generations: war captives or indebted people were among those who might be enslaved. But the demand for slaves exploded when traders from Europe and the Americas, such as the Company of Royal Adventurers, began to buy them in unprecedented numbers from their African captors.

Most of the familiar images of slave ships date from the peak of the trade in the eighteenth century, but the voyage from Africa to the Americas, known as the Middle Passage, was no easier in Rupert's time. A cargo of enslaved Africans—which could be as few as a couple of dozen, but was more often between 100 and 500—were crammed into a ship's hold. The slavers packed them in as tightly as possible, and chained them to avoid rebellions. With people lying together on the floor, each in a space smaller than a coffin, disease spread quickly. Those with diarrhea and vomiting had to lie in their own filth. Despair spread quickly too. Slaves who refused to eat or otherwise disobeyed were punished with whips and thumbscrews. They were often raped. The Atlantic crossing took around two months.

During almost four centuries of the transatlantic slave trade, 12.4 million people were transported from Africa to the Americas as chattel. Of those, 1.8 million died before they reached the Americas: often from disease or neglect, sometimes by suicide. Their bodies were thrown into the sea. Sharks were said to follow slave ships to eat the discarded human meat.[7]

This crossing was the fate of George Floyd's ancestors. His great-great-grandfather, Hillery Thomas Stewart Sr., was a slave in North Carolina, freed by the Thirteenth Amendment when he was eight years old. Stewart married, had an impressive

twenty-two children, and acquired 500 acres. The family might have prospered, but white farmers muscled in and took the land. Three generations later, Floyd's parents' generation grew up under segregation. The weight of this history was still felt by Floyd's family (and many like his) in the twenty-first century.[8]

In 1672, the Company of Royal Adventurers became the Royal African Company. The company would transport more slaves from Africa to the Americas than any other organization during the transatlantic slave trade. Many of the thousands of men, women, and children it took from Africa had the letters "RAC" or "DY" (for James, Duke of York) seared into their flesh with a hot brand: an indelible reminder that they were no longer people but property. Finally, in 1680, the fates of Prince Rupert of the Rhine, the royal family, and Edward Colston would meet—in the slave trade.

Edward Colston had been trading wine and textiles around the Mediterranean when he got in on trading slaves. He first invested in the Royal African Company in 1680 and rose to a senior position over the following decade. He served several times on its Company of Assistants before becoming deputy governor—effectively, chief executive—in 1689. By that time, Charles II had died, and the Duke of York had reigned briefly as James II. A courtier put up a statue of James in Whitehall in 1686.

Just two years after his statue went up, James was deposed. His statue was pulled down, but put back up by his successors. At the end of the nineteenth century, it was dumped in a garden off Whitehall, where it lay on its back with weeds growing over

it. Some years later, it was cleaned up and reinstalled outside the New Admiralty. During the Second World War, it was moved into Aldwych tube station for safekeeping, and after the war was relocated in Trafalgar Square. It is still there today: a deposed slaver king in the heart of London.

James II had been the Royal African Company's largest shareholder. Colston moved smoothly on to the new king, William III, offering him a large chunk of equity. William took it, but the company was losing its monopoly. Private slave traders leapt into the breach. Colston quit the company in 1692, though he continued to trade privately in slaves. Most of the 400,000 Africans transported to the Americas by English merchants before 1700 were traded by the Royal African Company, for the profit of the English and Scottish monarchy.[9]

It is often said that the slave trade was widely accepted in the seventeenth and early eighteenth centuries. It was not accepted by the slaves themselves. The first known slave rebellion in English history occurred on May Day 1638, on Providence Island in the Caribbean. Little about what happened has made it to the historical record, and the rebellion was quickly crushed. But almost a year later the governor was still recording in his diary that "we had a general Hunting after our rebel negroes, but they were so nimble as we could scarce get a sight of them: only one of their cabins was found upon the top of a high Hill, and burned."[10] The history of slave resistance and slave flight across the Americas shows that generation after generation fought for their freedom.[11]

Stories of the Providence Island revolt confirmed fears back

in England of the dangers of slavery. The following year, Sir Ralph Freeman published his play *Imperiale: A Tragedy*. The main character is an African slave, Molosso, who speaks powerfully against slavery:

> we
> *Have will and power to free our selves, behold*
> *Our liberty; these shall restore us now*
> *To that equality that nature gave.*[12]

Molosso credits his African heritage—"the traditions of our Countrey"—with his belief in freedom. He does not have to learn moral virtues from enlightened "white saviours": dignity is inherent in his origins. Freeman's play is not simplistically pro-African or antislavery—it ends horrifically with a bloodbath, as Molosso turns on his master. Significantly, though, it depicts slavery as a disaster for slave and master alike. Colston, just three years old when this was written, grew up in a world where it was entirely possible for men of his class and education to abhor slavery as unjust and grotesque. There is no reason to think he could not have understood that Africans had souls, intellects, and a desire for freedom.

Colston was reputedly an obstinate character, with strong feelings in favor of social order and against dissent. He attended church services daily. He never married, though when he was in his seventies he was accused of living "very much at his ease" in Surrey with a woman.[13] He is not known to have fathered any children. With no direct heirs, he gave much of his fortune away. Returning a few times to Bristol in the 1680s, he became a mem-

ber of the city's Society of Merchant Venturers, and founded almshouses, hospitals, charitable societies, schools, and so forth. When he died in 1721, his body was conveyed back to Bristol, and interred with great ceremony in All Saints' Church.[14]

Colston intended to make a mark on posterity. By the time of his death, his name was already on schools and other institutions in Bristol. The statue of him that is at the center of this story, though, was proposed 172 years later by another Bristol businessman and philanthropist: James Arrowsmith.

The Bristol of 1893 was very different from the Bristol of Colston's time. The British Empire had grown into an international behemoth. The Stuart monarchy had been replaced by the House of Orange-Nassau, then the House of Hanover, then the House of Saxe-Coburg and Gotha. Victoria had become Queen of Great Britain and later Empress of India. The slave trade had been abolished in the British Empire by the Slave Trade Act of 1807 and beyond that by the Slavery Abolition Act of 1833. Indenture had often replaced it. The Industrial Revolultion had occurred. European powers were in the middle of a colonizing frenzy characterized as the Scramble for Africa.

Though Britain appeared to be riding high by the 1890s, there was great anxiety about Britishness. Outside, it seemed as if every European nation was snapping at Britain's heels, trying to grab an empire of its own. Inside, there was inequality, poverty, and dissent.[15] There had been an upsurge of republican feeling against Victoria's stodgy monarchy in the 1870s. The Representation of the People Act of 1884 had enfranchised much of the male population. Forty percent of men and one hundred percent

of women still could not vote. Nonetheless, the increased franchise gave a boost to socialist ideas, which were then emanating as much or more from some Christian quarters as they were from Marxists.

This was the context in which James Arrowsmith made a fortune in publishing. He put out a run of bestsellers, including Jerome K. Jerome's *Three Men in a Boat* (1889), George and Weedon Grossmith's *Diary of a Nobody* (1892), and Anthony Hope's *The Prisoner of Zenda* (1894).[16] Arrowsmith idolized Colston as an example of Bristolian enterprise and virtue. Far from being forgotten since his death, during the nineteenth century Colston had become ever more popular. His name was plastered across public spaces, buildings, and institutions throughout Bristol. His birthday, November 13, was celebrated as Colston Day, when the charitable societies set up in his name held lavish banquets. "A life of integrity, of blameless piety, of unbounded benevolence, and of godlike philanthropy was the life of the good Edward Colston," cooed the *Western Daily Press* on Colston Day in 1868. "His name is enshrined in the great heart of prosperity, and encircled with a wreath of undying fame."[17]

By the 1890s, though, the various Colston societies had assumed different political agendas and squabbled with each other. One thing that united them was dismay at the rise of socialism. Arrowsmith proposed his statue as a restatement of what was now seen as Bristol's "golden past."[18] As the Bristol historian Madge Dresser has pointed out: "The statue was intended in part as a way to rally the workers to identify with the Bristol

elite—all in it together as Bristolians!—rather than with the la-bour movement."[19]

Colston's involvement in the slave trade was deliberately ob-scured. Arrowsmith's fund-raising campaign did not mention it at all. Slavery had been one of the foundations of British impe-rialism, and had made many British people and institutions ex-tremely rich. After abolition in the early 1800s, though, Britain performed a remarkable reversal. It redefined itself as the world champion of the fight *against* slavery. From 1807, the Royal Navy patrolled the coast of West Africa, intercepting slave ships. It took until 1838 for the British Empire's slaves, some 800,000 of them, to be given their freedom. Even before it had freed its own slaves, Britain was becoming self-righteous about ending slavery.

The antislavery crusade did not just take on other Europeans and Americans but Africans too. In 1851, for instance, the British government sent the navy to attack Lagos for conspiring with Dahomey to continue slave trading. Lord Palmerston, then Sec-retary of State for Foreign Affairs, wrote angrily that the "great purpose" of the British government and people was to end the slave trade, and that they would not be denied this by "the min-imal and piratical resistance of two barbarous African chiefs."[20] Slavery had helped build the British Empire; now *ending* it was that empire's "great purpose."

Imperialism had not transformed itself into a force for free-dom and democracy. The British and other nations continued to pursue colonization and economic interests in Africa. These were backed with force, including military action, as well as bru-

tal acts of violence and reprisal committed by European individuals and institutions against Africans. Arguments continue to be made about the extent to which the opposition to slavery was sincere, or whether the "civilizing mission" was a cover for renewed imperialism. The answers are not simple. Either way, by the 1890s, the slave trade was widely seen as abhorrent and antithetical to the whole idea of Britishness. The reality of Colston's central role in it was not compatible with the image Arrowsmith hoped to promote of a righteous Bristolian hero. The reality, then, had to be glossed over. Colston would be heralded as a merchant and a philanthropist. His slave trading would not be mentioned.

Arrowsmith asked the Colston charitable societies to raise £1,000 for a statue. Their first round of fund-raising produced only £201. A second round doubled this. Arrowsmith opened up his campaign to invite all citizens of Bristol to donate, but almost nobody did. An attempt to shake down schoolboys from Colston's foundations fared no better. At the beginning of 1895, he still had only a little over £400.

Arrowsmith staged concerts and exhibitions to raise funds, and ordered his statue from the sculptor John Cassidy. Colston was cast in bronze, depicted in a wig and frock coat, leaning on a cane in a pensive pose. He was raised on a plinth of Portland stone with bronze dolphins at its corners. Reliefs on the plinth showed him distributing money to widows and orphans, and patting a winsome street urchin on the head. Another featured a couple of merpeople and a merhorse with wings. There were no references to slavery. "Erected by citizens of Bristol as a memorial of one of the most virtuous and wise sons of their city: AD

1895," read an inscription. This was pushing a point: the vast majority of citizens had shown no interest, let alone coughed up. Nobody was so rude as to point that out during the grand unveiling on Colston Day 1895. At the ceremony, the mayor of Bristol made a glancing reference to that which could not be mentioned, noting that Colston's "business was mainly with the West Indies."[21] This was the only hint.

The statue still had to be paid for. Arrowsmith placed envelopes at every setting in the society banquets around Bristol that night, with pointed invitations to stuff them with donations. Yet again, the great and good of Bristol found it in themselves to resist. At the end of November 1895, the statue was up, the bills were in, and Arrowsmith only had £548. After one last fund-raising push, a single anonymous donor stumped up a final £150. It was probably Arrowsmith himself.[22]

If Arrowsmith hoped that putting up a statue of Colston would convince Bristolians to return to an imagined past of paternalism, individual enterprise, and the benevolent rule of elites, he would be disappointed. The veneration of Colston tailed off in the early half of the twentieth century. After the First World War, in a rapidly modernizing society, he had become an unfashionable symbol of Victorian pomposity. Colston Day celebrations dwindled.[23] The schools, institutions, and charitable societies that bore his name or association continued to do so, but the Colston name was not the brand it had been.

The Victorian idolization of Colston had explicitly involved cleansing his history and Bristol's. This could not last. In 1920, a new biography of Colston—published by Arrowsmith's com-

pany, though Arrowsmith himself was then dead—investigated his work with the Royal African Company and central involvement in the slave trade.[24] Yet it was not until the 1990s that criticism began to coalesce around the statue.

In 1998, Bristol held a consultation with members of the public in advance of its first major exhibition on its role in the slave trade. Many in the audience heard for the first time about Colston's role in the Royal African Company. The next morning, Bristol awoke to a new inscription on Colston's statue in red paint: the words "Fuck off slave trader." The city began to debate Colston's legacy. Plenty of voices were raised in his defense on letters pages and in radio phone-ins. The usual arguments were mustered: it was a different time, nobody knew slavery was wrong back then, think of all the good things he did, we can't hold the past to our modern moral standards, if we take him down then who's next, you can't erase history, and so on. The statue remained.

Over the following years, Colston's statue was subject to guerrilla modifications, viewed by some as vandalism and others as art. In 2007, drops of "blood"—more red paint—were splashed across its plinth. In 2018, a bright red ball and chain was placed around its feet: this had been made of wool, and was described as a "yarn bombing." The same year, around a hundred models of human figures lying on their backs were placed in front of the statue, recalling the placement of enslaved Africans in slave ships.[25]

In the wake of the Rhodes Must Fall movements in South Africa and Oxford, Colston's statue attracted ever more criticism. Yet it still had its defenders: notably the Colston societies and

the Society of Merchant Venturers. In 2018, Bristol City Council tried to compromise. Rather than pulling it down, they would add a second plaque to the statue, acknowledging Colston's connection to slavery. The original version written by historians was as follows:

AS A HIGH OFFICIAL OF THE ROYAL AFRICAN COMPANY FROM 1680 TO 1692, EDWARD COLSTON PLAYED AN ACTIVE ROLE IN THE ENSLAVEMENT OF OVER 84,000 AFRICANS (INCLUDING 12,000 CHILDREN) OF WHOM OVER 19,000 DIED EN ROUTE TO THE CARIBBEAN AND AMERICA.

Colston also invested in the Spanish slave trade and in slave-produced sugar. As Tory MP for Bristol (1710–1713), he defended the city's 'right' to trade in enslaved Africans. Bristolians who did not subscribe to his religious and political beliefs were not permitted to benefit from his charities.

This wording provoked fury from Colston's defenders. By the late twentieth century and into the twenty-first, the old political term "Tory" had become a nickname for members of the modern Conservative Party. Some felt, therefore, that describing Colston as a "Tory MP" was politically problematic, even though it was true. "This pathetic bid to mount a secondary revisionist plaque on Colston's statue is historically illiterate and a further stunt to try to reinvent Bristol's history," declared Richard Eddy, a Conservative councillor. "If it goes through, it will be a further slap in the face for true Bristolians and our city's history delivered by ignorant, left-wing incomers." Coun-

cillor Eddy had previously been in the news when he displayed a golliwog, a racist nineteenth-century caricature in the minstrel tradition, in Bristol's town hall. This led to his resignation as the deputy leader of the Conservative council group. "I have never been a believer in taking the law into one's own hands," he continued. "However, if this partisan and nauseous plaque is approved, I cannot find it in my heart to condemn anyone who damages or removes it."[26]

Meanwhile, the Society of Merchant Venturers found its own historian to rewrite the plaque. Their version read:

EDWARD COLSTON, 1636–1721, MP FOR BRISTOL 1710–1713, WAS ONE OF THIS CITY'S GREATEST BENEFACTORS.

He supported and endowed schools, almshouses, hospitals and churches in Bristol, London and elsewhere. Many of his charitable foundations continue. This statue was erected in 1895 to commemorate his philanthropy. A significant proportion of Colston's wealth came from investments in slave trading, sugar and other slave-produced goods. As an official of the Royal African Company from 1680 to 1692, he was also involved in the transportation of approximately 84,000 enslaved African men, women and young children, of whom 19,000 died on voyages from West Africa to the Caribbean and the Americas.

This provoked more fury. The mayor of Bristol, Marvin Rees—himself the descendant of slaves—issued a statement saying

the Merchant Venturers were "extremely naive to believe they should have the final say" and describing their wording as "unacceptable."

Both versions of the Colston plaque are essentially accurate, in that they are composed of verifiable facts. Two points are disputed: the precise number of children on Colston's ships, and whether Colston "played an active role in the enslavement" of the Africans concerned or was merely "involved in the transportation" of them. The facts that appear only in the first version (he was a Tory MP who defended slavery, his charities discriminated on grounds of religion and politics) or in the second version (he was one of the city's greatest benefactors, he supported multiple charitable foundations) are all true.[27]

Side by side, though, these two factual accounts create completely different impressions—not only of Colston but of the modern city of Bristol itself, its culture, its identity, and who gets to define those things. Everything depends on which facts are put in and which are left out, which are highlighted and which are pushed to the end, the precise choices of language and tone. This is why what may seem like a compromise over a controversial statue—adding a plaque with historical context—often does not work. Nobody can agree on what the appropriate historical context is. The statue of Colston itself was a reinvention of a seventeenth-century figure for nineteenth-century aims. It represented a fantasy. It showed him surrounded by mythical creatures. Imposing historical accuracy upon it is like trying to fact-check *Lord of the Rings*.

Though the mayor's office stated that further work would be done on the phrasing of the second plaque, the whole concept

had run aground.[28] Colston's statue stayed up without a new plaque.

Fourteen months later, in May 2020, Britain was in lockdown to slow the spread of coronavirus when the story of George Floyd's death broke.

Britain has a different history and culture surrounding race from that of the United States, but they are linked—most clearly, in historical terms, by empire and slavery. The protests that began in the United States were taken up by British protesters, partly as an act of solidarity with Black Americans and partly to protest against racism in Britain itself. Thousands gathered in London on May 31 despite the pandemic, with smaller groups around the country. On June 3, *Star Wars* actor John Boyega gave an emotional speech to a crowd in Hyde Park. "I need you to understand how painful this shit is," he said. "I need you to understand how painful it is to be reminded every day that your race means nothing and that isn't the case any more, that was never the case any more."[29] On June 7, a protest began in Bristol.

An estimated 5,000 protesters marched to Colston's statue that day. As the crowd watched and cheered, a rope was thrown around Colston's neck. Protesters pulled at it. The statue toppled forward and fell on its face to joyous whoops. Protesters rushed forward to jump and stamp on it, dousing it in white and red paint. It had taken them less than thirty seconds to accomplish what some had demanded for almost thirty years.

Protesters climbed up on to the empty plinth: one, Jen Reid, raised her fist in the Black Power salute. Someone changed the words "Erected by citizens of Bristol" on the statue's plinth to

"Rejected by citizens of Bristol." Two masked Black protesters in baseball hats, wearing T-shirts with the slogans "Black Lives Matter" and "Trump is a Wasteman," knelt on the statue's neck for eight minutes, just as Derek Chauvin had knelt on the neck of George Floyd.[30]

Colston was rolled and kicked through Bristol streets, covered in paint, with bits falling off him, until protesters reached Bristol Harbour. They set him back upright next to the railing around the harbor, and then, as a group, shoved him over it. With a tremendous splash, the bronze fell into the water.

Of those Africans transported on Colston's slave ships, 19,000 had died at sea. Their bodies were thrown into the waters. For Colston's statue, there could be no justice more poetic.

Videos and images went viral on social media. Many were exhilarated. "THEY WILL ALL FALL," said American rapper Ice Cube, on Twitter. "SPLOSHITY BYE YOU DEAD RACIST," tweeted the account for Momentum Bristol, a left-wing youth movement. On TikTok, a user created a video of herself captioned "Edward Colston waking up in Bristol Harbour," set to lyrics from the track "Rain" by British rappers Aitch x AJ Tracey: "What's going on, why am I wet?" Another Twitter user mocked up a fake opinion piece purportedly written by Colston's statue: "Unhand me at once, impudent whelps! Fetch my whip, at . . . oh no no no no *splash* Bbwrrrpplleeee gwwwrrbbbleeeee."[31]

But the glee of some was matched by distress from others. "I grew up in Bristol. I detest how Edward Colston profited from the slave trade," tweeted Sajid Javid, formerly the British chancellor of the Exchequer. "But, THIS IS NOT OK. If Bristolians wants

[sic] to remove a monument it should be done democratically—not by criminal damage." The prime minister, Boris Johnson, agreed: "The PM absolutely understands the strength of feeling, but in this country we settle our differences democratically and if people wanted the removal of the statue there are democratic routes which can be followed." The problem was that many people in Bristol had been trying to follow those democratic routes for decades, but had been stymied undemocratically by the Society of Merchant Venturers.

Remarkably, now, the Society of Merchant Venturers put out a statement reversing its previous position on the statue. "The fact that it has gone is right for Bristol," it said. "To build a city where racism and inequality no longer exist, we must start by acknowledging Bristol's dark past and removing statues, portraits and names that memorialise a man who benefitted from trading in human lives. It was inappropriate for the Society of Merchant Venturers to get involved in the rewording of the Colston statue plaque in 2018 and we have listened to the constructive comments put to us over this past week."[32] Minds can change, when they want to.

Some still defended Colston. Councillor Richard Eddy, who had two years before declared that he could not condemn anyone who damaged a corrective plaque on the statue, suddenly found he did not like criminal damage after all. He accused the protesters of "frenzied thug violence," and claimed that Colston was "a hero." "Who gives a shit what it's about and what the man's done?" said Tommy Robinson, a far right activist. "It's part of British history." Slavery was indeed part of British history. So was syphilis, and nobody wants a statue of that.

The usual arguments were wheeled out again. "Would it have hurt to add another plaque, explaining that, although Colston was a great philanthropist at home, he was also complicit in death and suffering abroad?" asked a reader of the *Spectator*, apparently unaware this precise question had caused vicious conflict in Bristol for years, and who accused the protesters of "trying to erase him [Colston] from history. It isn't right. Colston should be fished out of the docks and put back."[33]

"Now is not the time for those who for so long defended the indefensible to contort themselves into some new, supposedly moral stance, or play the victim," wrote David Olusoga, a professor of history at the University of Manchester. "Whatever is said over the next few days, this was not an attack on history. This is history."[34]

On June 11, a diver and a crane sent by Bristol City Council winched Colston out of the brine. There was no plan to put him back on his original plinth. "The ropes that were tied around him, the spray paint added to him, is still there so we'll keep him like that," said Ray Barnett, the head of collections and archives at the council.[35] It was decided that the statue would be relocated to a museum. A conservation team set about preserving it, complete with ropes and graffiti, alongside a collection of 500 placards from the protest.

On the morning of July 15, a truck backed up toward the empty plinth in The Centre. A small, unauthorized team quickly unloaded a new statue. It was a black resin cast of Jen Reid, the protester who had performed a Black Power salute on the empty plinth just after the felling of Colston. Her image had been

turned into a statue by the artist Marc Quinn, and was installed on the same spot.

Many were struck by the new statue's beauty, but some questioned the right of Quinn—a white man—to produce it. The sculptor Thomas J. Price described it as "a votive statue to appropriation." He remarked, "I think it would be far more useful if white artists confronted 'whiteness' as opposed to using the lack of black representation in art to try to find relevance for themselves." The author Bernardine Evaristo disagreed: "It's a demonstrable commitment to the cause of Black Lives Matter in that it shows active allyship. Isn't that what we need? Allies?" Reid herself commented, "I wanted to do this with Marc Quinn as he's always cared about pushing inclusion to the forefront and making people think. It's not about black or white. If people want to stand by me, that's great."[36]

There was not much time to discuss it, anyway. "I understand people want expression, but the statue has been put up without permission," tweeted Bristol's mayor, Marvin Rees. "Anything put on the plinth outside of the process we've put in place will have to be removed. The people of Bristol will decide its future." By the next morning, the new statue was gone.[37]

The most effective response to Colston's statue remains the events of June 7, 2020. The sequence of acts by the Black Lives Matter protesters on that day engaged profoundly with the stories of Colston, Bristol, and George Floyd, bringing them together in a statement against racism with global reverberations. Every phase in the protester's actions was rich with historical and contemporary meaning. Pulling Colston's statue down with

ropes recalled the toppling of the statues of tyrants around the world—George III, Stalin, Trujillo—and put the power to do so literally in the hands of the people. The protesters who knelt on its neck paid a sobering and powerful tribute to George Floyd. When the statue was lobbed into the harbor, it recalled breathtakingly the fate of almost one quarter of the Africans whom Colston's ships transported.

For anyone asking what a seventeenth-century merchant in Bristol had to do with a twenty-first-century security guard in Minneapolis, the protesters could not have made it clearer. Their action highlighted the links of slavery that bound American and British history from Edward Colston to George Floyd, illuminated the endurance of white supremacy and racism across the transatlantic world, and demanded justice.

American Idol

George Washington

Location: Portland, Oregon
Put up: 1926
Pulled down: 2020

The final story in this book brings us back to where we began: with the commander in chief of the Continental Army and the first president of the United States, George Washington. After Washington read out the Declaration of Independence in New York, his soldiers and the Sons of Liberty pulled the city's statue of King George III down. As we saw, Washington was not pleased by this "appearance of riot and want of order, in the Army," and directed his soldiers that in the future the pulling down of statues should "be executed by proper authority."[1]

Washington did not say he disapproved of pulling down the

king's statue. He objected to his soldiers acting without orders. He made no judgment on the civilians involved. It is impossible to know what he would he have thought of the iconoclasm of 2020, when groups of citizens pulled down statues across the world. On June 18, 2020, protesters in Portland, Oregon, took to the streets for the twenty-second consecutive night. In the early hours of June 19, some went to the intersection of Northeast 57th Avenue and Northeast Sandy Boulevard, where they knocked down a statue of George Washington himself. The date was significant: June 19 is the anniversary of the date that the Union Army declared freedom from slavery in Texas in 1865. It is now celebrated as a day of emancipation throughout the United States: Juneteenth.

This is the story of a historical reputation that, at the time of writing, is being reassessed anew. Some will find this uncomfortable. The overwhelming majority of Americans still revere Washington: whenever there is any kind of public vote ranking great Americans, he is placed near the top. Yet there has been growing criticism of the Founding Fathers in recent years, with slaveholding a particular bone of contention.

The previous chapter on Edward Colston looked at the beginning of the global iconoclasm of 2020. This chapter picks up that story and brings it home to the United States, where scores of monuments that had stood for decades or even longer would come down in a matter of weeks.

While the Washington statue in Portland, Oregon, was only one of many statues that were vandalized by protesters or removed by authorities, the fact that it was attacked at all represents a shift in historical memory. Might this reassessment,

or even rewriting, of history go too far? Does it fundamentally undermine the nation and its coherence? If so, what can be done about it? When the "Father of His Country" is left lying face-down on the pavement, covered in angry slogans and red paint, these questions are urgent.

George Washington "had everything to lose by going into the presidency," said historian Alexis Coe. "And in some ways, he did." Before his presidency, he was beloved. In 1796, a year before he left office, he was so unpopular that the House of Representatives declined to adjourn to wish him a happy birthday. Thomas Paine, once a great admirer, wrote to him that same year: "The world will be puzzled to decide whether you are an apostate or an impostor; whether you have abandoned good principles, or whether you ever had any." John Adams judged cattily in 1812 that the first president had been "Too illiterate, unlearned, unread for his station and reputation."[2]

Washington died in 1799. In the early 1800s, while some of the Founding Fathers were still alive or in living memory, they were not popular. Commemorations of American independence tended to focus on ordinary soldiers—and to some extent on Washington in his role as a general—rather than politicians. In the run-up to the Civil War, the Founding Fathers were deplored as villains and scoundrels by antislavery campaigners. At the Massachusetts Anti-Slavery Society's Fourth of July rally in 1854, abolitionist William Lloyd Garrison burned a copy of the United States Constitution, calling it "the source and parent of all the other atrocities—a covenant with death, and an agreement with hell." Some spectators hissed Garrison, but most cheered.[3]

By the time of the Civil War, though, the reputation of the Founding Fathers was on the rise. Abraham Lincoln took a softer line on them, finding in their words and deeds the desire to end slavery: "Thus, the thing is hid away, in the constitution, just as an afflicted man hides away a wen or a cancer, which he dares not cut out at once, lest he bleed to death; with the promise, nevertheless, that the cutting may begin at the end of a given time." Lincoln justified his own position by telling the historical story so that he was a natural product of it: "The plain unmistakable spirit of that age [the foundation of the United States], toward slavery, was hostility to the principle, and toleration, only by necessity."[14] Those Americans who defended slavery scoured the Founding Fathers' words and deeds to find evidence that they held the opposite view, and therefore that Confederates were the natural heirs to the nation's Great Men.

After the Civil War and Reconstruction, invoking the Founding Fathers became a way to bring the United States back together: creating a shared historical past whose glory could be agreed on by all. In 1848, before the Civil War, construction had begun on the Washington Monument, an obelisk in Washington, DC, that would for a while be the world's tallest structure. Building had been interrupted by the war and funding problems, but work began again in 1877, and by 1884 the memorial would tower over the nation's capital. In 1865, the artist Constantino Brumidi painted *The Apotheosis of Washington* in the eye of the United States Capitol's rotunda, depicting the first president in the heavens, flanked by allegorical female figures. It showed him literally becoming a god.

The history books of the late nineteenth century were as

effusive as the art. In 1889, the historian and politician Henry Cabot Lodge wrote that he had studied Washington's career for many years and had found no faults at all. Even the things that others perceived to be faults—such as Washington's notoriously haughty manner—could be explained: "He has been lifted high up into a lonely greatness, and unconsciously put outside the range of human experience," Lodge wrote. "From it has come the widespread idea that Washington was cold, and as devoid of human sympathies as he was free from the common failings of humanity." In Lodge's view, the reason people thought Washington was cold was simply because he was *too perfect*, unlike "other and lesser men who seemed to be nearer to us in their virtues and their errors alike." Lodge applauded ordinary people who held Washington to be a sacred figure: "The real hero needs not books to give him worshippers."[5]

He might, though, need statues. The upswell in Washington's reputation in the late nineteenth and early twentieth century coincided with statuemania, the international fad for putting up statues of Great Men. There are more than a hundred notable public statues of Washington in the United States, including many copies of Jean Antoine Houdon's famous sculpture, modeled from life and created between 1785 and 1796 (the original stands in the Virginia State Capitol). The statue in Portland, Oregon, was not one of these copies but an original piece. It was a gift to the city from the politician and physician Henry Waldo Coe in 1926, to celebrate the sesquicentennial of the Declaration of Independence.

Coe was keen on statues: he gave four to Portland. In addition to Washington, he commissioned a statue of his close

friend Theodore Roosevelt, as well as an Abraham Lincoln and a Joan of Arc (dedicated to the American infantrymen of the First World War). He had two copies of his Roosevelt statue made for the cities of Mandan and Minot in North Dakota. The four Portland statues were commissioned from different artists (Joan of Arc was a copy of her statue in Place des Pyramides, Paris: Coe had seen it on a visit there, admired it, and had a replica cast in the same molds).

The commission for Washington went to Pompeo Coppini, an Italian-born sculptor who had immigrated to the United States. Coppini made his name in Texas, sculpting local heroes and Confederate icons such as Jefferson Davis. He had already created one statue of George Washington, commissioned in 1910 by American residents in Mexico City. It had already been pulled down.

Coppini's Mexican Washington was unveiled in Plaza Washington in 1912, in the presence of President Francisco Madero and the American ambassador.[6] A year later, Madero was ousted and shot. By 1914, Mexico was spiraling into civil war. American marines occupied the port of Veracruz. In retaliation, there were anti-American riots in Mexico City by supporters of President Victoriano Huerta. "Last night they tore down the Washington monument," the American vice-consul told the *New York Times*. "I saw Huerta's son place a rope around the neck of the statue."[7] Coppini's bronze Washington was dragged through the streets and hacked to pieces. (The US government gave Mexico a new Washington statue in 1916. In the 1970s, it was moved from Plaza Washington to the city's great park, the Bosque de Chapultepec, where it still stands today.[8])

Despite this unfortunate omen, Coe decided to let Coppini have another go at the father of the Country. Coppini's Portland Washington depicted him in contemporary dress (Washington himself preferred this to a classical toga), with a cane in his right hand and a tricorn hat in his left. The statue was bronze, raised on a granite base. Coe would not see it dedicated: he suffered a heart attack and died in February 1927, aged seventy. The statue was unveiled on July 4. According to an obituary of Coe, "It was his wish that these representations of the great ones who are gone should be an inspiration to the daily lives of those who saw the statues, silent, calm and enduring."[9]

For nearly ninety-three years, George Washington's statue endured silently on a well-kept lawn outside the German American Society in Portland, Oregon. In 2020, though, everything changed.

The death of George Floyd was not the only racially charged incident fueling unrest in 2020. Ahmaud Arbery, a twenty-five-year-old Black man, was jogging in Brunswick, Georgia, on February 23 when he was shot and killed. The suspects, two white civilians, said they believed him to be responsible for a spate of local burglaries, though police later said they had no reports of these burglaries. Breonna Taylor, a twenty-six-year-old Black hospital worker, was shot multiple times by police officers as they stormed her apartment in Louisville, Kentucky, on March 13.[10] Floyd was killed in Minneapolis, Minnesota, on May 25. On June 12, twenty-seven-year-old Black man Rayshard Brooks was shot and killed in Atlanta, Georgia: the suspect was a white police officer. On August 23, Jacob Blake, a twenty-nine-year-old

Black man, was shot seven times in the back in front of his children in Kenosha, Wisconsin, leaving him partially paralyzed. Again, the suspect was a white police officer.

On May 26, Black Lives Matter protests began in Minneapolis and were broken up by police with tear gas. Unrest spread and became serious. Demonstrations were staged in at least 140 cities across the United States. The National Guard was mobilized in Minnesota on May 28. The following day, May 29, President Trump threatened to send in the military, saying, "When the looting starts, the shooting starts."[11] Some railed against protesters for the damage and looting. Others blamed the president, the police, and the National Guard for escalating the situation.

On May 31, protesters in Birmingham, Alabama, tried to remove a monument to Confederate soldiers and sailors. When they could not, they toppled a nearby statue of Charles Linn, a Finnish-born industrialist who served in the Confederate navy. The city's mayor, Randall Woodfin, removed the Confederate soldiers and sailors monument the next day. The state attorney general slapped the city with a $25,000 fine for violating Alabama's monument preservation law. Woodfin said that he would rather pay the fine than provoke more civil unrest: "We don't have time to worry about something that's not working for our city and relegates Black people to property and slavery. It's important that we take this down and move forward."[12]

Across the United States, dozens of monuments had already been removed or scheduled for removal by June 18, the day before Juneteenth. Most of them related to the Confederacy. Many more were connected to the conquest of the Americas and the

persecution and genocide of indigenous peoples. At least nineteen statues and busts of Christopher Columbus had come under discussion or physical attack by June 18. Many had been removed.

The targeting of George Washington in Portland, Oregon, though, was a surprise to many. Oregon is a long way from Minnesota, Kentucky or Georgia, where Floyd, Taylor, and Arbery were killed. In the American Civil War, Oregon fought for the Union. By 2020, Portland would be one of the whitest major cities in the United States: only 6 percent of the city's population was African American.[13] To put it mildly, Portland has a reputation for liberal politics.

Nonetheless, Oregon does have an uncomfortable racial history. When it was Oregon Territory, controlled by a joint occupancy agreement between the United States and Britain, it passed strict exclusion laws to prevent "any negro or mulatto" from entering or settling. In 1844, one notable mixed-race pioneer was forced to leave Oregon under these rules. His name, evocatively, was George Washington Bush.[14] Later, when Oregon became a state and adopted a constitution, it voted against slavery but for keeping its anti-Black exclusion rules. It was the only state admitted to the Union with such laws in place.[15]

On June 15, 2020, around fifteen people pulled down a statue of Thomas Jefferson outside Portland's Jefferson High School. One of the participants—a thirty-three-year-old white man— later spoke anonymously to the *Willamette Week* about toppling the statue. "It was a joyous moment," he said. "It didn't feel like full of hate or a desire to destroy. It felt like the community just spontaneously got together to do this thing that needed to be

done in that moment." Afterward, though, he felt conflicted. "I was reading a lot of things of what people were saying about that particular incident and statue toppling in general. A lot of people are comparing it to ISIS, like Black Lives Matter is the American ISIS, it's crazy. I understand their point of view. People have this idea about these evil vandals." On reflection, he did not accept that characterization. "I've been reading things about statue toppling and what that means. It's not vandalism, you're doing something by taking down this image. There wasn't rage. We were doing this thing that should've been done, that people in charge aren't doing." He considered it unacceptable that the statue of Jefferson stood outside a predominantly Black school.[16]

Jefferson was criticized in his own time over his attitudes to slavery, and still is. He professed to want to end slavery, yet owned more than 600 slaves. He made a profit on the births of Black babies (4 percent every year, he noted with pride in 1792). Slave boys as young as ten were whipped to make them work in his nail factory, though this horrible fact was carefully deleted from a 1953 edition of his papers. He maintained that Black people were inferior to whites and opposed racial mixing. For two centuries, there were rumors that Jefferson had fathered children with at least one of his slaves, Sally Hemings. Generations of historians furiously denied this, but in 1998 DNA tests proved it was true. Jefferson began their relationship when he was forty-four and she was fourteen. Consent was not relevant, regardless of Hemings's age. Jefferson owned her as a piece of property, and never freed her.[17] Property cannot say no.

In the 1960s and '70s, the Founding Fathers went out of fash-

ion because most of them were slave owners: a poor fit with the ideas of those decades about liberation. They would be back. As the historian H. W. Brands wrote in 2003: "The Founders' revival is in part a reflection of the anti-liberal reaction that began with Ronald Reagan and continues today."[18] A couple of decades on from Brands's observation, the reputations of the Founding Fathers are on the verge of a more critical interrogation once again.

The attack on George Washington's statue on the night of June 18, 2020, was about more than his slaveholding, though. It was an assault on assumptions about American heroism.

According to the Portland Police, there were several separate protests in the city on the night of June 18. There was a peaceful demonstration of several hundred people at Jefferson High School. A second group gathered at the Justice Center. A fence was cut, and, the police report gravely disclosed, "projectiles such as hotdogs" were thrown. A third group went to the George Washington statue on Northeast Sandy Boulevard, and set fire to its head.[19]

The statue's body and plinth were covered in graffiti: "Genocidal colonist," "Fuck cops," "Big Floyd" (a reference to George Floyd), "You're on native land," and "1619"—the date African slaves were first brought to the American colonies. Once the fire was out, ropes were tied around its neck and body, and it was hauled down—bringing much of its plinth with it. On smartphone videos, the crowd can be heard screaming with excitement. The statue was draped in the Stars and Stripes, which was also burned.[20]

Fallen Idols

The graffiti on Washington's statue combined three issues, two of which were historical: the colonization of Native American lands, African slavery, and contemporary concerns about police violence. During the protests of 2020, these apparently separate issues combined because they were all focused on the same targets: injustice and white supremacy.

Washington began to own slaves when he was just eleven years old (he inherited some when his father died). He acquired many more in adulthood, and his wife, Martha, brought yet more with her on their marriage. There is evidence that he began to feel uncomfortable about this during the Revolutionary War: in 1778, he told a cousin that he no longer wanted to keep slaves. Yet in 1782, when it became legal to free slaves, he chose not to do so. He stated in his will that he wanted the 123 slaves he then owned to be freed upon Martha's death. In practice, she freed them a year after his death, out of concern that they might not wait for her to die naturally and would hasten the event. She could not free the 153 slaves attached to her own estate, for they were the property of her first husband's family.

There has also been controversy over Washington's behavior toward Native Americans. Washington aggressively acquired Native lands for himself, resorting to the courts where necessary to enforce his claims. He supported a policy of settler expansion into Native lands, though he believed Native peoples should be paid a fair price to leave. If they did not leave, though, he was prepared to take harsher action. In 1779, he wrote to the Marquis de Lafayette that he had sent General Sullivan to fight the Susquehannock people: "I trust [he] will destroy their set-

tlements & extirpate them from the Country which more than probable will be effected by their flight as it is not a difficult matter for them to take up their Beds and Walk."[21]

These aspects of Washington's life are old news to scholars of history, but they are often suppressed in the "patriotic" history fed to the general public. Visitors to Walt Disney World in Orlando, Florida, may see all past presidents re-created as animatronics in the Hall of Presidents (there is rarely a queue for this ride, while you might have to wait hours for Space Mountain or the Haunted Mansion). The Hall of Presidents script has changed several times since it opened in 1971, yet still, in the most recent version, the first president is covered in terms Henry Cabot Lodge would have approved. "George Washington becomes the symbol of American ideals," a voice-over intones, as romantic portraits of him flash up on a wraparound screen. "In the first Presidential election, it's Washington by a landslide. The only doubt seems to be his own. He writes, 'Integrity and firmness is all I can promise.' Integrity and firmness is exactly what we need. Everything he does as President will set a model for his successors."

Throughout the whole ride, twenty minutes or so, there is no mention of Washington, or any president, owning slaves. Native Americans are only mentioned once, as allies of George Washington. Slavery, the expansion into indigenous lands, and the Civil War cannot be avoided altogether, but the terms in which they are described are impressively opaque: "We elect fifteen Presidents before the course of history brings us to the edge of a crisis like no other. A nation born of freedom still permits

slavery. As the country pushes west, will new states be slave or free?" In this retelling, no one is responsible for any of the nasty things in American history. The course of history brings forth the Civil War. Slavery happens inexplicably despite all the freedom. The country pushes west by itself, into a vacuum. At the end, a rubber-clad robot George Washington rises from his seat to anoint a rubber-clad robot of the current president: the leadership of America passed from animatronic statue to animatronic statue.

Liberal popular versions of history have often been just as kind to Washington. In Lin-Manuel Miranda's smash hit musical *Hamilton*, Washington is portrayed as a towering, if occasionally grouchy, hero. The musical took a "color-blind" approach: Washington's role was originated by the charismatic Black actor Christopher Jackson. "It's something I spent a lot of time and a lot of angst trying to figure out how I reconcile being in this man's skin," Jackson told *Vanity Fair*. "As a Black man, I just couldn't put it together." He settled on a gesture of acknowledgment during the final song, during Eliza Hamilton's line about speaking against slavery: indicating Washington's failure to address the issue.[22]

The historian Lyra Monteiro noted that the show played up the image of Thomas Jefferson as "this horrible elite asshole who has slaves." Yet it is never mentioned in the musical that Washington did too. "He's this perfect father figure and he has nothing to do with slavery. Even though he was as embedded in slavery, of course, as Jefferson was."[23] The musical does not mention Native Americans at all. *Hamilton* is a groundbreaking work of musical theater, yet its image of Washington is resoundingly traditional.

Washington cannot, of course, be held responsible for the death of George Floyd, nor for the excesses of twenty-first-century policing. But the protesters who pulled down his statue on the night of June 18, 2020, were not just attacking Washington as a man: they were attacking Washington's image as a symbol of the injustices they felt were rooted deep in the history of the United States itself. They aimed to shock; to make people question the historical story they had been told.

Soon after Washington's statue was pulled down, the director of public art for the Regional Arts and Culture Council went to mingle with the crowds milling past to look at the strange sight: Washington's desecrated form lying facedown on the pavement. She asked one man what he thought should be done with the statue. He suggested taking it to a museum. "Yeah, he's the founder of the country," he said. "But 300 slaves is a lot of slaves."

Two other residents suggested that the statue should be displayed in a museum as it lay on the ground: graffitied, prone. "We have this moment to consider who we want to idolize," one said. The council took both Washington's and Jefferson's statues into storage while considering what to do with them.[24] The man who had helped pull down Jefferson's statue was pleased that Washington had gone too. "I feel like I understand when people are upset about it, because it's such an icon of America and we think of him as this hero," he said. "But it's also a good thing it's happening. We no longer want to let those things just exist out in the open."[25]

President Donald Trump used the felling of the statue to stoke nationalist feeling at a rally in Oklahoma. "Two days ago leftist

radicals ripped down a statue of George Washington," he told a crowd, who began to boo loudly, "and wrapped it in an American flag and set the American flag on fire." He proposed tougher measures: "We should have legislation that if somebody wants to burn the American flag and stomp on it or just burn it, they go to jail for one year."[26] (The Supreme Court ruled in *Texas v. Johnson*, 1989, that flag burning constituted "symbolic speech," and therefore was protected under the First Amendment.)

Four months later, on October 11, 2020, the eve of Columbus Day, protesters in Portland held an Indigenous People's Day of Rage. Protesters, many clad in black, threw ropes around the statue of Theodore Roosevelt and went at it with a blowtorch. It fell at 8:51 p.m. They turned to the nearby statue of Abraham Lincoln, and just eight minutes later that too was toppled. The words "Dakota 38" were graffitied on its base: a reference to the 38 Native Dakota men executed on Lincoln's orders the day after Christmas in 1862, following the US-Dakota war of that year. Some protesters smashed windows at the Oregon Historical Society, though they did not damage any exhibits. They waved a banner which read: "Stop honoring racist colonizer murderers."[27]

Between June and October 2020, three of the four statues given to Portland by Henry Waldo Coe were removed: Washington, Roosevelt, and Lincoln. Only Joan of Arc remained. Two statues of pioneers at the University of Oregon were pushed off their plinths by protesters. Other statues were removed by authorities. A rather fetching statue of an elk, by the sculptor Roland Hinton Perry, disappeared from Main Street. Even in the complicated racial politics of the United States, elks are generally considered blameless. The elk had, though, by virtue of

its prominent position, become a rallying spot for protesters. Though it had not yet been damaged, the Regional Arts and Culture Council feared it was only a matter of time, and took it away for safekeeping.

In response, some Black Lives Matter protesters tried their hands at putting a statue up. They made a replacement elk out of welded metal and placed it on the plinth. Local opinion varied on the artistic merit of this piece, with some calling it the "Nightmare Elk" on account of its fearsome expression. It did not last long: it was stolen by a far-right group, who gleefully posted pictures of its kidnap on social media. A few days after that, locals built a third elk, this time out of bits of wood and duct tape.[28]

Elks aside, there were serious issues here, relating back to the toppling of Washington. Who is allowed to decide which stories get told in public space? How do Americans see their past? Who does it serve? What does that say about the United States today, and in the future?

Pulling down or altering a statue can be thought of as violent or nonviolent. No person is harmed: it just looks like one is, because statues look like people. Toppling a large structure that may weigh several tons is clearly risky, though few injuries have been recorded in the history of statue topplings in this book. Legally, in many jurisdictions, altering or pulling down a statue constitutes criminal damage, and at the time of writing there are various prosecutions underway around the world following the 2020 iconoclasms. Those are a matter for the courts. From a philosophical angle, some believe damaging property is inher-

ently violent. Others think, in the case of a statue, it may constitute a legitimate symbolic protest: even a performance of art in itself. Like burning a flag, it could be a form of free speech.

The racial justice movement in the United States had already tried peaceful protest. In 2016, American football quarterback Colin Kaepernick "took the knee"—kneeling during the obligatory playing of the national anthem before games. It was a protest against police brutality and racism. Kaepernick originally sat down, but he and his teammate Eric Reid settled on kneeling as a more respectful gesture. "I remember thinking that our posture was like a flag flown at half-mast to mark a tragedy," Reid wrote.[29]

Taking a knee—quiet, dignified, nonviolent—provoked a furious reaction. Kaepernick received intense, sustained public abuse, and effectively lost his career. Despite this, the protest spread to other teams and other sports. The National Football League obliged players to stand for the national anthem or remain in the locker room. As usual, President Trump went further: "You have to stand proudly for the national anthem, or you shouldn't be playing, you shouldn't be there. Maybe you shouldn't be in the country."[30]

"It should go without saying that I love my country and I'm proud to be an American," wrote Reid. "But, to quote James Baldwin, 'exactly for this reason, I insist on the right to criticize her perpetually.'"[31]

Taking a knee returned across the world as an expression of solidarity with the victims of racism in 2020. Protesters, public figures, and politicians took part, provoking angry as well as

supportive responses. In South Carolina, a protester dropped to his knee in front of police, saying, "I am not your enemy. All of you are my family." They arrested him.[32] Serious questions were raised about freedom of speech. "In a brazen display of this administration's disregard for the First Amendment, the nation's chief law enforcement officer, Attorney General William Barr, ordered federal officers to clear a peaceful protest in front of the White House," a *New York Times* editorial said. "The police used tear gas, rubber bullets and riot shields to drive away protesters, journalists and priests standing on the private porch of St. John's Church, all so Mr. Trump could pose for photos." The editorial was headlined: "In America, Protest Is Patriotic."[33]

It is notable that the *New York Times* and Eric Reid, as well as James Baldwin (writing in the 1950s), all framed their dissent in patriotic terms. They dissent not because they *hate* America but because they *love* America: they feel it has taken a wrong turning, and want it to correct that, to live up to its grand promises. It would be a bold protester today who dared to burn the Constitution, as William Lloyd Garrison did in 1854. President Trump, as we saw in the introduction, suggested that those attacking statues sought "the destruction of the United States system of government" or aimed to "overthrow the American revolution." The defensiveness of these writers, their appeal to patriotism, is an attempt to refute that argument.

What cannot be ignored, though, is that white supremacy, colonial conquest, and authoritarian policing have been and still are fundamental parts of the American story. This is why Trump and his supporters could portray criticism of them as criticism

of America itself. The Trumpists believe that attacks on national myths endanger the status quo—and, on that specific issue, they are right. That's usually the point of pulling down a statue.

George Washington could act as a focus for these grievances not only because of what he did personally but because of what he represents politically. Turning Washington into an American god served a purpose for those who wished to reunite the United States in the nineteenth century, and was extraordinarily successful for a long time. Yet becoming a symbol of your country may be a curse as well as a blessing. Attacking his statue is not a nuanced critique of George Washington, the man. It is a howl of protest against broken promises, dying dreams, and an America that is not working for everyone.

It is understandable that groups who have historically been shut out of the American national story feel frustrated. It is understandable too that many will see turning that anger on figures such as George Washington as dangerous. The historical myths around the Founding Fathers and an ever more perfect union were part of what brought the United States back together after the Civil War. If you pull that apart, might the nation be weakened, or even destroyed?

Trump's answer was to promise to build more statues, and to set up a 1776 Commission—intended to promote what he called "patriotic education." According to a White House briefing statement: "We will state the truth in full, without apology: We declare that the United States of America is the most just and exceptional Nation ever to exist on Earth."[34]

As we have seen repeatedly, you cannot keep building bigger myths forever. The "truth in full, without apology" is that

George Washington had slaves, he acquired Native lands, the original Founding Fathers wrote a Constitution which limited freedom to white men, and a great deal of injustice has proceeded from that. There is no point trying to cover up or censor any of this. Nor can it be "balanced" away against Washington's many extraordinary achievements. There is no meaningful way to quantify the value of winning independence and set it against the cost of perpetuating slavery: neither cancels the other out. These things coexisted in Washington's life and American history. The study of history is about understanding why and how.

"If we want to help young people to develop a sense of citizenship, they have to be able and willing to think for themselves," wrote the historian Richard J. Evans. "The study of history does this. It recognises that children are not empty vessels to be filled with patriotic myths. History isn't a myth-making discipline, it's a myth-busting discipline, and it needs to be taught as such in our schools."[35] Professor Evans was writing about British education, but his point is just as relevant in the United States, and in every other nation besides.

How Americans' views of their own history shift over the next few years will depend on what happens in the American present. For those who do want to see the American experiment flourish, no matter where they are on the political spectrum, the aim should not be to stop historical reassessment. The challenge is to reckon with history fairly and squarely: to build a shared future based not on propaganda, evasions, and fantasies, but on truth, reconciliation, and hope. This is the challenge for every nation whose stories we have encountered. So far, some are managing it better than others.

Fallen Idols

By 2021, there were a lot of empty plinths in the United States. The question is bound to arise of who, if anyone, should fill them. The public art made by protesters over the summer of 2020 included portrait murals of George Floyd and Breonna Taylor, as well as strikingly long lists of the names of the dead. As yet, they have not been memorialized as statues. Perhaps street art is simply a more resonant form for a generation not so beguiled by Great Men: less burdened with classical allusions, less permanent, more dynamic, more democratic.

Perhaps, in the future, we will not want statues at all.

Making Our Own History

We've traveled across nearly 350 years of history and five continents. We've met twelve supposedly Great Men and their statues. We've seen all of them pulled down, some put back up again, and some pulled down a second time. We've seen how historical memory can be manipulated for all sorts of political agendas—but we've also seen that this can and will be challenged.

Let's look again at the four arguments against pulling down statues from the introduction.

1. The Erasure of History

"Statues are not history; rather, its opposite," wrote the historian Simon Schama. "History is argument; statues brook none." Statues, he argues, by "lording it over civic space . . . shut off debate through their invitation to reverence."[1]

Pulling down these statues did not erase history: all of these histories still exist. Whether statues go up or come down makes no difference to how we understand history. The public understanding of history depends on much more significant factors, such as education, strong historical and heritage institutions, archive preservation and access, critical thinking, and freedom of speech.

2. The Man of His Time

The Man of His Time argument suggests that the historical figures commemorated in statues were acceptable in their own time, and it is only modern morality that cannot tolerate them. This is untrue in every case. All of these men had critics in their own times.

The Man of His Time argument is itself a way of erasing history. Take the ideas, for instance, brought up often in debates over Edward Colston, that "everyone was racist back then" or "most people supported slavery at the time." There is no evidence for these assumptions. No opinion polls were conducted in the 1700s. The written records that have been preserved were mostly left by wealthy white men: they didn't all support slavery, and some of them were vocally against it. We have little idea what most people thought, especially women or working-class people.

We *do* know that most enslaved people did not like or accept their position: the whole history of captivity, control, punishment, rebellions, and slave memoirs attests to it. Their opinions should matter. They must be included when we talk about "everyone" or "most people." Why would we assume that the views of a subset of elite white men can stand for everyone in their

era? If we do that, we may be in danger of erasing a great deal of history.

3. The Importance of Law and Order

This argument suggests that statues should be taken down through the proper authorities, rather than being pulled down by mobs. It often appeals to moderates, because it seems like a compromise: it doesn't say that statues shouldn't be removed at all, just that they should be removed consensually and non-violently.

The problem with this is that those processes can be frustrated for decades: either as a result of inaction by public authorities, or through deliberate sabotage by particular interests. Sometimes, sustained pressure will yield a democratic removal. This often requires an enormous expense on legal challenges and responses. It is hard to justify pouring ever greater quantities of public money and time into the question of statues when there are so many more pressing needs. We might also note that it is often easy to get a statue *put up* with little or no democratic assent. By what right does it then occupy public space?

If statue removal must happen through due process, then that process must work. A dysfunctional process is not a compromise: it's a way of obstructing change. It is not surprising that sometimes people simply lose patience with endless bureaucratic delays, and knock the thing down themselves.

4. The Slippery Slope

This argument was about the fear that there will be a "domino effect": pull down one statue, then someone will object to an-

other, and another, and soon we will have no statues at all. In the United States, there are fears about iconoclasm attacking the Founding Fathers. In Britain, there are fears about the likes of Oliver Cromwell, Robert Clive, and Winston Churchill. The question is often asked: Where will it stop?

The answer is that it will not stop—and that's good. In a free, democratic society, there can be no limits on which historical figures can be discussed and reassessed. A lively debate on what we value is healthy.

Statues do not have rights. They stand at the pleasure of those who live alongside them. Any community is entitled to reconsider over and over again what it values, and how it remembers history. We needn't worry about people "rewriting" history—that, after all, is what historians do all the time, incorporating new evidence and new interpretations. We should worry if people stop asking questions about the stories they are told.

What should we do with statues that no longer represent us? Some should be pulled down, if they provoke serious hurt or division. There is no beauty in causing pain. Removing statues altogether need not be the answer in every case, though. Across the world, statues have been altered or recontextualized to change their meaning.

Adding an explanatory plaque is the most boring and least effective way to do this. Cast your mind back to the writer Robert Musil's tongue-in-cheek line: "There is nothing in this world as invisible as a monument." There is one thing even less visible, and that's a plaque on a monument. Instead of adding footnotes to our statues, we could embrace creative interventions. In Par-

aguay, a statue of the dictator Alfredo Stroessner was broken up by the artist Carlos Colombino: select pieces were rearranged to make it appear as if Stroessner was being crushed between two concrete blocks. It now stands as a memorial to Stroessner's victims. The artist Manfred Butzmann proposed planting ivy all around Lenin's monument in Berlin, allowing it to be slowly swallowed up by nature.

Temporary modifications to statues can be made with paint, props, or light projection. In 1990, the Polish artist Krzysztof Wodiczko used projection to transform the vast Lenin statue in Berlin into a Polish tourist, piling his shopping cart high with cheap electronics. In 2011, the artist Jesse Hemmons felt that the statue of fictional boxer Rocky Balboa outside the Philadelphia Museum of Art was too touristy, so she knitted him a pink sweater emblazoned with the words: "Go see the art." The same year, a graffiti artist transformed a bas-relief of soldiers on the Soviet Army memorial in Sofia, Bulgaria, into painted figures of Superman, Father Christmas, and Ronald McDonald. Hundreds of statues around the world were adorned with face masks in 2020 and 2021, during the coronavirus pandemic, while a projection on Rio de Janeiro's enormous Christ the Redeemer statue transformed it into a doctor with a stethoscope.

A fallen statue is a powerful symbol, and can be kept that way. The French conceptual artist Daniel Buren once asked whether "a statue lying flat—for example, one that is knocked down during a revolution—automatically becomes a sculpture."[2] After the 1966 coup that overthrew Ghana's first prime minister, Kwame Nkrumah, his image and works were banned, and his statue in Accra was beheaded. The statue's head was retrieved

and hidden by a member of the public. In 2009, and in a different political climate, it was returned. The statue is now displayed headless in Kwame Nkrumah Memorial Park, with the head on a separate plinth next to it: inviting the public to remember both Nkrumah and the violence that forced him out.

One suggestion that comes up frequently in debates over monuments is to move controversial statues into museums. At this, a collective groan goes up from curators. Museums are not dumping grounds, and most don't have the space to amass large, undistinguished collections of discarded statuary.

A better solution is to create dedicated outdoor sculpture parks. This could be the way forward for Britain's colonial statues and the United States' Confederate memorials. If these parks prove popular, the statues will be looked at and thought about far more there than they ever were when standing on a traffic island or outside a shopping mall. If the parks are not popular, let them crumble: that will tell its own story.

What should go in the place of all these fallen statues? In recent years, there have been movements in Britain and the United States to raise more statues of women and people of color. These campaigns are no doubt well meant, but they do not address the fundamental problem that statues represent the Great Man theory of history. Supplementing the Great Men with a few Great Women represents a cosmetic change, not a meaningful change, in how we think about history. Some may argue that a cosmetic change is better than nothing. It is not. Putting up yet more statues legitimizes the old-fashioned idea that history is driven by a few virtuous individuals and we should venerate them.

Statuary itself is the problem. It's didactic, haughty, and un-involving. In the modern world, its links with the history of tyr-anny and racism are regrettably strong. Again and again, as we have seen, statues have been used to glorify an (often ques-tionable) individual and to obscure a more complex history. We can do better. There are far more effective ways to memorialize, through festivals, museums, exhibitions, books, documenta-ries, public events, performance, and all the creative arts. These forms of commemoration engage people, allow space for them to participate, and bring history to life.

This does not mean that monuments have had their day. In re-cent years, many have shown that memorialization can be pro-foundly affecting when it moves away from traditional statuary. In Budapest, a row of bronze shoes on the bank of the Danube marks the place where Jews were ordered to take their shoes off before being shot and thrown into the river by a fascist militia. In Berlin, the spot on Bebelplatz where books were burned by the Nazis is marked with a glass panel set in the cobblestones; look down, and below are haunting rows of empty bookshelves. The Molinere Underwater Sculpture Park off the coast of Gre-nada can be visited by divers and glass-bottomed boats: figures of slaves stand silently on the seabed, recalling those who were thrown overboard during the Middle Passage. When you re-move the individual from a memorial, the viewer becomes the protagonist. That's how these installations encourage us to con-nect ourselves to the events they commemorate.

There are ways to commemorate individuals too, while main-taining a wider view of history. The National Memorial for Peace and Justice in Montgomery, Alabama, consists of 800

steel columns hanging from a roof—one for each county in the United States where racial terror lynchings took place. Close up, each county's column has the names of victims engraved upon it. Thus the memorial manages to convey both the appalling scale of atrocities, and a sense of every individual story. Another series of memorials that pulls this off are the Stolpersteine, or "stumbling stones," begun by the artist Gunter Demnig in Berlin in 1992. The stones are small metal plaques laid in the street outside the last freely chosen addresses of victims of Nazi terror, listing each person's name, date, and fate. It is possible not to see a Stolperstein at all; once you notice them, though, you will realize that there are dozens in one street. These tiny plaques in huge numbers again reinforce both the individual losses and the overwhelming horror of the Holocaust. There are now around 75,000 Stolpersteine across Europe.

While it is important as communities to remember trauma, wars, and genocides, we can also memorialize joy. Some of the most uplifting monuments are those to liberations, community spirit, scientific breakthroughs, and artistic triumphs. The Statue of Liberty in New York symbolizes freedom. The Eiffel Tower in Paris symbolizes the age of science, engineering, and industry. Mannekin Pis in Brussels symbolizes the city's rebellious sense of humor. The Taj Mahal in Agra has come to symbolize love (though it was built as a mausoleum for Shah Jahan's beloved wife, Mumtaz Mahal). An outstanding modern addition to this genre is the Angel of the North, by sculptor Antony Gormley, which went up outside Gateshead in 1998. Its rusting steel form is raised on a mound of destroyed pithead baths

from a nearby coal mine, spreading its wings as if to take flight. The Angel is deeply rooted in history, and full of hope for the future. It is far more uplifting and memorable than yet another honorific statue of a local dignitary, however worthy.

Though the heyday of statues may be in the past, the art of portrait sculpture is not dead. There are some delightful modern statues—and sculptors who approach the form with wit and ingenuity. The Monument to the Laboratory Mouse in Novosibirsk, Russia, honors those mice that have (involuntarily) contributed to scientific research, with a bronze figure of one in spectacles knitting a DNA double helix. The statue of Charles La Trobe at La Trobe University, Melbourne, is upside down, balanced on its head with its plinth in the air—because the sculptor thought universities should turn ideas on their heads. One of the few political statues that Londoners treat with genuine affection is the Allies sculpture of Winston Churchill and Franklin Delano Roosevelt on a public bench in New Bond Street. It is subtle where most statues dominate—the figures are often mistaken by passersby for real people. It invites visitors to sit between Churchill and Roosevelt and interact with them in any way they like, in contrast to most statues, which tower above the viewer, out of reach. All of these statues are charming *because* they subvert a form that is inherently pompous.

Of course we can keep and cherish the statues we love, the ones that uplift or move us. When we debate how to memorialize our history *now*, though, we have a chance to think creatively: beyond the Great Men, into a past and future of unlimited possibilities.

Fallen Idols

‗ ‗ ‗

While pulling statues down may offer a moment of exhilaration to those who topple them, does it really change anything? Generally, the answer is no. In Russia, though few regret the pulling down of statues such as that of KGB chief Felix Dzerzhinsky in 1991, some feel that many of the problems they had with the old regime are back. "Waging war on bronze men doesn't make your life any more moral or just," the Russian journalist Maria Lipman, who cheered the destruction of Dzerzhinsky's statue, told the *New York Times* in 2020. "It does nothing really."[3]

A symbolic moment such as pulling a statue down may have resonance. What it does not do—at least, not by itself—is *actually change anything*. Pulling down a statue does not create liberation. Correlation is not causation.

Modern movements that have targeted statues, such as Rhodes Must Fall and Black Lives Matter, have broad aims. They challenge legacies of colonialism, racism, and slavery, and include strands of feminism, LGBTQ+ activism, and disability activism. These movements' focus, methods, and actions are open to criticism, and there has been plenty of that—from inside the movements as well as outside. It is clear, though, that their vision does not end with statues. Real change will not be achieved with purely symbolic acts.

There have always been political operators on all sides who will try to turn debates over historical memory into "culture wars": who will try to reduce history back to the binaries of pride and shame, good and bad, heroes and villains. They will not stop trying to do this, because it serves their propaganda.

Conclusion

We were given a glimpse of what "patriotic history" means when President Donald Trump's 1776 Commission published its report, on Martin Luther King Day, January 18, 2021. The report claimed that the Founding Fathers were opposed to slavery, that progressivism was comparable to fascism, and that the civil rights movement had rejected the ideals of the Founding Fathers in favor of "identity politics." It accused American universities of obscuring "patriotic" history and being "hotbeds of anti-Americanism."

No professional historian contributed to this report, though among the authors there was one history podcaster.[4] Historians repudiated it. "Almost everything in it is wrong, just as a matter of fact," Eric Rauchway, a professor of history at the University of California at Davis, told the *Washington Post*.

"It's a hack job. It's not a work of history," said James Grossman, the executive director of the American Historical Association. "It's a work of contentious politics designed to stoke culture wars."[5]

"This document may end up anthologized some day in a collection of fascist and authoritarian propaganda," said David W. Blight, a professor of history at Yale.[6]

Two days later, Joe Biden was inaugurated as president of the United States. He swiftly issued an executive order disbanding the 1776 Commission. The ridiculed report promptly disappeared from the White House website.

Satisfying as that may have been, it would be naïve to think the history wars are over. Even when the truth comes out, there are those who will deny it, or try to cover it up again. Sometimes, they will succeed—at least, for a while.

Fallen Idols

For those of us who care about history and historical memory, this moment is an opportunity. The controversies over these statues have shed light on how public historical memory is constructed and how it can be challenged. They have brought many more people into the historical debate. Let's keep opening it up. Let's create and inform a much wider and more mature engagement with the past. Having an informed debate means dragging public history out of the clutches of those who try to weaponize it for political purposes. It means shifting away from those binaries that are about our feelings today: pride and shame, good and bad, heroes and villains. It means teaching history through argument and critical thinking. It means trying to understand history rather than use it.

Informing the debate opens up a thrilling panorama of history that is not about *us* but about *them*—the complicated, messy, fascinating human beings who lived through it. This is a huge and highly rewarding job that many historians, teachers, museum curators, and documentary filmmakers are already doing. The media and politicians can help by avoiding debates that reduce history to point scoring. They have the power to promote genuine historical engagement, and to amplify the voices of those with real expertise over whichever partisan pundits shout the loudest. Some, to their credit, already do. Politicians can improve state funding for history in schools, lifelong learning, and museums, and can support initiatives that aid those processes. In 2020, the Andrew W. Mellon Foundation in the United States committed to a Monuments Project. It will spend $250 million on "reimagining" approaches to monuments and memorials. This will include creating new monuments, altering or moving

existing ones, and putting on exhibitions and art installations to memorialize history.[7]

We can all get involved in history, as societies, communities, families, and individuals. You have involved yourself by reading this book. You may disagree with me on some things. That's fine. You may have been intrigued by some historical stories you hadn't previously known about. That's wonderful. There's a whole wide world of the past out there. In the internet age, you have more power than ever to explore it for yourself.

In the meantime, as with Stalin's boots, the Alley of the Leaders, or the wreckage of Edward Colston, statues often tell us far more poignant and meaningful historical stories after they are pulled down than they ever did when they were up. No version of history can be set in stone forever. Perhaps the most powerful statements of who we are right now are the empty plinths where Great Men once stood.

Acknowledgments

It's common for authors to hide their research assistants somewhere in the middle of their acknowledgments. This book calls for us to move away from glorifying the individual, so that would be hypocritical. Thank you first and foremost, then, to a team of phenomenal historical minds who helped me with the background research for this book: Lewis Baston (William, Duke of Cumberland), Thomas Ellis (Lenin and Robert E. Lee), Dan Johnson (George III and George Washington), Pauline Kulstad González (Rafael Trujillo), Abaigh McKee (Saddam Hussein and Cecil Rhodes), and Henri Ward (Leopold II). Without them, this book would be much worse. All mistakes are my fault, as usual.

I'm so grateful to the exceptional publishers who helped turn this idea into a reality: to my brilliant editors, Iain MacGregor at Headline and Jennifer Barth at HarperCollins, and to their wonderful teams. At Headline: Mari Evans, Sarah Emsley, Feyi Oyesanya, Georgina Polhill, Jack Storey (the designer), Anna Hervé

(the sharp-eyed copyeditor), and Tara O'Sullivan (the equally sharp-eyed proofreader). At HarperCollins: Jonathan Burnham, Sarah Ried, Leah Carlson-Stanisic (designer), and Milan Bozic (cover designer). Thanks, as always, to my terrific agent Natasha Fairweather and her assistant Matthew Marland at RCW.

Many thanks to Jonathan Teplitzky, who put the germ of this idea into my head; to Paul Lay at *History Today*, who first commissioned me to write about statues; and to the London Library, whose excellent book-delivery service made it possible to keep reading and researching even during a global pandemic and repeated lockdowns.

Many scholars and friends were extremely generous in sharing their thoughts and ideas with me. Thanks to David Andress, Kabund Arqabound, Manuel Barcia, Sara Barker, Alice Bell, Jill Burke, Simukai Chigudu, William Dalrymple, Lauren (Robin) Derby, Jean-Pierre Dikaka, Vicky Donnellan, Madge Dresser, Sasha Dugdale, Beata Fricke, Ian Garner, Adom Getachew, Madeleine Gray, Hannah Greig, Chris Hill, Huma Imtiaz, Greg Jenner, Faiza S. Khan, Keith Lowe, Nesrine Malik, Lucy Marten, Áron Máthé, Tom Menger, Clare Mulley, Hannah Murray, Dora Napolitano, Georges Nzongola-Ntalaja, Nick O'Connor, Matthew Parker, Timothy Phillips, Abigail Rieley, Imogen Robertson, Rana Safvi, Kamila Shamsie, Sanjay Sipahimalani, Meera Somji, Mehul Srivastava, Dóra Szkuklik, Ameya Tripathi, Davy Verbeke, Kim A. Wagner, Maddie West, Howard Williams, and Fay Young.

Thanks, as always, to my mother, Carol Dyhouse, and my sister, Eugénie von Tunzelmann, for their advice and support. This is the first book I have written without the wisdom of my father,

Acknowledgments

Nick von Tunzelmann, who died in 2019: I miss him and his ideas very much. Finally, love and thanks to my husband, Mike Witcombe. It is never an easy thing to live with an author, and much worse when you're in lockdown and can't get away from them. He has been very patient. I'm extremely grateful, among many other things, for his voracious mind and judicious feedback.

Notes

Introduction: The Making of History

1. Jon Henley, "Copenhagen's Little Mermaid Branded 'Racist Fish' in Graffiti Attack," *Guardian*, July 3, 2020.
2. Executive Order on protecting American monuments, memorials, and statues and combating recent criminal violence, June 26, 2020, https://trumpwhitehouse .archives.gov/presidential-actions/executive-order-protecting-american-mou ments-memorials-statues-combating-recent-criminal-violence/.
3. Kristi Noem, quoted in Chris Cillizza, "Yes, of Course Donald Trump Wants His Face Added to Mount Rushmore," CNN, August 10, 2020.
4. @realdonaldtrump, Twitter, August 10, 2020, 9:07 p.m. EST.
5. @BorisJohnson, Twitter, June 12, 2020, 11:25 a.m.; Greg Heffer, "Labour to Support 10-Year Jail Sentences for War Memorial Vandals," Sky News, June 14, 2020.
6. Taitimu Maipi, quoted in Charles Anderson, "City of Hamilton in New Zealand Removes Statue of British Naval Captain," *Guardian*, June 12, 2020.
7. Quoted in "British Museum 'Won't Remove Controversial Objects' from Display," BBC News, September 28, 2020.
8. Remarks by President Trump at the White House Conference on American History, September 17, 2020, at https://www.whitehouse.gov/briefings-statements /remarks-president-trump-white-house-conference-american-history/.
9. Robert Musil, "Monuments," *Posthumous Papers of a Living Author* (Hanover, NH: Steerforth Press, 2012), 64.
10. Author's interview with Kim Wagner, October 5, 2020.
11. Quoted in *Mount Rushmore National Memorial* (Mount Rushmore National Memorial Society of Black Hills, 1948), Project Gutenberg: https://www .gutenberg.org/files/61106/61106-h/61106-h.htm.

12. Robert Bevan, *The Destruction of Memory: Architecture at War* (London: Reaktion Books, 2006), 8.

13. Rudolf Wittkower, *Gian Lorenzo Bernini: The Sculptor of the Roman Baroque* (London: Phaidon, 1955), 17–18.

14. Brad Downey, quoted in Elian Peltier, "A Melania Trump Statue Is Set on Fire. Its Patron Gets Inspired," *New York Times*, July 2020.

15. John Ma, *Statues and Cities: Honorific Portraits and Civic Identity in the Hellenistic World* (Oxford: Oxford University Press, 2013), 2, 294–97.

16. Christopher H. Hallett, *The Roman Nude: Heroic Portrait Statuary 200 BC–AD 300* (Oxford: Oxford University Press, 2005), 5–19.

17. Julia Vaughan-Morgan, *Equestrian Monuments* (Oxford: Oxford Polytechnic, 1979), 1–2.

18. Sarah E. Bond, "Why We Need to Start Seeing the Classical World in Color," *Hyperallergic*, June 7, 2017; Sarah E. Bond, "Whitewashing Ancient Statues: Whiteness, Racism and Color in the Ancient World," *Forbes*, April 27, 2017; Margaret Talbot, "The Myth of Whiteness in Classical Sculpture," *The New Yorker*, October 22, 2018; Lyra D. Monteiro, "Power Structures: White Columns, White Marble, White Supremacy," *Medium*, October 27, 2020.

19. Quoted in Dario Gamboni, *The Destruction of Art: Iconoclasm and Vandalism Since the French Revolution* (London: Reaktion Books, 2012), 226; see also 225–26 on "Statuemania."

20. "China Has Around 180 Outdoor Mao Statues Left After Political Shift," *Global Times*, December 25, 2016.

21. "$16 Million Gold Mao Statue Unveiled in China," Agence France Presse, December 13, 2013; Tom Phillips, "'Mega Mao' No More as Ridiculed Golden Statue Destroyed," *Guardian*, January 8, 2016.

22. Italo Calvino, "Il Duce's Portraits," *The New Yorker*, January 6, 2003.

23. Alex von Tunzelmann, "The Shameful Legacy of the Olympic Games," *Guardian*, June 12, 2012.

24. Ruth Ben-Ghiat, "Why Are So Many Fascist Monuments Still Standing in Italy?," *The New Yorker*, October 5, 2017; Susan Neiman, "There Are No Nostalgic Nazi Memorials," *Atlantic*, September 14, 2019.

25. East End Women's Museum, @EEWomensMuseum: "A SHORT THREAD CONCERNING STATUES: There Are More Statues of Goats than of Black Women in The UK. (1/7)," Twitter, June 12, 2020, 5:11 p.m. Illustrated with pictures of three goat statues. The following tweet was illustrated with the named statues of Mary Seacole and Floella Benjamin.

26. Tim Stanley, "Tearing Down Confederate Statues Won't Wipe Out Past Evils," *Daily Mail*, August 18, 2017.

27. @Boris Johnson, Twitter, June 12, 2020, 11:25 a.m.

28. Chris Wallace speaking on Fox News, June 11, 2020, https://www.mediamatters.org/chris-wallace/chris-wallace-compares-removal-confederate-statues-mao-zedongs-cultural-revolution.

29. Tammy Bruce speaking on Fox News, June 23, 2020, https://video.foxnewscom/v/6166637768001sp=show-clips.

30. Andrew Roberts, "Stop This Trashing of Monuments—and of Our Past," *Mail on Sunday*, June 13, 2020.

31. @Boris Johnson, Twitter, June 12, 2020, 11:25 a.m.

32. Sarah Vine, "I Fear for Britain's Future if We Erase the Past (Good and Bad)," *Daily Mail*, June 9, 2020.

33. Robert Jenrick, "We Will Save Our Statues from the Woke Militants Who Want to Censor Our Past," *Daily Telegraph*, January 17, 2021.

34. Donald Trump, speaking on Fox News, June 23, 2020, video at https://www.foxnews.com/media/trump-blasts-weak-states-for-allowing-targeting-of-statues-to-happen.

1. A Revolutionary Beginning: King George III

1. Remarks by President Trump at the 2020 Salute to America, July 5, 2020, https://www.whitehouse.gov/briefings-statements/remarks-president-trump-2020-salute-america/.

2. Ruth Kenny, "Joseph Wilton's Equestrian Statue of George III, Bowling Green, New York," in Tabitha Barber and Stacy Boldrick, eds., *Art Under Attack: Histories of British Iconoclasm* (London: Tate Publishing, 2013), 106; Arthur S. Marks, "The Statue of King George III in New York and the Iconology of Regicide," *The American Art Journal*, vol. 13, no. 3 (Summer 1981): 61–62.

3. Krystal D'Costa, "The History Behind the King George III Statue Meme," *Scientific American*, August 23, 2017, https://blogs.scientificamerican.com/anthropology-in-practice/the-history-behind-the-king-george-iii-statue-meme/; Ruth Kenny, *Art Under Attack*, 106.

4. Marks, "The Statue of King George III in New York and the Iconology of Regicide," 61.

5. Ruth Kenny, *Art Under Attack*, 106.

6. Ron Chernow, *Washington: A Life* (London: Allen Lane, 2010), 229–37.

7. Marks, "The Statue of King George III in New York and the Iconology of Regicide," 65; David W. Dunlap, "Long-Toppled Statue of King George III to Ride Again, from a Brooklyn Studio," *New York Times*, October 20, 2016; Valerie Paley, "A Spirit of Patriotism: John Rodgers and New York City's First Presbyterian Church in the American Revolution," *The Journal of Presbyterian History*, vol. 94, no. 2 (Fall/Winter 2016): 52–63, 61; Erika Doss, "Augustus Saint-Gaudens's *The Puritan*: Founders' Statues, Indian Wars, Contested Public Spaces, and Anger's Memory in Springfield, Massachusetts," *Winterthur Portfolio* vol. 46, no. 4 (2012): 237–70, 239; Bob Rupert, "The Statue of George III," *Journal of the American Revolution*, September 8, 2014.

8. "General Orders, 10 July 1776," *Founders Online*, National Archives, https://founders.archives.gov/documents/Washington/03-05-02-0185. [Original source: *The Papers of George Washington*, Revolutionary War Series, vol. 5, June 16, 1776–August 12, 1776, Philander D. Chase, ed. (Charlottesville, VA: University Press of Virginia, 1993), 256–57.]

9. Quoted in Kenny, *Art Under Attack*, 107.

10. "Journals of Capt. John Montresor, 1757–1778," *Collections of the New-York Historical Society for the Year 1881*, vol. XIV (Printed for the Society, New York, 1882), 123–24.
11. Quoted in Kenny, *Art Under Attack*, 106.
12. Skinner: Historic Arms & Militia, 3305M, lot 204, November 4, 2019, https://www.skinnerinc.com/auctions/3305M/lots/204.
13. Collection highlights, New-York Historical Society Museum & Library: https://www.nyhistory.org/exhibit/william-pitt-elder-first-earl-chatham-1708-1778.
14. Quoted in Marks, "The Statue of King George III in New York and the Iconology of Regicide," 74.
15. Ibid., 78.
16. Randy's Random, "Down With the Losers," August 18, 2017, https://randysrandom.com/down-with-the-losers/.
17. Patricia Renaud, "American Colonists Destroy Statue of King George III," imgflip.com, https://imgflip.com/meme/111352538/American-Colonists-Destroy-Statue-of-King-George-III.

2. From Prince to Pariah: William, Duke of Cumberland

1. "'Worst' Historical Britons Named," BBC, December 27, 2005, http://news.bbcco.uk/1/hi/uk/4560716.stm.
2. Quoted in Murray Pittock, *Culloden* (Oxford: Oxford University Press, 2016), 99–101, 107; and Stephen Conway, *War, State, and Society in Mid-Eighteenth-Century Britain and Ireland* (Oxford: Oxford University Press, 2006), 87n21.
3. Pittock, *Culloden*, 104.
4. Geoffrey Plank, *Rebellion and Savagery: The Jacobite Rising of 1745 and the British Empire* (Philadelphia: University of Pennsylvania Press, 2006), 93.
5. "This is the Butcher Beware of Your Sheep" engraving, from the collection of Walter Biggar Blaikie, Blaikie.SNPG.1.5, National Library of Scotland.
6. Pittock, *Culloden*, 121–25.
7. Quoted in W. A. Speck, "William Augustus, Prince, Duke of Cumberland," *ODNB*, January 3, 2008.
8. James Stuart, *Critical Observations on the Buildings and Improvements of London* (London: Printed for J. Dodsley, 1771), quoted in "Cavendish Square 5: The Duke of Cumberland's Statue," Survey of London, UCL, August 19, 2016: https://blogs.ucl.ac.uk/survey-of-london/2016/08/19/cavendish-square-5-the-duke-of-cumberlands-statue/.
9. John R. Gold and Margaret M. Gold, "'The Graves of the Gallant Highlanders': Memory, Interpretation and Narratives of Culloden," *History and Memory* 19, no. 1 (Spring/Summer 2007): 16, 22.
10. Lytton Strachey, *Queen Victoria* (London: Penguin, 2000), 157.
11. Theo Aronson, *Heart of a Queen: Queen Victoria's Romantic Attachments* (London: John Murray, 1991), 150–59.
12. Houghton Townley, *English Woodlands and Their Story* (London: Methuen & Co, 1910), 266.
13. Pittock, *Culloden*, 143.

Notes

14. Charles MacFarlane and Thomas Thomson, *The Comprehensive History of England, vol.3* (London: Blackie & Son, 1861), 312.
15. Author's correspondence with Lewis Baston, November 2020.
16. Howley Hayes Architects, "The Cumberland Column, Birr, Co. Offaly: Conservation Report," February 2009, https://www.offaly.ie/eng/Services/Heritage/Documents/Birr_Column_Report_2009.pdf.
17. Meekyoung Shin, "Written in Soap: A Plinth Project," 2012, https://www.meekyoungshin.com/2012-cavendish.
18. All quoted in Stephen McGinty, "Perfumed Effigy of 'Butcher' Duke Raises a Stink in the Highlands," *Scotsman*, July 8, 2012.

3. The Cult Leader: Joseph Stalin

1. Robert Conquest, *Stalin: Breaker of Nations* (London: Weidenfeld & Nicolson, 1991), 1–2, 52.
2. Quoted in Robert Service, *Stalin: A Biography* (London: Macmillan, 2004), 209.
3. Ibid., 343, 345.
4. Quoted in Lee Hockstader, "From a Ruler's Embrace to a Life in Disgrace," *Washington Post*, March 10, 1995.
5. Conquest, *Stalin*, 325.
6. Service, *Stalin*, 548. A (somewhat doctored) picture of this event can be seen on the cover of *Ogoniok*, no. 52 (December 1949); reproduced in Coquest, *Stalin*, between 174–75.
7. Quoted in Conquest, *Stalin*, 12.
8. Ibid., 37.
9. Gamboni, *The Destruction of Art: Iconoclasm and Vandalism Since the French Revolution* (London: Reaktion Books, 2012), 59–60.
10. Quoted in Katalin Sinkó, "Political Rituals: The Raising and Demolition of Monuments," in *Art and Society in the Age of Stalin*, Péter György and Hedvig Turai, eds. (Budapest: Corvina, 1992), 81.
11. Sándor Kopácsi, *In the Name of the Working Class*, translated by Daniel and Judy Stoffman (London: Fontana, 1989), 82.
12. For a much fuller account of the Hungarian Rebellion of 1956, see Alex von Tunzelmann, *Blood and Sand: Suez, Hungary, and Eisenhower's Campaign for Peace* (New York: HarperCollins, 2016).
13. Nikita Sergeivich Khrushchev, *Memoirs of Nikita Khrushchev Vol 2: Reformer 1945–1964*, edited by Sergei Khrushchev, translated by George Shriver (Pennsylvania: Pennsylvania University Press, 2006), 217
14. Quoted in Victor Sebestyen, *Twelve Days: The Story of the 1956 Hungarian Revolution* (New York: Pantheon Books, 2006), 117–18.
15. Gamboni, *The Destruction of Art*, 60.
16. Quoted in Reuben Fowkes, "Public Sculpture and the Hungarian Revolution of 1956," conference paper, Liverpool University, 2002, https://ungarn1956.zeitgeschichte-online.de/?q=node/95.
17. Géza Bánkuty quoted in Örs Csete, *1956 Budapest: arcok és sorsok/Faces and Stories* (Budapest: Magyar Napló Kiadó, 2001), 18.
18. Kopácsi, *In the Name of the Working Class*, 128.

19. Quoted in Fowkes, "Public Sculpture and the Hungarian Revolution of 1956."
20. Ibid.
21. Quoted in Sebestyen, *Twelve Days*, 119.
22. Various elements of this account are drawn from von Tunzelmann, *Blood and Sand*, 103–110, Sebestyen, *Twelve Days*, 117–18; Csete, *1956 Budapest*, 196; Noel Barber, *Seven Days of Freedom: The Hungarian Uprising 1956* (London: Macmillan, 1974), 25–27; Tibor Meray, *Thirteen Days That Shook the Kremlin*, translated by Howard L. Katzander (London: Thames & Hudson, 1959), 88.
23. Von Tunzelmann, *Blood and Sand*, 439.
24. Kopácsi, *In the Name of the Working Class*, 129.
25. Author's interview with Dóra Szkuklik, August 2020; http://www.mementopark.hu/pages/conception/.
26. Walter Laqueur, *Stalin: The Glasnost Revelations* (London: Unwin Hyman, 1990), 201.
27. Andrei Kolesnikov, "Facing a Dim Present, Putin Turns Back to Glorious Stalin," *Washington Post*, May 8, 2020.
28. Oleksander Lavrynovich, quoted in Mykhailo Yelchev, "New Stalin Statue Fuels Tension in Ukraine," Reuters, May 5, 2010.
29. "Ukraine Says Blowing up Stalin Statue Was Terrorism," Reuters, January 5, 2011.
30. Kathryn Watson, "Stalin Bust Has Virginia Town Red-Faced," *Washington Times*, June 7, 2010; Josh Rogin, "Stalin Statue in Virginia a Huge Bust," *Foreign Policy*, June 7, 2010; Tina Korbe, "D-Day Memorial Board to Relocate Stalin Sculpture," *Daily Signal*, September 29, 2010.
31. Eva Hartog, "Is Stalin Making a Comeback in Russia?," *Atlantic*, May 28, 2019.

4. Imposing Erections: Rafael Trujillo

1. Much of the information in this chapter is fully sourced in Alex von Tunzelmann, *Red Heat: Conspiracy, Murder, and the Cold War in the Caribbean* (New York: Henry Holt, 2011).
2. Few have ever exceeded Trujillo's statue density, though a rare exception may be Kim Il-sung of North Korea. Kim was estimated at one point to have 40,000 statues, busts, and bas-reliefs: one for every three square kilometers. Victor Cha, *The Impossible State: North Korea, Past and Future* (London: Vintage Books, 2013), 71, estimates that there were 40,000 Kim monuments by 1992; see also "23 Things You Probably Didn't Know about North Korea," *Telegraph*, January 8, 2019. The AccessDPRK blog analyzed Google Earth images of North Korea in 2017 and 2018 and estimated the number of monuments in the country as 11,170. This project would not have been able to spot statues that were indoors, so it is likely that the total number is considerably higher. See Jacob Bogle, "The Monuments of North Korea," February 27, 2019, https://mynorthkorea.blogspot.com/2019/02/the-monuments-of-north-korea.html.
3. Oral history interview with Barón Antonio González Santana, January 14, 2021, by Pauline Kulstad González.
4. Lauren Derby, *The Dictator's Seduction: Politics and the Popular Imagination in the Era of Trujillo* (Durham, NC, and London: Duke University Press, 2009), 174.

5. Quotes from ibid., 119.
6. Quoted in Castilia Vargas, "Edwin Espinal," *Listín Diario*, September 11, 2007; see also Víctor A. Mármol, "Mármoladas," *Hoy*, August 28, 2007.
7. Derby, *The Dictator's Seduction*, 109.
8. "El escultor de Trujillo," *El Socialista* (Spain), July 27, 1961.
9. "Estatua en mármol, de 7 metros de alto, se levanta a Trujillo," *El Tiempo* (Colombia), January 17, 1960.
10. Quoted in Robert D. Crassweller, *Trujillo: The Life and Times of a Caribbean Dictator* (New York: Macmillan, 1966), 346.
11. Edwin N. Clark to Dwight D. Eisenhower, re: "U.S. Plan for Trujillo's Retirement," April 13, 1960, USNA: RG 59, Entry 3148, Box 4, Dominican Republic: Gen. Edwin N. Clark.
12. National Security Council meeting, July 25, 1960, in David F. Schmitz, *Thank God They're on Our Side: The United States and Right-Wing Dictatorships, 1921–1965* (Chapel Hill, NC, and London: University of North Carolina Press, 1999), 231; *Foreign Relations of the United States*, 1958–60, vol. v, 807–8.
13. See interview with Minou Tavárez Mirabal in EFE, "Violencia y discriminación de la mujer, un problema muy grave en R.Dominicana," MSN Colombia, August 27, 2011,https://web.archive.org/web/20131203034941/http://noticias.latam.msn.com/co/internacional/articulo_efe.aspx?cp-documentid=30300013.
14. Henry Dearborn, March 22, 1961, quoted in Stephen G. Rabe, *The Most Dangerous Area in the World: John F. Kennedy Confronts Communist Revolution in Latin America* (Chapel Hill, NC, and London: University of North Carolina Press, 1999), 38.
15. John F. Kennedy in ibid., 39.
16. Robert Crassweller, *Trujillo*, 437–39; Arturo R. Espaillat, *Trujillo: The Last Caesar* (Chicago: Henry Regnery Company, 1963), 19.
17. "Ciudad de Santiago vuelve normalidad," *La Nación*, November 20, 1961; "Six Trujillo Foes Reported Killed," *New York Times*, November 21, 1961.
18. "Numerosas personas destruyen monumento memoria Trujillo," *La Nación*, November 27, 1961.
19. "Derriban estatua erigida a Trujillo en San Cristóbal," *El Caribe*, December 19, 1961.
20. Comment in the *Imágenes de Nuestra Historia* Facebook group, October 15, 2017.
21. Michael J. Kryzanek, "The Dominican Intervention Revisited: An Attitudinal and Operational Analysis," in John D. Martz, ed., *United States Policy in Latin America: A Quarter Century of Crisis and Challenge, 1961-1986* (Lincoln, NE, and London: University of Nebraska Press, 1988), 145–46.
22. "11,000 víctimas en Doce Años de JB," *Listín Diario*, March 10, 2013.
23. Roberto Cassá, "Algunos componentes del legado de Trujillo," *Iberoamericana*, vol. I, no. no. 3 (2001): 123.
24. Ibid.
25. Quoted in Randal C. Archibold, "A Museum of Repression Aims to Shock the Conscience," *New York Times*, September 12, 2011.

26. "La vida de Ramfis Trujillo, el nieto del dictador que aspira a presidente de la República," *Listín Diario*, February 25, 2020.
27. Larry Rohter, "The Three Sisters, Avenged: a Dominican Drama," *New York Times*, February 15, 1997.

5. The Great White Elephant: King George V

1. Mary Ann Steggles and Richard Barnes, *British Sculpture in India: New Views and Old Memories* (Kirstead, UK: Frontier Publishing, 2011), 60; Mary Ann Steggles, *Statues of the Raj* (London: BACSA, 2000), 22–23.
2. Quoted in "The Imperial Crown of India," Royal Collection Trust, https://www.rct.uk/collection/31706/the-imperial-crown-of-india.
3. Prince Edward, HRH the Duke of Windsor, *A King's Story* (London: Prion Books, 1998), 163.
4. Steggles, *Statues of the Raj*, 1–10.
5. Ibid, 178–80.
6. David Cannadine, *Ornamentalism: How the British Saw Their Empire* (London: Allen Lane, 2001), 55–56.
7. "Ça sera la plus magnifique de toutes ces ruines," quoted in Malcolm Muggeridge, *The Thirties* (London: Hamish Hamilton, 1940), 76.
8. Lord Curzon to Queen Victoria, September 12, 1900, quoted in P. N. Chopra, Prabha Chopra, and Padmsha Jha, *Secret Papers from the British Royal Archives* (Delhi: Kornak Publishers, 1998), 89.
9. Ann Compton, *The Sculpture of Charles Sargeant Jagger* (The Henry Moore Foundation in association with Lund Humphries, 2004), 90–92, 131.
10. British Pathé, "An Unfinished Symphony in Stone," 1935, https://www.britishpathe.com/video/an-unfinished-symphony-in-stone; "Delhi Statue of King George," *Times of London*, February 21, 1936.
11. Steggles and Barnes, *British Sculpture in India*, 287.
12. For a much more detailed account of the British Raj and Indian independence, see Alex von Tunzelmann, *Indian Summer: The Secret History of the End of an Empire* (New York: Henry Holt, 2007).
13. Steggles, *Statues of the Raj*, 36–38; Paul M. McGarr, "'The Viceroys Are Disappearing from the Roundabouts in Delhi': British Symbols of Power in Post-Colonial India," *Modern Asian Studies*, vol. 49, no. 3 (May 2015): 797–98.
14. Quoted in McGarr, "'The Viceroys Are Disappearing'": 800–1.
15. Quoted in Sushmita Pati, "'A Nation Set in Stone': Insight into the Politics of Statuary in Delhi (1950–65)," *Economic and Political Weekly*, July 28, 2012, 234.
16. Via a British diplomat, quoted in McGarr, "'The Viceroys Are Disappearing'": 797.
17. Quoted in Pati, "'A Nation Set in Stone'": 235.
18. Dwight D. Eisenhower, *The White House Years: Waging Peace, 1956–1961* (New York: Doubleday & Co, 1965), 501–2.
19. Alex von Tunzelmann, "Who Is to Blame for Partition? Above All, Imperial Britain," *New York Times*, August 18, 2017.
20. Sushmita Pati, "'A Nation Set in Stone,'": 235.
21. Quoted in "Statue of George V and Other British Figures Trouble Indians," *New York Times*, July 31, 1966.

22. Ibid.
23. Quoted in McGarr, "'The Viceroys Are Disappearing'": 825.
24. Quoted in "Statue of George V and Other British Figures Trouble Indians," *New York Times.*
25. Quoted in Sanjoy Hazarika, "Delhi Cupola Waits Twenty Years for the Mahatma," *New York Times,* May 29, 1988.
26. Author's interview with Rana Safvi, January 1, 2021.
27. Sameet Yasir, "Gandhi's Killer Evokes Admiration as Never Before," *New York Times,* February 4, 2020.
28. Debika Ray, "The Rise of the Monumental Statue in Modern-Day India," *Apollo,* March 11, 2019.
29. Corey Flintoff, "In India, Once Marginalized Now Memorialized," NPR, October 28, 2011; "Is India's Poverty Line of 65 US Cents a Day Fair?," BBC News, November 5, 2011.
30. "Mayawati Should Reimburse Public Money Spent on Building Statues, Observes Supreme Court," *Scroll.in,* February 8, 2019, https://scroll.in/latest/912521/-mayawati-should-reimburse-public-money-spent-on-building-statues-observes-supreme-court.
31. Krishnadas Rajagopal, "Why No Questions Raised on 182-m High Sardar Patel Statue, Mayawati Asks in SC," *The Hindu,* April 2, 2020.

6. "The Horror! The Horror!": King Leopold II

1. Daniel Boffey, "New Find Reveals Grim Truth of Colonial Belgium's 'Human Zoos,'" *Guardian,* October 4, 2020.
2. Quoted in Isam Shihada, "Historicizing Joseph Conrad's *Heart of Darkness*: A Critique of King Leopold II's Colonial Rule," *English Language and Literature Studies* 5, no. 1 (2015).
3. Valérie Rosoux, "The Two Faces of Belgium in the Congo: Perpetrator and Rescuer," *European Review of International Studies,* no. 3 (Winter 2014): 20–21.
4. George Washington Williams, "An Open Letter to His Serene Majesty Leopold II, King of the Belgians and Sovereign of the Independent State of Congo By Colonel, The Honorable Geo. W. Williams, of the United States of America," July 18, 1890.
5. Quoted in J. D. Whelphey, "The Real King Leopold," *New York Times,* January 27, 1907.
6. "Art notes," *New York Times,* January 4, 1903.
7. Quoted in "King Leopold Denies Charges Against Him," *New York Times,* December 11, 1906.
8. Georges Nzongola-Ntalaja, "Reversing a Bloody Legacy," *Wilson Quarterly* (Fall 2020).
9. British Pathé newsreel, November 22, 1926, film ID 656.16, media URN 26436.
10. "Het ruiterstandbeeld was van bij het begin een rehabilitatie van een verbrand figuur. Als een mooi, proper deksel boven een stinkend riool." Davy Verbeke, "De koning in Kinshasa die nooit in Congo was [Deel I]" *MO*,* August 30, 2015, https://www.mo.be/wereldblog/de-koning-kinshasa-die-nooit-congo-was.

11. "Marred: M. Lumumba's Offensive Speech in the King's Presence," *Guardian*, July 1, 1960.

12. Patrice Lumumba, "Speech at the Ceremony of the Proclamation of the Congo's Independence,", June 30, 1960, https://www.marxists.org/subject/africa/lumumba/1960/06/independence.htm.

13. Quoted in Ian Black, "Belgium Blamed for Icon's Murder," *Guardian*, November 17, 2001.

14. "DR Congo's Leopold Statue Removed," BBC News, February 4, 2005.

15. Ibid.

16. Daniel Boffey, "Reappearance of Statue's Missing Hand Reignites Colonial Row," *Guardian*, February 22, 2019.

17. "La statue de Léopold II 'attaquée,'" *DHnet*, https://www.dhnet.be/archive/la-statue-de-leopold-ii-attaquee-51b7ecc5e4b0de6db9991425.

18. Video at https://www.youtube.com/watch?v=xG6GbBoZGNg&ab_chanel=Th%C3%A9ophiledeGiraud.

19. Robyn Boyle, "Brussels Cancels Homage to Leopold II Amid Protest," *The Bulletin*, December 16, 2015, https://www.thebulletin.be/brussels-cancels-homage-leopold-ii-amid-protest.

20. Scott McLean, "Belgium's King Leopold II Has a 21st Century Nemesis. He's 14 Years Old," CNN, June 25, 2020, https://edition.cnn.com/2020/06/25/europe/belgium-king-leopold-statue-petition-colonialism-intl/index.html.

21. Godfrey Olukya, "Belgian Royal Asks Nation to Apologize to DRC for Past," *Andalou Agency*, June 15, 2020, https://www.aa.com.tr/en/africa/belgian-royal-asks-nation-to-apologize-to-drc-for-past/1877073; Marie-Esmeralda speaking to BBC Newsnight on Twitter, July 1, 2020, https://twitter.com/BBC-Newsnight/status/1278456811834814466.

22. Daniela De Lorenzo, "Belgian's Congolese Mark 60 Years Since DRC's Independence," Al Jazeera, June 30, 2020.

23. Author's interview with Kabund Arqabound conducted by Henri Ward, March 7, 2021.

24. Jack Parrock and Alice Tidey,

25. "Leopold II: Quick Decision Needed Over Whether to Remove Statues to Ex-King, Says Minister," Euro News, June 10, 2020,https://www.euronews.com/2020/06/09/leopold-ii-quick-decision-needed-over-whether-to-remove-statues-to-belgium-s-ex-king-says.

26. Davy Verbeke, "Verlegde Sisyfus een steen? Gecontesteerd Belgisch koloniaal erfgoed en de herdenking van de herdenking (2004–2020)," *Brood & Rozen* (September 2020).

27. Author's interview with Kabund Arqabound conducted.

28. Nzongola-Ntalaja, "Reversing a Bloody Legacy."

7. Lying in State: Vladimir Ilyich Lenin

1. Wesley T. Huntress and Mikhail Ya. Marov, *Soviet Robots in the Solar System: Mission Technologies and Discoveries* (Chichester, UK: Springer Praxis, 2015), 166.

2. Richard S. Wortman, "Statues of the Tsars and the Redefinition of Russia's Past," in Donald Martin Reynolds, ed., *Remove Not the Ancient Landmarks:*

Notes

Public Monuments and Moral Values (London: Routledge, 1996), 122; Nicholas V. Riasanovsky, *The Image of Peter the Great in Russian History and Thought* (Oxford: Oxford University Press, 1985), 87–92.

3. Orlando Figes, *A People's Tragedy: The Russian Revolution 1891–1924* (London: The Bodley Head, 2017), 15, 209.

4. Quoted in Victoria E. Bonnell, "The Leader's Two Bodies: A Study in the Iconography of the Vozhd," *Russian History*, vol. 23, nos. 1–4 (Spring-Summer-Fall-Winter 1996): 114.

5. Igor Grabar remembering the words of Anatoly Lunacharsky, quoted in Christina Lodder, "Lenin's Plan for Monumental Propaganda," in Matthew Cullerne Bown and Brandon Taylor, eds., *Art of the Soviets: Painting, Sculpture and Architecture in a One-Party State, 1917–1992* (Manchester: Manchester University Press, 1993), 19.

6. Quoted in James Rann, "Maiakovskii and the Mobile Monument: Alternatives to Iconoclasm in Russian Culture," *Slavic Review* 71, no. 4 (Winter 2012): 771.

7. Lodder, "Lenin's Plan for Monumental Propaganda," 18–21.

8. Frederick C. Corney, *Telling October: Memory and the Making of the Bolshevik Revolution* (London: Cornell University Press, 2004), 202. See also Nina Tumarkhin, *Lenin Lives! The Lenin Cult in Soviet Russia* (Cambridge, MA: Harvard University Press, 1997), 25–27.

9. James von Geldern, *Bolshevik Festivals, 1917–1920* (Berkeley, CA: University of California Press, 1993), 83–84.

10. Bonnell, "The Leader's Two Bodies," 115–16.

11. Quoted in Alexei Yurchak, "Bodies of Lenin: The Hidden Science of Communist Sovereignty," *Representations*, 129 no. 1, (Winter 2015). 120.

12. Ibid., 121. As the Russian anthropologist Alexei Yurchak has written, quoting the German historian Benno Ennker, "The party leadership was now actively constructing 'Lenin' as 'a particular object of political iconography that was not connected in any way with the real living Lenin.

13. Robert Conquest, *Stalin: Breaker of Nation* (London: Weidenfeld & Nicolson, 1991), 110.

14. Yurchak, "Bodies of Lenin," 124–27.

15. Sergiusz Michalski, *Public Monuments: Art in Political Bondage 1870–1997* (London: Reaktion Books, 1998), 115; Bonnell, "The Leader's Two Bodies," 121, 124.

16. Bonnell, "The Leader's Two Bodies," 125, 128–29, 141.

17. Sona Stephan Hoisington, "'Ever Higher': The Evolution of the Project for the Palace of Soviets," *Slavic Review*#62, no. 1 (Spring, 2003): 62.

18. Sergei Kruk, "Profit Rather Than Politics: The Production of Lenin Monuments in Soviet Latvia," *Social Semiotics* vol. 20. no. 3, (2010): 263, 266, 271; Dario Gamboni, *The Destruction of Art: Iconoclasm and Vandalism Since the French Revolution* (London: Reaktion Books, 2012), 57.

19. Tumarkhin, *Lenin Lives!*, 264.

20. Kruk, "Profit Rather Than Politics," 246, 260; Trevor J. Smith, "The Collapse of the Lenin Personality Cult in Soviet Russia 1985–1995," *The Historian* 60, no. 2 (Winter 1998): 327.

21. Quoted in Smith, "The Collapse of the Lenin Personality Cult in Russia 1985–1995," 331–32.
22. Nina Tumarkhin, *Lenin Lives!*, 279–82; Kathleen E. Smith, "Conflict over Designing a Monument to Stalin's Victims: Public Art and Political Ideology in Russia, 1987–1996," in James Cracraft and Daniel Rowland, eds., *Architectures of Russian Identity, 1500 to the Present* (Ithaca, NY: Cornell University Press, 2003), 193–94, 199–200.
23. Joe Segal, *Art and Politics: Between Purity and Propaganda* (Amsterdam: Amsterdam University Press, 2016), 112–14; Elizabeth Grenier, "Head Start: Lenin's Bust Returns to Berlin despite Red Tape," *Deutsche Welle*, September 10, 2015.
24. Quoted in Svetlana Alexievich, *Second-hand Time*, translated by Bela Shayevich (London: Fitzcaraldo Editions, 2017), 109. See also Smith, "The Collapse of the Lenin Personality Cult," 341.
25. Charlotte Edwardes, "Lord Heseltine Talks Gardens, Politics and His Mother's Dog Kim," *Tatler*, November 1, 2016.
26. Trevor J. Smith, "The Collapse of the Lenin Personality Cult," 333–34; "Lenin Monument Removed from Kremlin," Associated Press, August 16, 1995.
27. Quoted in Benjamin Forest and Juliet Johnson, "Unravelling the Threads of History: Soviet-Era Monuments and Post-Soviet National Identity in Moscow," *Annals of the Association of American Geographers* 92, no. 3 (September 2002): 536.
28. Johannes von Moltke, "Ruin Cinema," in Julia Hell and Andreas Schönle, eds., *Ruins of Modernity* (London: Duke University Press, 2010), 406.
29. Quoted in Benjamin Forest and Juliet Johnson, "Unravelling the Threads of History," 537.
30. Ksenia Isaeva, "Who Lives Under the Sea? Lenin Monument in the Most Unusual Museum Ever," rbth.com, September 26, 2016, https://www.rbth.com/multimedia/pictures/2016/09/26/underwater-museum_633329; "Crimea's Sunken Collection of Soviet Affection," themoscowtimes.com, September 23, 2016, https://www.themoscowtimes.com/2016/09/23/crimeas-sunken-collection-of-soviet-affection-a55470.
31. Quoted in "Bomb Damages Lenin Statue in St Petersburg Suburb," BBC News, December 7, 2010. See also Natalya Krainova, "Small Bomb Explosion Damages Lenin Statue," *Moscow Times*, December 7, 2010.
32. Lenin Falls, Digital Atlas of Ukraine, Ukrainian Research Institute Harvard University, http://gis.huri.harvard.edu/lenin-falls.
33. Andriy Shevchenko, quoted in Eyder Peralta, "In Kiev, Protesters Topple Statue of Vladimir Lenin," NPR, December 8, 2013.
34. Stanislav Holubec, "Lenin, Marx and Local Heroes: Socialist and Post-Socialist Memorial Landscapes in Eastern Germany and Czechoslovakia—The Case Study of Jena and Hradec Králóve," in Agnieszka Mrozik and Stanislav Holubec, eds., *Historical Memory of Central and East European Communism* (London: Routledge 2018); Lenin Falls, op. cit.,;Lenin Statues website, http:///www.leninstatues.ru; Anastasia Pshenychnykh, "Leninfall: The Spectacle of Forgetting," *European Journal of Cultural Studies* 23, no. 3 (2020): 395–406; "Crowd Defends Lenin Statue in Eastern Ukraine City," BBC News, February 23, 2014, video at https://www.bbc.co.uk/news/av/world-europe-26313792.

35. Quoted in Kim Kelly, "Decapitating Lenin Statues Is the Hottest New Trend in Ukraine," VICE.com, May 25, 2017.
36. Malcolm Borthwick, "Revisiting Chernobyl: 'It Is a Huge Cemetery of Dreams,'" *Guardian*, February 28, 2019.
37. Yurchak, "Bodies of Lenin," 145, 148; Andrew Osborn, "Goodbye Lenin? Russian Lawmakers Try to Tweak Law to Get Him Buried," Reuters.com, April 20, 2017; "Poll Shows Two-Thirds of Russians Want Lenin to Be Buried," TASS, April 21, 2017.

8. "The Desert of the Real": Saddam Hussein

1. George W. Bush, Presidential Radio Address: "President Discusses Beginning of Operation Iraqi Freedom," White House Archives, https://georgewbush-whitehouse.archives.gov/news/releases/2003/03/20030322.html.
2. M. Roy, "Saddam's Arms: Nationalist and Orientalist Tendencies in Iraqi Monuments," *Public* 28 (2004): 68.
3. Stefan Heidemann, "Memory and Ideology: Images of Saladin in Syria and in Iraq," in *Visual Culture in the Modern Middle East: Rhetoric of the Image*, Christiane Gruber and Sune Haugbolle, eds. (Bloomington, IN: Indiana University Press, 2013), 64; Florian Göttke, *Toppled* (Rotterdam: Post Editions, 2010), 14–15, 83.
4. M. Roy, "Saddam's Arms 58–59.
5. Jason Farago and Tim Arango, "These Artists Refuse to Forget the Wars in Iraq," *New York Times*, November 14, 2019.
6. Robert Windrem, "Saddam's Palaces Triple in 10 Years," NBC News, http://www.nbcnews.com/id/3340771/t/saddams-palaces-triple-years/.X427li9Q2u4; Brendan Koerner, "How Many Palaces Hath Saddam?," *Slate*, https://slate.com/news-and-politics/2002/10/how-many-palaces-hath-saddam.html.
7. James Meek, "The Sculptor," *Guardian*, March 19, 2004; Andrew Buncombe, "Mayawati Kumari: Untouchable and Unstoppable," *Independent*, February 4, 2008; Lalmani Verma and Chinki Sinha, "The Men and Women at Work," *Indian Express*, July 5, 2009; Swati Mathur, "Indian idols," *Times of India*, April 3, 2010.
8. Jean Baudrillard, *The Gulf War Did Not Take Place*, translated by Paul Patton (Bloomington, IN: Indiana University Press, 1995), 53, 24, 64. See also Samuel Strehle, "A Poetic Anthropology of War: Jean Baudrillard and the 1991 Gulf War," *International Journal of Baudrillard Studies* 11, no. 2 (May 2014).
9. Quoted in Nicholas Watt, "Baghdad Is Safe, the Infidels Are Committing Suicide," *Guardian*, April 8, 2003.
10. Colonel Chris Vernon, transcribed in "British Military Update," CNN, March 29, 2003, http://transcripts.cnn.com/TRANSCRIPTS/0303/29/se.14.html.
11. Peter Maass, "The Toppling: How the Media Inflated a Minor Moment in a Long War," *The New Yorker*, January 3, 2012.
12. Göttke, *Toppled*, 58–65.
13. Maass, "The Toppling"; "I Toppled Saddam's Statue, Now I Want Him Back," BBC News, July 5, 2016, https://www.bbc.co.uk/news/av/world-36712233;

"Iraqi Who Toppled Saddam Hussein's Statue 15 Years Ago Regrets His Action," NPR, April 9, 2018; "Saddam Hussein Statue Toppled in Baghdad, April 2003—Video," *Guardian*, March 9, 2013, https://www.theguardian.com/world/video/2013/mar/09/saddam-hussein-statue-toppled-bagdhad-april-2003-video; Göttke, *Toppled*, 21–40.

14. Patrick Baz, "A Tale of Two Statues," AFP Correspondent, April 9, 2018, https://correspondent.afp.com/tale-two-statues.

15. Quoted in Maass, "The Toppling"; Dhiaa Kareem, "'The Butcher of Baghdad': US Press Hyper-personalization of the US-led Invasion of Iraq," *Annual Review of Education, Communication & Language Sciences* 16: 124; Anton Antonowicz, "What Was It Like in Baghdad When Saddam Hussein's Statue Was Toppled? Defining Moment Vividly Retold," *Mirror*, April 9, 2018; "Bush Compares Fall of Saddam's Statue to Fall of Berlin Wall," *Los Angeles Times*, April 13, 2005.

16. Quotes from Maass, "The Toppling."

17. Sean Aday, John Cluverius, and Steven Livingston, "As Goes the Statue, So Goes the War: The Emergence of the Victory Frame in Television Coverage of the Iraq War," *Journal of Broadcasting & Electronic Media* 49, no. 3 (September 2005): 314–318.

18. Göttke, *Toppled*, insert between 16–119.

19. Maass, "The Toppling"; Sean Aday et al., "As Goes the Statue, So Goes the War," 314–320.

20. "Text of Bush Speech," CBS News, May 1, 2003, https://web.archive.org/web/20060525022143/http://www.cbsnews.com/stories/2003/05/01/iraq/main551946.shtml.

21. Matthew Pressman and James J. Kimble, "The Famous Iwo Jima Flag-Raising Photo Captured an Authentic Moment—but Gave Many Americans a False Impression," *Time*, February 21, 2020.

22. "I Toppled Saddam's Statue, Now I Want Him Back," BBC News.

9. Colossus: Cecil Rhodes

1. Quoted in Paul Maylam, *The Cult of Rhodes: Remembering an Imperialist in Africa* (Claremont, SA: DavidPhilip/New Africa Books, 2005), 12.

2. Quoted in Brenda Schmahmann, "The Fall of Rhodes: The Removal of a Sculpture from the University of Cape Town," *Public Art Dialogue* vol. 6, no. 1 (2016): 94.

3. Quoted in Maylam, *The Cult of Rhodes*, 41.

4. Duncan Bell, *Dreamworlds of Race: Empire and the Utopian Destiny of Anglo-America* (Princeton, NJ: Princeton University Press, 2020), 133.

5. Cecil Rhodes, "Confession of Faith," June 2, 1877, https://pages.uoregon.edu/kimball/Rhodes-Confession.htm.

6. Diary entry of H. Adams-Acton on the dynamiting of Manyepera's caves, Mashonaland, October 1896. Quoted in Richard Hodder-Williams, "Marandellas and the Mashona Rebellion," *Rhodesiana*, vol. 16 (July 1967): 48. With thanks to Tom Menger for this reference.

7. "Death of Mr. Cecil Rhodes," *Manchester Guardian*, March 27, 1902.

8. Cecil Rhodes to Cape Colony Parliament, July 30, 1894, https://www.sahistory.org.za/sites/default/files/glen_grey_speech.pdf. See Robert I. Rotberg, *The*

Founder: Cecil Rhodes and the Pursuit of Power (Oxford: Oxford University Press, 1988); A. Thomas, *Rhodes: The Race for Africa* (London: BBC Books, 1996).

9. Robert I. Rotberg, "Reviewed Work: *The Cult of Rhodes: Remembering an Imperialist in Africa* by Paul Maylam," *Kronos* vol. 32 (2006): 272.

10. W. T. Stead, ed., *The Last Will and Testament of Cecil Rhodes, with Elucidatory Notes* (London: Review of Reviews, 1902), 177.

11. G. P. Gooch, "Imperialism," in C. F. G. Masterman, ed., *The Heart of the Empire* (London: T. Fisher Unwin, 1907, 2nd edition), 362.

12. Stead, *The Last Will and Testament of Cecil Rhodes*, 51.

13. Rotberg, *The Founder*, 408.

14. Maylam, *The Cult of Rhodes*, 13–15.

15. Olive Schreiner to John X. Merriman, April 3, 1897, https://www.olivescreiner.org/vre?view=personae&entry=82.

16. Maylam, *The Cult of Rhodes*, 33–34.

17. Stead, *The Last Will and Testament of Cecil Rhodes*, 64–66. See also Bell, *Dreamworlds of Race*, 138–41.

18. The full will is available in Stead, *The Last Will and Testament of Cecil Rhodes*, 3–50.

19. Anthony Kirk-Greene, "Doubly Elite: African Rhodes Scholars, 1960–90," *Immigrants & Minorities* vol. 21, no. 3 (1993): 220–35.

20. See "#BlackLivesMatter, Racism and Legacy," Rhodes Trust, June 14, 2020, https://www.rhodeshouse.ox.ac.uk/blm-covid-impact/blacklivesmatter--racism-and-legacy/.

21. Quoted in Maylam, *The Cult of Rhodes*, 12.

22. S. H. Scott to Provost Phelps, May 10, 1906, Oriel College Archives, quoted in "Cecil John Rhodes," Oriel College, Oxford, https://www.oriel.ox.ac.uk/cecil--john-rhodes-1853-1902.

23. See John M. MacKenzie, *Propaganda and Empire: The Manipulation of British Public Opinion, 1880–1960* (Manchester: Manchester University Press, 1984), 77, 111.

24. See letter of March 26, 1920 in, *Letters from a Prince: Edward, Prince of Wales, to Mrs Freda Dudley Ward, March 1918–January 1921*, Rupert Godfrey, ed. (London: Warner Books, 1999), 323.

25. Britta Timm Knudsen and Casper Andersen, "Affective Politics and Colonial Heritage, Rhodes Must Fall at UCT and Oxford," *International Journal of Heritage Studies* vol. 25, no. 3 (2019): 253.

26. Anonymous, "Students Daub UCT Statue," *The Argus*, September 14, 1979, quoted in Schmahmann, "The Fall of Rhodes," 96.

27. Quoted in Maylam, *The Cult of Rhodes*, 39.

28. Author's interview with Simukai Chigudu, January 2021.

29. Paul Maylam, "Monuments, Memorials and the Mystique of Empire: The Immortalisation of Cecil Rhodes in the Twentieth Century: The Rhodes Commemoration Lecture Delivered on the Occasion of the Centenary of Rhodes' Death, 26 March 2002," *African Sociological Review* vol. 6, no. 1 (2002): 143.

30. Isabel Wilkerson, "Apartheid Is Demolished. Must Its Monuments Be?," *New York Times*, September 25, 1994.

31. "Our Story: Nelson Mandela and the Rhodes Trust," Mandela Rhodes Foundation, https://www.mandelarhodes.org/about/story, accessed January 2021.

32. Nelson Mandela, remarks at the Mandela Rhodes Banquet, 2003, Nelson Mandela Foundation Archive, https://atom.nelsonmandela.org/index.php/za-com--mr-s-993.

33. Quoted in Nita Bhalla, "South Africa's #RhodesMustFall Founder Speaks Out on Statues That Glorify Racism," *Global Citizen*, June 17, 2020, https://www.globalcitizen.org/en/content/rhodes-must-fall-founder-racist-statues/.

34. Quoted in Mphutlane Wa Bofelo, "Fallism and the Dialectics of Spontaneity and Organization: Disrupting Tradition to Reconstruct Tradition," *Pambazuka News*, May 11, 2017, https://www.pambazuka.org/democracy-governance/fallism-and-dialectics-spontaneity-and-organization-disrupting-tradition.

35. Andrew Harding, "Cecil Rhodes Monument: A Necessary Anger?," BBC News, April 11, 2015, http://www.bbc.com/news/world-africa-32248605.

36. Ramabani Mahapa, "Press Release on UCT Student Protest," March 11, 2015, http://www.scribd.com/doc/258502122/UCT-SRC-Press-Release-on-UCT--Student-Protest.

37. Quoted in Amanda Castro and Angela Tate, "Rhodes Fallen: Student Activism in Post-Apartheid South Africa," *History in the Making*, vol. 10 (2017): 207–8.

38. Kim Cloete, "Dignifying Sarah Baartman," *University of Cape Town News*, September 21, 2018, https://www.news.uct.ac.za/article/-2018-09-21-dignifying--sarah-baartman.

39. Recalled in Zethu Matebeni, "#RhodesMustFall—It Was Never Just About the Statue," *Heinrich Böll Stiftung*, February 19, 2018, https://za.boell.org/en/2018/02/19/rhodesmustfall-it-was-never-just-about-statu.0.

40. Author's interview with Simukai Chigudu, January 2021.

41. Quoted in Ntokozo Qwabe, "Protesting the Rhodes Statue at Oriel College," in R. Chantiluke, B. Kwoba, and A. Nkopo, eds., *Rhodes Must Fall: The Struggle to Decolonise the Racist Heart of Empire* (London: Zed Books, 2018).

42. See Javier Espinoza, "Oxford Student Who Wants Rhodes Statue down Branded 'Hypocrite' for Taking Money from Trust," December 21, 2015, https://www.telegraph.co.uk/education/educationnews/12060780/Oxford-student-who--wants-Rhodes-statue-down-branded-hypocrite-for-taking-money-from-trust.html?WT.mc_id=tmgoff_pq_tw_20150423.

43. Rupert Fitzsimmons, "Rhodes Must Not Fall," *History Today*, December 22, 2015.

44. Amelia Jenne, "Mary Beard Says Drive to Remove Cecil Rhodes Statue from Oxford University Is a 'Dangerous Attempt to Erase the Past,'" *Independent*, December 22, 2015.

45. Quoted in Ailbhe Rea, "'It Was Intensely Painful': The Story of Rhodes Must Fall in Oxford," *New Statesman*, June 11, 2020.

46. *Oxford History*, "Oxford Inscriptions: Cecil Rhodes Statue on Rhodes Building," http://www.oxfordhistory.org.uk/streets/inscriptions/central/rhodes_oriel.html.

47. Javier Espinoza, "Cecil Rhodes Statue to Remain at Oxford University After Alumni Threaten to Withdraw Millions," *Telegraph*, January 29, 2016.

48. Will Dahlgreen, "Rhodes Must Not Fall," YouGov, January 18, 2016, https://yo-gov.co.uk/topics/politics/articles-reports/2016/01/18/rhodes-must-not-fall.

49. Anuradha Henriques, "Conversation Between Anuradha Henriques and Athi-nangamso Nkopo, Tadiwa Madenga and Roseanne Chantiluke," in Chantiluke et al., eds., *Rhodes Must Fall*.

50. Simukai Chigudu, "'Colonialism Had Never Really Ended': My Life in the Shadow of Cecil Rhodes," *Guardian*, January 14, 2021.

51. Quoted in Rea, "'It Was Intensely Painful': The Story of Rhodes Must Fall in Oxford."

52. Quoted in Anna McKie, "Universities Minister: Removing Statue of Rhodes Would Be 'Short-Sighted,'" *Times Higher Education*, June 17, 2020.

53. Quoted in Bill Gardner, "Mandela 'Would Not Want to Topple Rhodes,'" *Daily Telegraph*, June 11, 2020.

54. Quoted in "Oxford Vice-Chancellor Condemned by Dons," *Daily Telegraph*, June 17, 2020.

55. "Lessons from Nelson Mandela on Reconciliation, Reparation, and the Path to Prosperity," Mandela Rhodes Foundation, June 15, 2020, https://www.madelar-hodes.org/ideas/mandela-rhodes-foundation-statement/.

56. Quoted in Michael Race, "Cecil Rhodes: Oxford Scholarship 'Needs Reform,'" BBC News, June 11, 2020.

10. Dedicated to a Lost Cause: Robert E. Lee

1. "Ceremonies at Unveiling of Statue of General Lee," in *Southern Historical Society Papers*, vol. 14, 98.

2. Charles Fenner's speech in "Ceremonies at Unveiling of Statue of General Lee," in *Southern Historical Society Papers*, vol. 14, 64–96; Mayor Behan's speech, 99–101.

3. Georgia secession declaration, January 29, 1861; "A Declaration of the Immediate Causes Which Induce and Justify the Secession of the State of Mississippi from the Federal Union," January 9, 1861; "A Declaration of the Causes Which Impel the State of Texas to Secede from the Federal Union," February 2, 1861.

4. Alexander H. Stephens, Cornerstone speech, March 21, 1861, in Stanley Harold, ed., *The Civil War and Reconstruction: A Documentary Reader* (Malden, MA: Blackwell, 2008), 60–61.

5. Testimony of Wesley Norris, 1866, in John W. Blassingame, ed., *Slave Testimony: Two Centuries of Letters, Speeches, and Interviews, and Autobiographies* (Baton Rouge, LA: Louisiana State University Press, 1977), 467–68.

6. For extensive evidence on all of this, see Michael Fellman, "Robert E. Lee: Postwar Southern Nationalist," *Civil War History* 46, no. 3 (September 2000): 185–204.

7. Robert E. Lee to Jefferson Davis, February 1866, quoted in Fellman, "Robert E. Lee: Postwar Southern Nationalist," 193.

8. Patsy Sims, *The Klan* (Lexington, KY: University Press of Kentucky, 1996), 16, 85.

9. Eric Foner, *Reconstruction: America's Unfinished Revolution, 1863–1877* (New York: HarperCollins, 1988), xxv; John Michael Giggie, "Rethinking Reconstruction," *Reviews in American History* 35, no. 4 (December 2007): 545–55.

10. Emily Suzanne Clark, *A Luminous Brotherhood: Afro-Creole Spiritualism in Nineteenth-Century New Orleans* (Chapel Hill, NC: University of North Carolina Press, 2016), 55–57.

11. See, for instance, Mark Grimsley, "Wars for the American South: The First and Second Reconstructions Considered as Insurgencies," *Civil War History* 58, no. 1 (March 2012): 8–9.

12. James G. Dauphine, "The Knights of the White Camelia and the Election of 1868: Louisiana's White Terrorists; A Benighting Legacy," *Louisiana History: The Journal of the Louisiana Historical Association* 30, no. 2 (1989): 174–76.

13. Michael A. Ross, "The Commemoration of Robert E. Lee's Death and the Obstruction of Reconstruction in New Orleans," *Civil War History* 51, no. 2 (June 2005): 135, 138.

14. Lawrence Powell, "Reinventing Tradition: Liberty Place, Historical Memory, and Silk-Stocking Vigilantism in New Orleans Politics," *Slavery & Abolition* vol. 20, no. 1, (1999): 129–31; James Keith Hogue, *Uncivil War: Five New Orleans Street Battles and the Rise and Fall of Reconstruction* (New Orleans: Louisiana State University Press, 2006), 136–38, 143–44.

15. Powell, "Reinventing Tradition," 132–33.

16. One 1972 Lost Cause book states that Charles Fenner was also a member of the White League: "During the era following the Civil War when the negro element became so abusive to the white and the Crescent regiment of volunteers was organized by the White League, Judge Fenner was made Colonel." This claim is difficult to verify, but not implausible. As an upper-class Southerner, Confederate veteran and lifelong white supremacist, Fenner fit exactly the profile of the White League. Herman Boehm de Bachellé Seebold, *Old Louisiana Plantation Homes and Family Trees*, vol. 2 (Gretna, LA: Pelican Publishing, 1971), 356.

17. House of Representatives, Report 261, 43rd Congress, 2nd Session, Report of the Select Committee on that Portion of the President's Message Relating to the Condition of the South (Washington, DC: US Government Printing Office, 1875), 34–35, 692–93.

18. R. A. Brock, ed., Historical Sketch of the R. E. Lee Monumental Association, in "Ceremonies Connected with the Unveiling of the Statue of General Robert E. Lee at Lee Circle, New Orleans, February 22, 1884," *Southern Historical Society Papers*, vol. 14, 96–97; "The Lee Monument. An Account of the Labors, etc.," *Daily Picayune*, February 22, 1884; Robert Jeanfreau, *The Story Behind the Stone* (Gretna, LA: Pelican Publishing, 2012), 43.

19. W. E. B. Du Bois, *Black Reconstruction in America 1860–1880* (New York: Simon and Schuster, 1999), 30.

20. Charles A. Lofgren, *The Plessy Case: A Legal-Historical Interpretation* (Oxford: Oxford University Press, 1989), 3, 52–53.

21. Richard D. Starnes, "Forever Faithful: The Southern Historical Society and Confederate Historical Memory," *Southern Cultures* 2, no. 2 (Winter 1996): 174–78.

22. Charles Reagan Wilson, "The Religion of the Lost Cause: Ritual and Organization of the Southern Civil Religion, 1865–1920," *Journal of Southern History* 46,

no. 2 (May 1980): 229; Deborah C. Pollack, *Visual Art and the Urban Evolution of the New South* (Colombia, SC: University of South Carolina Press, 2015), 145–47.

23. John Bardes, "'Defend with True Hearts unto Death': Finding Historical Meaning in Confederate Memorial Hall," *Southern Cultures* 23, no. 4 (2017): 39; Dell Upton, *What Can and Can't Be Said: Race, Uplift, and Monument Building in the Contemporary South* (New Haven, CT: Yale University Press, 2015).

24. Quoted in James Karst, "The Leaning Tower of Lee: Statue of Confederate General Was Encircled in Controversy in 1953," *Times-Picayune*, May 14, 2017.

25. Quoted in Sims, *The Klan*, 152–53. In some online sources this incident is conflated with a later one involving David Duke, sometime Grand Wizard of the Ku Klux Klan. Contemporary and printed sources do not place Duke at the 1972 incident but do place him at a 1978 incident at the Battle of Liberty Place monument, as detailed here.

26. Llewelyn J. Soniati, quoted in "Removal of a Marker Linked to Klan Urged," *New York Times*, September 12, 1976.

27. "New Orleans Klan Rallies Early, Missing Irate Blacks: National Director Present," *New York Times*, November 27, 1978.

28. "Racism Is Issue in Clash Over New Orleans Monument," *New York Times*, January 18, 1981.

29. Ryan Erik McGeough, *The American Counter-Monumental Tradition: Renegotiating Memory and the Evolution of American Sacred Space*, unpublished doctoral dissertation, Louisiana State University (2011), https://core.ac.uk/download/pdf/217398051.pdf.

30. James Gill, *Lords of Misrule: Mardi Gras and the Politics of Race in New Orleans* (Jacksonville, MS: University of Mississippi Press, 1997), 262–64.

31. Katy Reckdahl, "3 Defaced New Orleans Monuments Are Cleaned by Volunteers," *Times-Picayune*, March 30, 2012.

32. Ken Daley, "Ferguson-Related Protest March Through New Orleans Affirms Value of Lives," *Times-Picayune*, December 1, 2014.

33. TEDN, "Leaving Them Up Is Not an Option," August 25, 2015, http://takeedownnola.org/updates.

34. Mayor's Office: Landrieu Outlines Process to Relocate Prominent Confederate Monuments, July 9, 2015, NOLA.gov, https://www.nola.gov/mayor/news/archive/2015/20150709-pr-monuments.

35. Stacy Head and Jason Williams, quoted in "New Orleans Council Votes to Remove Confederate Monuments," NBC News, December 18, 2015.

36. "1/12/16 Press Release: Take 'Em Down NOLA Legal Team Files Brief in Support of Taking Down Confederate Monuments in New Orleans," February 2, 2016, http://takeemdownnola.org/updates.

37. The senator was Beth Mizell. Jessica Williams, "Bill Filed in Legislature to Prevent Takedowns of Confederate Monuments," *Times-Picayune*, March 8, 2016; Megan Trimble, "Bill to Block Removal of Confederate Monuments Rejected," Associated Press, April 6, 2016, APNews.com; Megan Trimble, "Tie Vote Stalls Bill to Protect Confederate Monuments," SunHerald.com, April 14, 2016.

38. Jessica Williams, "'Death Threats,' 'Threatening Calls' Prompt Firm Tasked with Removing Confederate Monuments to Quit," *Times-Picayune*, January 15, 2016;

David Lohr, "Man Hired to Remove Confederate Monuments in New Orleans Has $200,000 Lamborghini Torched," HuffingtonPost.com, January 20, 2016.

39. Rob Krieger, "Monument Supporters Hope Legislation Halts Removal," March 27, 2017, Fox8Live.com, https://www.fox8live.com/story/35001019/monument-supporters-hope-legislation-halts-removal.

40. Jenny Jarvie, "New Orleans Removes a Statue of Confederate Gen. Robert E. Lee from Its Perch of 133 Years," *Los Angeles Times*, May 19, 2017.

41. "New Orleans Mayor Mitch Landrieu's Address on the Removal of Confederate Monuments in New Orleans," BlackPast, August 12, 2017, https://www.blacpast.org/african-american-history/2017-new-orleans-mayor-mitch-landrieus-address-removal-confederate-monuments-new-orleans/.

42. A Scribe Called Quess, "What I Told Mayor Mitch Landrieu About Co-Opting Black Activist's [sic] Work," *Medium*, April 24, 2018.

43. Transcript of Donald Trump's remarks by Politifact at https://www.politifact.com/article/2019/apr/26/context-trumps-very-fine-people-both-sides--remarks/. For reporting of the rally, see Matt Pearce, "Chanting 'Blood and Soil!' White Nationalists with Torches March on the University of Virginia," *Los Angeles Times*, August 11, 2017; Sheryl Gay Stolberg and Brian M. Rosenthal, "Man Charged after White Nationalist Rally in Charlottesville Ends in Deadly Violence," *New York Times*, August 12, 2017.

44. Thomas J. Brown, *Civil War Monuments and the Militarization of America* (Chapel Hill, NC: University of North Carolina Press, 2019), 293.

11. Making a Splash: Edward Colston

1. Manny Fernandez and Audra D. S. Burch, "George Floyd, From 'I Want to Touch the World' to 'I Can't Breathe,'" *New York Times*, June 9, 2020; "Before His Deadly Encounter with Police, George Floyd Had Begun a New Life in Minnesota," *Los Angeles Times*, May 28, 2020.

2. Dalton Bennett, Joyce Sohyun Lee, and Sarah Cahlan, "The Death of George Floyd: What Video and Other Records Show about His Final Minutes," *Washington Post*, May 30, 2020.

3. Frank Kitson, *Prince Rupert: Portrait of a Soldier* (London: Constable, 1994), 132–37, 257–63; George Malcolm Thomson, *Warrior Prince: Prince Rupert of the Rhine* (London: Secker & Warburg, 1976), 76–81, 134–37. Butterfly's real name was Mary Villiers, the orphaned daughter of the Duke of Buckingham. It did not work out with Rupert and she eventually married the Duke of Richmond.

4. Eliot Warburton, *Memoirs of Prince Rupert and the Cavaliers* (London: Richard Bentley, 1849), vol. III, 361–425.

5. Frank Kitson, *Prince Rupert: Admiral and General-at-Sea* (London: Constable, 1998), 137.

6. Matthew Parker, *The Sugar Barons: Family, Corruption, Empire, and War* (London: Hutchinson, 2011), 56; Peter Linebaugh and Marcus Rediker, *The Many-Headed Hydra: The Hidden History of the Revolutionary Atlantic* (London: Verso, 2012, revised edition), 78.

7. Marcus Rediker, *The Slave Ship: A Human History* (London: John Murray, 2007), 5; Adam Hochschild, *Bury the Chains: The British Struggle to Abolish*

Slavery (London: Macmillan, 2005), 19–20, 32. The most celebrated first-person account of the Middle Passage is probably that recorded by Olaudah Equiano in his memoir *The Interesting Narrative of the Life of Olaudah Equiano, or Gustavus Vassa, the African* (London, c. 1789), 69–75; chapter 2 in other editions. Equiano was writing a century after Rupert's time, but his experience would have been all too familiar to many who went before him.

8. Molly Hennessy-Fiske, "The Many Chapters Marked by Racism in George Floyd's Family History," *Los Angeles Times*, June 3, 2020; Toluse Olorunnipa and Griff Witte, "Born with Two Strikes," *Washington Post*, October 8, 2020.

9. Carrie Gibson, *Empire's Crossroads: A History of the Caribbean from Columbus to the Present Day* (London: Macmillan, 2014), 97.

10. Letter from the Providence Island Company to Governor Hunt; Governor Butler's diary, March 27, 1639. Both quoted in Karen Ordahl Kupperman, *Providence Island, 1630–1641: The Other Puritan Colony* (Cambridge: Cambridge University Press, 1993), 170–71.

11. See John Hope Franklin and Loren Schweninger, *Runaway Slaves: Rebels on the Plantation* (Oxford: Oxford University Press, 1999).

12. Sir Ralph Freeman, *Imperiale: A Tragedy*, quoted in A. R. Bossert, "Slavery and Anti-Republicanism in Sir Ralph Freeman's 'Imperiale: A tragedy' (1639)," *Early Theatre* 13, no. 1 (2010): 88. Bossert's article is an excellent historical and literary analysis to which this section is indebted.

13. An anonymous contemporary pamphlet accused him of being a Jacobite and immoral—"Mr. C— [Colston], who has shown how far he prefers good Works to the Purity of Life, by laying out some Thousands of Pounds in building Hospitals here, while himself liv'd very much at his ease with a *Tory, tho'* of a different Sex at M—ke [Mortlake]." Dated November 26, 1714, reproduced in H. J. Wilkins, *Edward Colston [1636–1721 A.D.]: Supplement to a Chronological Account of His Life and Work* (Bristol: J. W. Arrowsmith, 1925), 21.

14. Kenneth Morgan, "Edward Colston, 1636–1721," *ODNB*, July 9, 2020.

15. Hannah Rose Woods, "The Destruction of Edward Colston's Statue Is an Act of Living History," *New Statesman*, June 8, 2020.

16. John R. Turner, "James Williams Arrowsmith, 1839–1913," *ODNB*, September 23, 2004.

17. *Western Daily Press*, November 14, 1868, quoted in Spencer Jordan, "The Development and Implementation of Authority in a Regional Capital: A Study of Bristol's Elites, 1835–1939," PhD thesis, University of the West of England, 1999, 322.

18. Jordan, "The Development and Implementation of Authority in a Regional Capital," 324–26.

19. Madge Dresser, "Good People, Hate Groups, and History," TEDx Bristol talk, December 19, 2017.

20. Quoted in Richard Huzzey, *Freedom Burning: Anti-Slavery and Empire in Victorian Britain* (Ithaca, NY: Cornell Press, 2012), 145–46.

21. Quoted in Roger Ball, "Myths Within Myths: Edward Colston and That Statue," published by the Bristol Radical History Group, https://www.brh.org.uk/site/articles/myths-within-myths/.

22. Ibid.

23. Jordan, "The Development and Implementation of Authority in a Regional Capital," 330–32.

24. H. J. Wilkins, *Edward Colston: A Chronological Account of His Life and Work* (Bristol: J. W. Arrowsmith, 1920).

25. Madge Dresser, "Obliteration, Contextualisation or 'Guerrilla Memorialisation'? Edward Colston's Statue Reconsidered," *Open Democracy*, August 29, 2016; Ellie Pipe, "New Plaque on Colston Statue Declares Bristol Slavery Capital," *Bristol 24/7*, August 17, 2017; Martin Booth, "Colston Statue Given Ball and Chain," *Bristol 24/7*, May 6, 2018; Tristan Cork, "100 Human Figures Placed in Front of Colston Statue in City Centre," *Bristol Live*, October 18, 2018.

26. Quoted in Tristan Cork, "Theft or Vandalism of Second Colston Statue Plaque 'May Be Justified'—Tory Councillor," *Bristol Live*, July 23, 2018; for the golliwog story, see David Ward, "Golliwog Stunt Leaves Tory in a Jam," *Guardian*, September 6, 2001.

27. For a longer discussion of this, see Roger Ball, "The Edward Colston 'Corrective' Plaque: Sanitising an Uncomfortable History," published by the Bristol Radical History Group, n.d. [2019], https://www.brh.org.uk/site/articles/the-edward-colston-corrective-plaque/.

28. Tristan Cork, "Second Colston Statue Plaque Not Axed and Will Happen but Mayor Steps in to Order a Re-Write," *Bristol Live*, March 25, 2019.

29. Catherine Shoard, "John Boyega's Rousing Black Lives Matter Speech Wins Praise and Support," *Guardian*, June 4, 2020.

30. @beardedjourno, Twitter,"Historic scenes in Bristol as protesters kneel on the neck of the toppled statue of Edward Colston for eight minutes. #blacklivesmatter," June 7, 2020, 3:13 p.m. Photograph included in tweet. See also Luke O'Reilly, "Black Lives Matter Protesters in Bristol Topple Statue of Slave Trader Edward Colston," *Evening Standard*, June 7, 2020.

31. @icecube, Twitter, June 7, 2020, 5:09 p.m.; @MomentumBristol, June 7, 2020, 16:05 p.m.; TikTok: rhianna_jay, 'bristol really ran up on edward colston'; @DrFuck_, Twitter, June 8, 2020, 9:22 a.m.

32. Twitter: @sajidjavid, June 7, 2020, 5:36 p.m.; 10 Downing Street statement quoted in "Edward Colston: Bristol Slave Trader Statue Was 'an Affront,'" BBC News, June 8, 2020;Statement by the Society of Merchant Venturers, June 12, 2020, https://www.merchantventurers.com/news/statement-from-the-society--of-merchant-venturers/.

33. Councillor Richard Eddy quoted in Tristan Cork, "Edward Colston Was 'a Hero' for Bristol Says Outraged Tory Councillor," *Bristol Live*, June 9, 2020; Tommy Robinson quoted in Joel Golby, "A Bat Signal Has Gone Out to Britain's Proud Patriots: Save Our Statues," *Guardian*, June 10, 2020; Will Heaven, "Why Edward Colston's Statue Should Have Stayed Up," *Spectator*, June 7, 2020.

34. David Olusoga, "The Toppling of Colston's Statue Is Not an Attack on History. It Is History," *Guardian*, June 8, 2020.

35. Quoted in "Edward Colston Statue Pulled Out of Bristol Harbour," BBC News, June 11, 2020.

36. Thomas J. Price and Bernardine Evaristo quoted in Lanre Bakare, "Allyship or Stunt? Marc Quinn's BLM Statue Divides Art World," *Guardian*, July 15, 2020;

Jen Reid quoted in Aindrea Emelife, "'Hope Flows Through This Statue': Marc Quinn on Replacing Colston with Jen Reid, a Black Lives Matter Protester," *Guardian*, July 15, 2020.

37. @MarvinJRees, Twitter, July 15, 2020, 2:27 p.m.

12. American Idol: George Washington

1. "General Orders, July 10, 1776," *Founders Online*, National Archives, https://founders.archives.gov/documents/Washington/03-05-02-0185.

2. Quotes in Gillian Brockell, "Everyone Loved George Washington, Until He Became President," *Washington Post*, February 17, 2020.

3. Donald Yacovone, "A Covenant with Death and an Agreement with Hell," Massachusetts Historical Society, July 2005, https://www.masshist.org/object-of-the-month/objects/a-covenant-with-death-and-an-agreement-with-hell-2005-07-01.

4. Abraham Lincoln, speech at Peoria, Illinois, October 16, 1854, https://www.nps.gov/liho/learn/historyculture/peoriaspeech.htm.

5. Henry Cabot Lodge, "The Real George Washington," from *George Washington—American Statesman Series*, 1889, https://www.bartleby.com/400/prose/2288.html.

6. "Cheerful Americans in Mexico," *New York Times*, February 13, 1912.

7. "Our Envoy Now Safe on Board the Minnesota," *New York Times*, April 25, 1914.

8. Carlos Villasana and Ruth Gómez, "Washington en la capital, símbolo de amistad," *El Universal*, July 26, 2019.

9. The S. J. Clarke Publishing Company, "Multnomah County OR Archives Biographies: Coe, M.D., Henry Waldo, November 4, 1857–February 15, 1927," usgwarchives.net, http://files.usgwarchives.net/or/multnomah/bios/coed359gbs.txt.

10. "Ahmaud Arbery: What Do We Know About the Case?," BBC News, June 5, 2020, https://www.bbc.co.uk/news/world-us-canada-52623151; BBC News, "Breonna Taylor: Police Officer Charged but Not Over Death," BBC News, September 23, 2020, https://www.bbc.co.uk/news/world-us-canada-54273317.

11. Derrick Bryson Taylor, "George Floyd Protests: A Timeline," *New York Times*, July 10, 2020.

12. Quoted in Erik Ortiz, "'I Chose My City': Birmingham, Alabama, Removes Confederate Monument, Faces State Lawsuit," NBC News, June 3, 2020.

13. Andrew Buncombe, "'We're Not Going Anywhere': Why Portland Is Still Protesting 100 Days after George Floyd's Killing," *Independent*, September 4, 2020.

14. "George Washington Bush," National Park Service, https://www.nps.gov/people/georgewashingtonbush.htm.

15. Greg Nokes, "Black Exclusion Laws in Oregon," Oregon Historical Society, Oregon Encyclopedia, https://www.oregonencyclopedia.org/articles/exclusion_laws/.

16. Quoted in Latisha Jensen, "Portland Man Describes Tearing Down Thomas Jefferson Statue: 'It's Not Vandalism,'" *Willamette Week*, June 20, 2020.

17. Henry Wiencek, "The Dark Side of Thomas Jefferson," *Smithsonian Magazine*, October 2012; Britni Danielle, "Sally Hemings Wasn't Thomas Jefferson's Mistress. She Was His Property," *Washington Post*, July 7, 2017.

18. H. W. Brands, "Founders Chic," *The Atlantic*, September 2003.

19. Portland Police Bureau, "Demonstrations in Portland June 18–19, 2020," https://www.portlandoregon.gov/police/news/read.cfm?id=250900.

20. David Williams, "Protesters Tore Down a George Washington Statue and Set a Fire on Its Head," CNN, June 19, 2020.

21. "From George Washington to Major General Lafayette, July 4, 1779," *Founders Online*, National Archives, https://founders.archives.gov/documents/Washington/03-21-02-0286.

22. Katey Rich, "George Washington Never Mentions Slavery in *Hamilton*, but the Actor Who Plays Him Does," *Vanity Fair*, April 29, 2016.

23. Quoted in Rebecca Onion, "A *Hamilton* Skeptic on Why the Show Isn't as Revolutionary as It Seems," *Slate*, April 5, 2016.

24. Rebecca Ellis, "George Washington Statue Toppled in Portland," *News-Review*, June 19, 2020.

25. Quoted in Jensen, "Portland Man Describes Tearing Down Thomas Jefferson Statue."

26. Quoted in Lizzy Acker, "Trump Invokes Portland Protests, Removal of George Washington Statue During Tulsa Rally," *Oregonian*, June 21, 2020.

27. Shane Dixon Kavanaugh, "Portland Protesters Topple Statues of Theodore Roosevelt, Abraham Lincoln in 'Day of Rage'; Police Declare Riot," *Oregonian*, October 11, 2020.

28. Shannon Gormley, "Protesters Have Built Another Elk Statue Downtown After the Previous One Was Taken by Patriot Prayer," *Willamette Week*, October 13, 2020.

29. Eric Reid, "Why Colin Kaepernick and I Decided to Take a Knee," *New York Times*, September 25, 2017.

30. Quoted in Adam Edelman, "Trump Says NFL Players Who Kneel During National Anthem 'Maybe Shouldn't Be in the Country,'" NBC News, May 24, 2018.

31. Reid, "Why Colin Kaepernick and I Decided to Take a Knee."

32. Joseph Cranney, "He Told Charleston Police, 'I Am Not Your Enemy.' Then He Was Handcuffed," *Post & Courier*, June 1, 2020.

33. "In America, Protest Is Patriotic," *New York Times*, June 2, 2020.

34. "President Donald J. Trump Is Protecting America's Founding Ideals by Promoting Patriotic Education," White House fact sheet, November 2, 2020, https://trumpwhitehouse.archives.gov/briefings-statements/president-donald-j-trump-protecting-americas-founding-ideals-promoting-patriotic-education/..

35. Richard J. Evans, "Michael Gove's History Wars," *Guardian*, July 13, 2013.

Conclusion: Making Our Own History

1. Simon Schama, "History Is Better Served by Putting the Men in Stone in Museums," *Financial Times*, June 12, 2020.

2. Quoted in Dario Gamboni, *The Destruction of Art: Iconoclasm and Vandalism Since the French Revolution* (London: Reaktion Books, 2012), 51–52.

3. Quoted in Andrew Higgins, "In Russia, They Tore down Lots of Statues, but Little Changed," *New York Times*, July 7, 2020.

4. The 1776 Report, January 2021, https://trumpwhitehouse.archives.gov/wp-content/uploads/2021/01/The-Presidents-Advisory-1776-Commission-Fnal-Report.pdf.

5. Both quoted in Gillian Brockell, "'A Hack Job,' 'Outright Lies': Trump Commission's '1776 Report' Outrages Historians," *Washington Post*, January 20, 2021.

6. @davidwblight1, Twitter, January 18, 2021, 10:44 p.m.

7. Jennifer Schuessler, "Mellon Foundation to Spend $250 Million to Reimagine Monuments," *New York Times*, October 5, 2020.

ABOUT THE AUTHOR

ALEX VON TUNZELMANN is the author of *Blood and Sand*, *Indian Summer*, and *Red Heat*. Her writing has appeared in the *New York Times*, the *Los Angeles Times*, the *Washington Post*, and more. She is also a screenwriter for film and television. She lives in London.